THE ARTIFICIAL KINGDOM

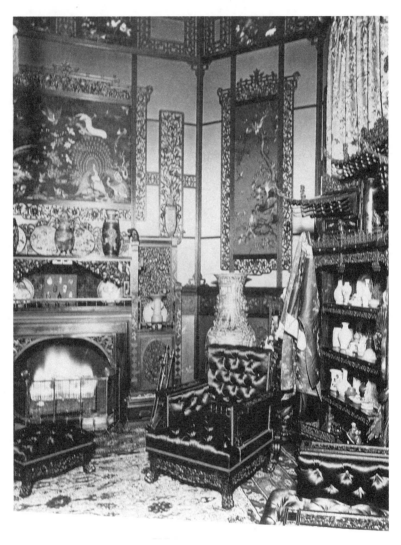

CHINESE ROOM IN THE HAVEMEYER RESIDENCE, 1894.
Photograph by Joseph Byron. © *Museum of the City of New York.*

The Artificial Kingdom

ON THE KITSCH EXPERIENCE

CELESTE OLALQUIAGA

UNIVERSITY OF MINNESOTA PRESS

MINNEAPOLIS

Published by arrangement with Pantheon Books, a division of Random House, Inc.

Book design by Loid Der

First University of Minnesota Press edition, 2002

Published by the University of Minnesota Press
111 Third Avenue South, Suite 290
Minneapolis, MN 55401-2520
http://www.upress.umn.edu

Library of Congress Cataloging-in-Publication Data

Olalqiaga, Celeste.
 The artificial kingdom : on the kitsch experience / Celeste Olalquiaga.
 p. cm.
 Originally published: New York : Pantheon Books, 1998.
 Includes bibliographical references and index.
 ISBN 978-0-8166-4117-8 (pbk. : alk. paper)
 1. Kitsch. I. Title.

BH301.K5 O43 2002
709'.03'48—dc21 2002072438

Printed in the United States of America on acid-free paper

The University of Minnesota is an equal-opportunity educator and employer.

17 16 15 14 13 12 10 9 8 7 6 5 4

Au bonheur des dames

(To the ladies' happiness)

What guides poetic thinking is the conviction that although the living is subject to the ruin of time, the process of decay is at the same time a process of crystallization, that in the depth of the sea, into which sinks and is dissolved what once was alive, some things "suffer a sea-change" and survive in new crystallized forms and shapes that remain immune to the elements, as though they waited only for the pearl diver who one day will come down to them and bring them up into the world of the living. . . .

HANNAH ARENDT

Contents

———

A CKNOWLEDGMENTS

I WOULD like to begin by expressing my gratitude to all of those people, friends and strangers alike, who during the years that this book was in the making manifested great interest and complete trust in my work. Such support, at times fragmentary and sporadic, helped carry me through what often seemed a solitary, though infinitely delectable, confinement.

I feel very privileged to have been living in New York City, my home for the last fifteen years; it provided me with the intellectual freedom and energy necessary for a project of such breadth, as well as the resources that made it possible. I especially thank the New York Public Library, in the midst of whose nineteenth-century architecture and extraordinary book collection I was literally transported to the period of my research.

The Rockefeller Foundation granted me a Summer 1994 Bellagio Residency which helped me lay down the foundations for *The Artificial Kingdom*. The Writers Room, particularly during its Waverly Place period, offered a quiet place to work and the instructive experience of

watching other writers in their daily toil. The National Writers Union provided the professional support fundamental for independent writers.

My agent, Lydia Wills, envisioned my career as a writer while I was still trying to untangle myself from academic trappings. My editor, Erroll McDonald, understood from the beginning that this was an unconventional project that "obscured the obvious," rather than banalizing what everyone took for granted. I thank him for his courage and his respect for my ideas and my writing. I am also very grateful to the staff at Pantheon Books, who did a beautiful job with a particularly laborious project. I especially appreciate Joan Benham's insightful comments and queries, Jeanne Morton's sharp, patient, and enthusiastic copy editing, and Amy Claire Gray's dedicated assistance with the illustrations.

Above all, I want to thank my friends, those who are still around and those who no longer are. In one way or another, they all helped me understand the importance of this book. I am particularly grateful to those who read my manuscript: Kristin Royer, whose love and support were vital throughout the years; Catherine Benamou for her suggestions and her translations from the French; Sammy Cucher for his knowledge of art history and our shared interests; Juan Ordieres for having found in my writing "a garden of exotic flowers," and for being there; and Loid Der for unconditionally accompanying me in this long and difficult journey, and helping make it into a magnificent reality.

THE ARTIFICIAL KINGDOM

RODNEY AND ME

●◆▶◀◆●

MEET Rodney, king of the hermit crabs. From the distant proximity of his glass-globe prison, Rodney stares back at me with silent intensity. Doomed to be mine for as long as I desire, perhaps he finds within the brittle limits of his crustacean body some forgiveness towards the human longing that drives me to love his death, a permanent state of suspension that sparks in my heart the boundless joy of recognition. Looking into Rodney's minuscule pupils (my friends claim those can't be real eyes, yet they shine like silver pins) I enter a faraway world: vaguely familiar memories beckon me with the magic appeal of those ocean waves which people often hear resonate in the huge open whorl of imperial Purpura shells. Spellbound, I travel to a time beyond memory, a place that stands still, vast and gleaming, in a remote corner of my mind.

My first encounter with Rodney took place in San Francisco at a bed-and-breakfast, an old Victorian mansion where each bedroom was fancily decorated and named after a famous turn-of-the-century guest: the Isadora Duncan room, the Enrico Caruso room, the Luisa Tetrazzini suite. After sleeping one night in each,

I made my way to a small white chamber hidden away in one of the towers and replete with ocean paraphernalia. Half the size of the others, this dormitory, a true sky parlour, radiated a soft pink light and seemed suspended in the breeze. A tiny frigate navigating happily amidst an urban sea, the Jack London room would take wind in the sails of its sheer muslin curtains, flying away from the Château Tivoli with a marine treasure-load of coral branch, dried sponges, captain's cap, ship photos, rusty anchor and, next to the bed, Rodney. The roundness of this self-contained world afforded me a unique kind of protection, the safety of receding into an intimacy at once foreign and very mine, a place where objects and atmosphere became the continuation of a static interior landscape. I had found a private décor where my feelings could manifest themselves outwardly in the most palpable of ways, as if having walked into a long-forgotten attic.

Rodney's impassive condition is an open threshold, a portal where life and death meet, each one stepping back to let the other go by, neither concerned about a primacy that can only be momentary in an otherwise intertwined destiny. When I stare at Rodney, trapped in his ice palace as if the sea had frozen unexpectedly around him, enveloping his small life in a hard vitric globe like the hazy, hyalescent vision of a gypsy's magic ball, I feel my heart burst into tears, hoping that somehow the warmth of this lachrymal flood will dissolve Rodney's prison. Buried alive, Rodney will never again know the gradual unfolding of events, the sequential expectation generated when one is accustomed to

watching one thing follow another. Time for this hermit crab is a
static dimension from which there is no possible escape or
change—only a resigned abeyance, a complete surrender to a
single, infinite moment that he occupies entirely alone.

Rodney's is the tempo of things that remain in a deep slumber
until they are discovered anew, brought back to life in the glori-
ous intensity of amazement, an experience where objects and
events are able to flourish again, Sleeping Beauties whose radiant
youth has only been enhanced by the long period during which
they remained latent. It is as if their dormancy gave such things a
quiet depth impossible to attain in the heavy bustling of continu-
ous, uninterrupted time. As if suspension in limbo, instead of
being empty or blank, carried the imprint of a peculiar duration,
one that is measured, not in the productive accumulation of years
or days, but rather in the subtle persistence of a stubborn
anachronicity, the stoic refusal of things to depart once their use-
fulness is exhausted.

The lost hours of temporal travelers—those who continually
roam in the boundless space of distraction—are made up of cher-
ished memories that somehow wandered off and miraculously
found their way back, if only to bid a permanent farewell. For
daydreamers there is no such thing as wasted time, only the busy
intervals between one fantasy and the next, pregnant lapses dur-
ing which reminiscing takes a back seat to a direct action that,
nevertheless, secretly scrounges the landscape of the present for
the wicks of invisible fires. Such ignitions act like the sudden

blazes that are said to overcome boats while they innocently glide on a smooth sea: as they burst into flames, these watercrafts' customary voyage comes to an abrupt end, their hulks dragging them down into an all-consuming depth where they will begin a new existence as shipwrecks.

Sunken treasures, the once-buoyant nautical crafts are now anchored to the bottom of the ocean as fantastic sculptures in a vast underwater garden. Here, these humbled navigators commence a new, sedentary existence: their whole physiognomy starts to metamorphose, camouflaging into the hues and textures of the marine scenario, in the same way that loose memories and idle fantasies slowly conform to the irregular panorama of our psyche. Contraband fixtures of the undulatory ocean desert, these capsized vessels develop and unfold, like madrepores, from the abandoned carcasses of transient creatures, one corpse piling upon another as in the mineral chimneys of coral reefs, which grow taller with each discarded life.

Sometimes, these marine palaces rise high over the waves, as if challenging the sunlight to filter through their mazelike crevices without getting lost. More often, however, they remain within the seclusion of their island universe, along with the schools of colorful fish that glide past them and those occasional divers who tear entire chunks from their body, fragments of an existence based on what no longer is, but which as mementos will never cease to be. Memories, too, often lie peacefully sequestered in the recondite folds of our mind, patiently awaiting the moment

when they will be aroused from this entrancement to fly again on the wings of fantasy. And despite all the transformations that have piled upon them, rendering them unrecognizable to a credulous beholder, the best of their sunken cargo remains untouched, ready to be salvaged or plundered, resuscitated anew.

The fates of ships and of thoughts are very similar: confident, they sail on uncharted grounds, seeking to arrive at their destinations by the straightest possible line. Yet once at sea, set on their voyage, strange things beset them: nightmares of marine serpents, unpredictable storms, gigantic waves that roll them pitilessly, often swallowing their fragile bodies without warning. Few are the ships and thoughts that, having ventured forth on unknown—and sometimes even well-known—waters, emerge intact from the perilous experience. The bed of the sea is littered with the remnants of adventurous boats, much as the human mind is often but a cemetery of fearless thoughts gone astray. Yet these random thoughts, these forgotten shipwrecks, are full of secret treasures and untold mysteries, and here is to be found a plenitude like no other: a new life that, however still, abruptly transforms what it comes in contact with, charging the present with the unavoidable weight of things past.

It is this miraculous palingenesis, this apparent return from the dead, that the casual encounter with stray objects can trigger in our hearts, those bivalve organs in whose cloistered interior experiences settle like grains of sand or parasites in oysters. These audacious intruders are then slowly enveloped by their

receptacles' vital fluids—here nacre, there emotion—eventually producing a smooth, shiny pearl, a unique amalgam of interior and exterior whose birth celebrates the fusion of fixed and fluid, isolated and continuous, dejected and splendid: such are the veritable fruits of the bottom of the sea. These magnificent creations are what connect us to our innermost nature, as if to arrive there we first had to travel a long and circuitous road, paved with time, full of detours, strewn with the most exquisite delights and torturous pains, all to finally understand that only in such a transit, only in the precarious balance of suspended permanence and unrelenting change, excruciating solitude and boundless communion, lies the secret of all creatures and things.

Rodney's eyes become sharply focused as my castle in the air pops and, motionless, I land after this kaleidoscopic voyage in the dim glow of a recalcitrant dusk. All of a sudden, the Jack London room comes back to life amidst late afternoon sounds that, one by one, make their distinct entrances, the crepuscule's reddish haze quickly giving way to a colorless penumbra. It is that time of day when light and darkness trade places, although neither is quite at its post yet: the last rays of the sun linger, hanging on to clouds whose bizarre formation is never more apparent, while the evening gently settles in, erasing the nitid contours of objects and people. Everything seems to disappear in this twilight, yet no amount of electric incandescence can bridge the uncertain gap between day and night, no human eye can grasp the polychromatic variegation of the skies' change

of guard: alterations are so swift one would say they occur with every blink.

Squinting, I stretch out my arm to grab Rodney. Unwilling to let go of the reverie, I press my face against the transparent bubble that holds him, hoping this gesture will bring him a little closer for a few more seconds. But I have returned from my musing and the spell is broken. Somewhere outside, a child's cry and its mother's gentle prodding remind me that I am on a rented bed in an unfamiliar city, thousands of miles from home and even further from the small girl who, for a moment there, returned to existence in the evanescent life of daydreams.

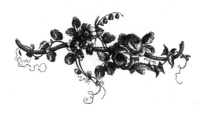

The
Intoxication
of
Modernity

Styles die, only kitsch survives.

———

A N O N Y M O U S

HE domestic aquarium fad that hit Victorian England during the 1850s and 1860s may be considered, along with its direct antecedent, the collecting of ferns, a true mass-culture phenomenon: one where an object or cluster of objects becomes the focus of an obsessive and pervasive consumption that, despite its seriality or multiplicity, is felt as intimately personal.

Re-creating the mysterious aura of organic authenticity that the industrial and mechanical trappings of their era had apparently preempted, aquariums provided a miniature scenario aptly suited to Victorian interiors, which they enhanced and reproduced. Together with pteridomania (the mania for ferns) and close on the heels of the collecting of shells and butterflies—although with the unique advantage of holding live beings—aquariums were among the first mass collectibles. As such, they encompassed the main aspects of modern popular culture,

in particular the inducement of visual pleasure through the scenographic images and the miniaturization proper to most souvenirs.

The nineteenth century witnessed a multiplication in image-making techniques that transformed Western culture's optical unconscious. Mechanical reproduction not only altered the proliferation and affordability of images, but also enabled a particular, modern sensibility based on the preeminence of looking and collecting. Although this sensibility may be traced back several centuries, what emerges at this moment is the unprecedented democratization of the practices of looking and collecting. The popularity of photography and the reconstitution of the street into a site of middle-class mercantile and spectacular exchange make this very clear. Already by the 1830s the first dioramas had been built and the pioneer daguerreotypes produced, launching an era of public voyeurism. Scientific research and industrialization were beginning to reconstruct the world anew, burgeoning with the possibilities of taming and artificially reproducing nature.[1]

Imagistic representation, for centuries the privileged domain of the Church and the rich, was now accessible in a way that surpassed the previous popularity of lithographs and illustrated books, since possessing photographs required little education and less financial means. Ironically, photography registered a pre-industrial world that was being lost while making its representations publicly available.[2] The fashionable "picture albums"—one of those modes of collecting that have survived,

1. For the cultural impact of modernization, see Walter Benjamin, *Charles Baudelaire: A Lyric Poet in the Era of High Capitalism*, trans. Harry Zohn (London: Verso, 1983); Dolf Sternberger, *Panorama of the Nineteenth Century*, trans. Joachim Neugroschel (New York: Urizen Books, 1955); Raymond Williams, *The Long Revolution* (Westport, Conn.: Greenwood Press, 1961); and Rosalind H. Williams, *Dream Worlds: Mass Consumption in Late Nineteenth-Century France* (Berkeley and Los Angeles: University of California Press, 1982).

2. See Walter Benjamin, "A Short History of Photography," *Screen* 13, no. 1 (Spring 1972): 5–26, and Susan Sontag, "Melancholy Objects," in her *On Photography* (New York: Doubleday/Anchor Books, 1977), pp. 51–82.

in one way or another, to our day—are an interesting example of how mechanical reproduction began to occupy the European cultural imagination. Picture albums started in the late 1850s as collections of "cartes de visite," photographic calling cards of friends and relatives or well-known personalities. At first exchanged on special occasions and later treasured and proudly exhibited in Victorian parlours, by the turn of the century these albums had reached monumental proportions, their cards busily purchased and traded. In the 1880s, picture albums incorporated scenic postcards, which sold by the millions.[3]

Picture albums illustrate an aspect of popular culture that had been forming slowly, finding in mechanical reproduction a new twist: the art of collecting. While the tremendously expensive collections of earlier centuries had banked on exclusivity for their prestige, the form of collection that took shape during the nineteenth century incorporated the modern phenomenon of repetition. Part of this has to do with the novelty of mass production itself: the impact of a different way of looking at things through technical achievements like photography, the dizzying reproduction of imagery, and the increase in modes of exhibition by innovative uses of glass (allowing larger shop windows, for example), all made of newness—as opposed to legacy—a prime commodity. Instead of being dismissed, the serial and mechanical aspects of industrial culture were valued as signs of a modern, cosmopolitan spirit that replaced vintageness and authenticity with novelty and quantity. Collections came to be more about many versions of the same or similar items—with even classic organic collectibles, such as shells and butterflies, systematically or-

3. Cartes de visite were the first prints of which many copies could be made from one negative, unlike daguerreo- and ambrotypes. Also very popular were the stereographs, for whose three-dimensional effect middle-class homes had a viewer (a stereoscope) in the late 1800s. See *Cartes-de-Visite: Precedents and Social Influences*, booklet issued by the *CMP Bulletin* (California Museum of Photography) 6, no. 4 (1987), with text by Dan Younger; also Charles Panati, *Panati's Parade of Fads, Follies, and Manias* (New York: HarperCollins, 1991).

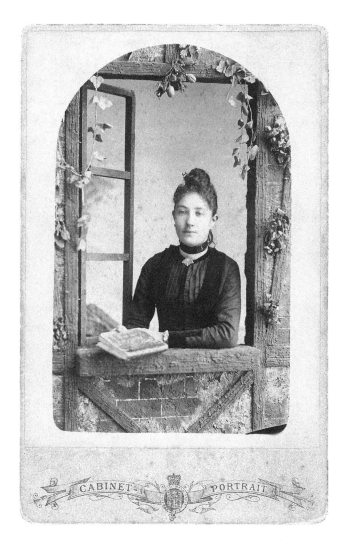

CABINET PORTRAIT OF A YOUNG WOMAN. Photograph by Alberto Bixio, Montevideo, Uruguay. Used as calling cards and often placed in large family albums, early photographs required a long exposure time and therefore sometimes register as a blur the impatience or fatigue of their subjects.

ganized to show their common features—than about sophisticated selections of rare objects or unique specimens ornamentally arranged to display their differences, as had been the case with earlier collections.

Modern popular perception can be better understood by distinguishing between two notions that, however unacknowledged as such, until the nineteenth century had gone hand in hand: authenticity and uniqueness.[4] The massive proliferation of copies did away with authenticity insofar as it was linked to an originating, or founding, object. Directly related to the symbolic notion of essence, authenticity's underlying tenet is that only a primary object can convey its meaning in an immaculate and irrevocable manner, something that is consequently distorted or lost in the object's reproduction. Devoid of original essence, copies are immediately devalued as shallow imitations, while the authentic object gains even more prestige in its contrasting exclusivity.

A true fetish, authenticity stands for an era where the perception of things was more direct, mainly because it lacked both the complicating dimension of capital, with its added symbolic layer of a false equivalence system—exchange value—and the process of mechanical reproduction, in which the proliferation of copies unintentionally enhances the value of immediacy and originality. Constituted by a singularity in time and space, authenticity is rare and consequently antithetical to the process of modernization.

Uniqueness, on the other hand, rather than a material fact as discernible as an original from a copy, is a feeling or perception that can be aroused by a number of different experiences, including, but not re-

4. For the classic discussion of the impact of modernity on the notions of authenticity and uniqueness, see Walter Benjamin, "The Work of Art in the Age of Mechanical Reproduction," *Illuminations: Essays and Reflections*, ed. Hannah Arendt, trans. Harry Zohn (New York: Schocken Books, 1969), pp. 217–51. What follows is my own understanding and development of Benjamin's proposals, as is the case in all my uses of his work. The epigraph to my book is quoted from Hannah Arendt's introductory essay, "Walter Benjamin: 1892–1940," in *Illuminations*, p. 51.

stricted to, that of authenticity. As the word implies, uniqueness suggests a distinction that is presumably worthy. Most importantly, uniqueness is not intrinsic to an object, but rather takes place in the historical interaction between subject and experience. In this sense, it may be more properly associated with use value than with authenticity. Uniqueness happens when objects are personalized in the privacy of someone's specific universe, whether it be an album, a room, or any individually articulated space. Selection and organization allow collectors to establish a particular relation with their objects: no matter how common, an object can always be rescued from its apparent banality by the investment in it of personal meaning, that ineffable "sentimental value" which can beat the most priceless items.

By challenging the notion of authenticity—whose primacy only surfaced with the threat of its disappearance—the collecting fad that started at a popular level with industrialization enabled consumers to engage dynamically with objects and events, instead of being recipients of predetermined experiences, as usually occurs with essentialist phenomena. Nevertheless, mass reproduction contradictorily helped to reassert the one-of-a-kind quality of objects usually associated with authenticity and conceptually represented in the "aura," a metaphysical halo that surrounds certain experiences and things, giving them an invisible glow.[5]

Fundamentally connected to tradition, the aura is an incidental aspect of an object or event, derived from its use value or direct relationship to production: usually made by hand or at the early stages of industrialization, aureatic objects bear the imprint of the hands that gave

5. On the aura, see Benjamin, "The Work of Art in the Age of Mechanical Reproduction" and "A Short History of Photography." The singularity of photographs can be appreciated both in the cartes de visite and in the popular nineteenth-century genre of post-mortem photography. See Stanley B. Burns, M.D., *Sleeping Beauty: Memorial Photography in America* (Altadena, Calif.: Twelvetrees Press, 1990), and Jay Ruby, "Post-Mortem Portraiture in America," *History of Photography* 8, no. 3 (July–Sept. 1984).

them birth.[6] Rather than an intrinsic aspect of an object, therefore, the aura is a consequence of the particular mode of production that generated it, much like the glow of a comet, which does not emanate from its body but from the dust that surrounds it. The aura may be said

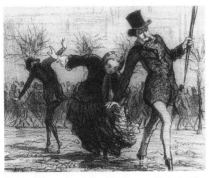

to have appeared ontologically at the very moment when it disappeared as a phenomenon, emerging when the pre-industrial conditions and labor structure that made it possible partially ceased to exist. In other words, the aura is basically a precapitalistic phenomenon whose low degree of market mediation is flaunted as prime worth, the raw material for an authenticity that is

PARISIENS EN PROMENADE. Drawing by Honoré Daumier (1808-1879). Dust and rain joined forces to make city streets into veritable rivers of mud until the late 1800s.

either nostalgically recovered or melancholically longed for.

With mass reproduction the aura survived as something fragmentary and scattered, no longer exclusively attached to an essential and authentic object. This "shattered aura" is closer to a feeling of uniqueness, enabling the historical experience of that object's loss. Consequently,

6. Use and exchange values were originally proposed by Karl Marx to describe the changes that modernization caused in modes of production and social conditions of labor. In use value, there is a direct connection between the workers who produce an artifact and the artifact itself, since the workers own, control or understand the process of production and can therefore benefit from their labor. By extension, use value implies a closeness between a society and the things it produces and consumes. This closeness is lost in late capitalism, where workers are not only disassociated from the process of production as a whole (they connect to it in a segmented and specialized way), but also alienated from the fruits of their labor, which no longer bear the traces of their work. In exchange value, the human connection to production is abstracted by the laws of market economy.

mass-culture products are perceived, not as numberless or even as repetitive, but as the remains of a larger phenomenon that both precedes and inhabits them. This residual aureatic character is fundamental to understanding the change that took place with industrialization and also its limitations, as well as why mass products, in their paradoxical resistance to and glorification of a wholesale notion of authenticity, are critically despised as its degraded, or kitsch, version.[7]

What is most relevant here is that mass culture cannot be entirely located at either end of the authenticity spectrum: it neither fully supports authenticity nor wholly abolishes it, but rather maintains an intermediate, fluctuating position in which certain aspects of authenticity adapt to modernity. The changes brought about by the aura's shattering are not limited to its dismantling and dispersion—and ensuing obsessive collection—but also consummate a centuries-old sense of loss manifested in a highly visual aesthetics of saturation, artifice and melancholia, as will be shown later.

7. For kitsch and mass culture, see Umberto Eco, *Apocaliticci e integrati* (Milan: Casa Editorial Valentino Bompiani, 1965). It is important to clarify that Benjamin does not speak of the shattering of the aura as something material (although it obviously takes place in the material realm) but rather as a metaphysical process of disapparition and disintegration. I have extended this concept to the notion of a physically shattered aura (whose remains are what I consider kitsch) in order to provide a tangible image of this disintegration, filling the gaps, so to speak, in Benjamin's theory. My concept of "the debris of the aura" is akin to Benjamin's notion of the ruin and consistent with the importance he attributes to the role of dust in kitsch, both of which will be discussed later on, so I believe Benjamin would have appreciated its metaphorical value. On the other hand, it is worth pointing out that Benjamin's relation to the aura is fraught with contradictions. Although some of his work openly criticizes the aura for its exclusive and hierarchic connotations—which imply that authentic objects are better than non-authentic, or reproduced, ones—a large part of his writing reflects the sheer delight he took in aura-infused objects, from his lifelong habit of collecting first editions and old mechanical toys to his romantic definition of "real beauty" as that which is forever remote. The aura's distance and intangibility—it cannot be seen, heard, smelled or touched, only emotionally "felt" or cognitively apprehended—along with an ensuing Olympian detachment (it transcends mortal experience) endow it with an extremely seductive elusiveness.

The shattering of the aura can be illustrated with an urban phenome-
non that, caught between two eras and inaugurating modern consump-
tion, may be said to foreground kitsch: the Parisian arcades whose study
became Walter Benjamin's lifelong project.[8] Built between 1780 and
1860, the arcades were covered passageways between busy avenues,
lined on both sides with stores. They transformed the way of being in the
city, providing a respite from the narrow, irregularly paved streets of an
early nineteenth-century Paris moored in the labyrinthine layout of the
Middle Ages. Lacking public transportation and sidewalks (buses would
not circulate until 1828 and the diffusion of ample Parisian boulevards
did not happen until the 1850s and 1860s) people had no option but to
walk at their peril, avoiding carriages and the rivers of mud that dust
formed on rainy days, hardening into impassable mounds thereafter,
while streetlights would not be systematically installed until 1877.

Parisian arcades offered something that had been inconceivable until
then but immediately became a favorite urban activity: strolling. A prod-
uct of capitalistic development and bourgeois investment (they were fi-
nanced by the businessmen of the time), arcades profited from the real
estate speculation that followed the French Revolution and placed ex-
tensive properties on the market for very low prices. They were often
constructed in the space of demolished mansions or religious buildings,
replacing them with long, narrow galleries that provided a thoroughfare
between streets while boasting tiled floors and covered roofs. It was this
last feature, which protected pedestrians from the inclemencies of the

8. Benjamin's *Das Passagen-Werk* is forthcoming in English from Harvard University
Press in fall 1999. I consulted the Italian edition: *Parigi, capitale del XIX secolo (I "Pas-
sages" di Parigi)*, ed. Rolf Tiedemann (Turin: Giulio Einaudi Editore, 1986). For a study
of this work, see Susan Buck-Morss, *The Dialectics of Seeing: Walter Benjamin and the
Arcades Project* (Cambridge: MIT Press, 1989). For a descriptive history of the arcades,
see Jean-Claude Delorme and Anne-Marie Dubois, *Passages couverts parisiens* (Paris:
Parigramme, 1996); Patrice de Moncan, *Les Passages couverts de Paris: Histoire, actual-
ité, commerces, plans et promenades* (Paris: Les Éditions du Mécène, 1996).

PASSAGE DE CHOISEUL, PARIS, BUILT 1823–25. As a child, the French writer Céline lived in this arcade, where his mother kept a novelty shop. As was usual with arcade shopkeepers, the family lived on the claustrophobic second floor, which Céline considered a smelly prison. © *LL Viollet*.

street and weather, that accidentally turned the Galerie de Bois, despite its wooden roof and bare floor, into an overnight success in 1786, eventually producing a loose grid of more than fifty arcades, most of them concentrated in the mercantile heart of Paris.

Replacing wood ceilings with glass sheets through which the sunlight could filter, covered arcades were totally innovative. They also inaugurated window-shopping, an activity in which rich and poor Parisians could participate side by side, finding in this disparate voyeurism an unprecedented, however relative, urban equality. Filled with restaurants, reading rooms, theatres and even toilets and fully equipped bathrooms where women and men could indulge in the luxury of a bath (by the 1850s there were still only six thousand bathtubs for a population of over one million Parisians), the arcades became a place of lively transactions—including gambling and prostitution—and at peak hours they were so jam-packed that walking from one end to another of these two- to three-hundred-foot-long galleries could easily take one hour.

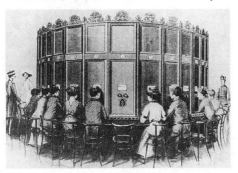

VIEWERS AT A PANORAMA. From Friederich V. Zglinicki, *Der Weg des Films*, 1956. Depicting urban settings or war scenes, nineteenth-century panoramas were circular sets with painted interior walls; they were usually viewed from a platform in the center or, as in this case, through peepholes. *MIT Press.*

Because of their structure, hodgepodge assortment of services and goods and the multitude of people constantly transiting them, arcades were from the start compared to Oriental bazaars. The Eastern influence on this Western metropolis, at the time completely infatuated with Egyptomania from the imagery and loot brought back during the Napoleonic Wars, can also be traced in the explosion of what, transformed into a

quintessential Parisian activity, was slowly becoming one of the most symptomatic of modern mores: coffee drinking. Cafés in the arcades attracted clients with spectacles such as "monsters, giants, strange animals, poets, clowns and acrobats," creating an exotic atmosphere which, dense with filtered light and pipe smoke, made the delight of the flaneur, that "ocular gastronomer" always "insatiable for cheap emotions."[9]

The arcades were also alive at night: not only because of an in-house population of shopkeepers who lived above their stores in claustrophobic quarters with no street windows—their apartments looked into the arcades—but because it was here, in the popular Passage des Panoramas (which boasted the premier Continental panoramas, among them Fulton's "Panorama de Paris"), that in 1811 gaslight first illuminated Paris.[10] This aureatic glow sealed the arcades' success, burning briefly but brightly: light made these early, comparatively microscopic malls into refuges from the street (even the homeless of the time found safety in them) as well as glistering palaces of consumption. Here, the decorative

9. The flaneur, or urban stroller, is one of Benjamin's favorite characters; see *Charles Baudelaire*, pp. 35–66. For Balzac, *flânerie* was the gastronomy of the eye, as cited in Moncan, *Les Passages couverts de Paris*, p. 64. On the spectacles in the arcades, see Sebastien Mercier, "Nouveau Tableau de Paris" (1889), as quoted in Patrice de Moncan, *Guide littéraire des passages de Paris* (Paris: Hermé, 1996).

10. Panoramas were long, circular painted sets that usually surrounded spectators and often included props and light effects, anticipating the cinematic experience. They generally depicted views of cities or of historical events, such as the "Panorama of Rome," which can still be viewed at the Victoria and Albert Museum in London. Invented towards the end of the eighteenth century, they were refined by Daguerre, one of the inventors of photography, who showed his "Diorama" in Paris, where it was considered a "salle de miracle," a sort of wonder chamber. The genre found its niche in the three-dimensional scenes of animal life that were staged in natural history museums in the late nineteenth and early twentieth centuries. One of the largest and most prominent exhibits of dioramas may be seen in the American Museum of Natural History in New York City. Balzac chronicles the popularity of "machins en rama" (rama contraptions): besides a Cosmorama, a Cyclorama, an Europarama and a Georama, there were also diaphanoramas, navaloramas, cineoramas and stereoramas, inspiring the fashion of "speaking in rama." As cited in Moncan, *Guide littéraire des passages de Paris*, p. 48. For a history of the panoramas, see Sternberger, *Panorama of the Nineteenth Century*, pp. 7–16.

use of glass, metal and mirrors enhanced the exhibition and attractiveness of goods, celebrating capital growth and modern technology's prolific child: the commodity.

Wanted by most and disdained by a few, plentiful to some and unavailable to more, new to everybody one day but to no one the next, modern commodities rode on the affluence and leisure of a rising middle class and the emergence of places such as the arcades, rapidly deluging the culture of tradition and maintenance. The new soon became full of itself, "the intoxication of modernity," standing for a notion of progress whereby a rapid consumption turnover implied a movement forward in time. By depositing on the shoulders of novelty the main burden of modernity—to leave a dark past behind and move into an illuminated future—commodities were assured a place in the fetishistic pantheon. Commodities were "dream images" or "wish images": more than objects, they represented utopian desires.[11] Buying goods quenched the thirst for temporal transcendence, replacing a heavy, stifled era with a lightweight, mobile one in which the world was felt to be more at hand due to the myriad items now available in a rapidly expanding market.

The rise of these iron-and-glass interior streets shows the impact of dream images on the lives of city dwellers and how society changed with commodity production: the appearance of crowds, the development of urban distraction and anonymity, the restructuring of the city from a place of habitation and commerce to one of leisure and ongoing spectacle, and the collapsing of exterior and interior space, private and public life. Yet the same modernity that originated these apparently endless pleasures ended up leaving them, literally, in the dust. Tied as it was to the imperative of continuous movement and tireless production, the

11. This is a Benjaminian concept that Susan Buck-Morss studies at length in "Mythic Nature: Wish Image," *The Dialectics of Seeing*, pp. 110–58. The phrase "the intoxication of modernity" is an extrapolation of Benjamin's "intoxication of the commodity," which he discusses in *Charles Baudelaire*, p. 55.

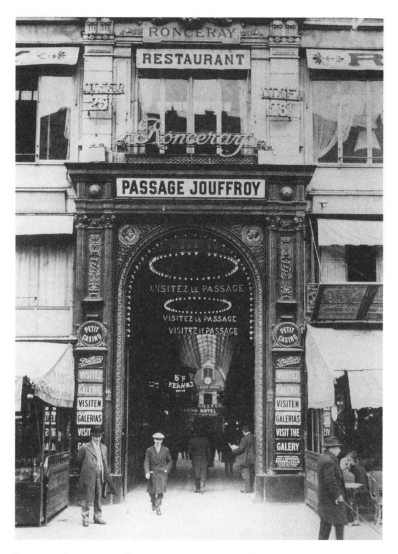

PASSAGE JOUFFROY, PARIS, INAUGURATED 1847. One of the most popular arcades, thanks to its proximity to the Passage des Panoramas. Crowds would converge here daily, jammed together at peak hours. © *Collection Viollet.*

newness of arcades aged in the face of department stores, in the same way that the amazing light effects of panoramas would eventually be replaced by the moving images of silent film.

Ironically, the places that had been hailed for providing solace from an aggressive street were considered a few decades later stifling and dirty by their once adoring customers, who abandoned the arcades for their massive successors, department stores, as well as for the expansive Haussmannian boulevards which cut across the maze of Paris during the 1850s and 1860s.[12] Destroyed and mutilated by this reurbanization, or simply forgotten in the exodus for a fresh air that their poor ventilation had made impossible, finally deglamorized by a ban on gambling and prostitution, the arcades rapidly languished into oblivion. Their fate ran parallel to that of the gaslight which had so boosted their popularity: initially welcomed as a savior, gaslight's brief glory was stopped short by a phenomenon for which it had paved the way, electricity, becoming undesirable overnight, its smell dizzying and its hazardousness frightening faithful admirers.

The cheerful excitement that filled once brightly-lit arcades was now a phantom echo vaguely resonating between run-down or empty stores, bouncing between signs. Novelty gave way to decrepitude, wish images to the now-faded urban blossoms that spoke so eloquently of their recent glory, becoming "dialectical images."[13] Fundamental to the understand-

12. Émile Zola describes this transition in *Au bonheur des dames* (1883), his novel on the formation of department stores, whose title I borrowed for the dedication of this book. See also the extraordinary work of the photographer Charles Marville, who was commissioned by the city of Paris with chronicling its old streets before their destruction and reconstruction by Haussmann; reproduced in Marie de Thézy, *Marville: Paris* (Paris: Éditions Hazan, 1994). Nowadays, several of the surviving Parisian arcades have been refurbished and are treated as landmarks, while others live out their decline in quiet abandon or, returning to their "Arab" origins, as busy bazaars. Almost a century after their European predecessors, arcades were built in many cities of Latin America and the United States as a sign of modernization; they still fulfill this role in their current decrepit state, selling mass-consumption articles to marginal populations.

ing of modernity and contrary to a linear interpretation, dialectical images reverse the connection between past and present. Instead of viewing the present as a continuation of what came before it, an uninterrupted concatenation of causes and effects, dialectical images explore the deteriorated conditions in which we now find the past, focusing on their current state (what is, not what was) as a source of meaning.

In other words, dialectical images show how the life of a phenomenon may not be as revealing as its death, and how such downfall may be another mode of living, one less blinded by the splendor of immediacy and more modest in accepting mortality. Dialectical images speak of the transitoriness of all circumstances, emphasizing their potential impact on a modernity which thought itself rid of past anchorages for good, but which is constituted equally by both the failures and the successes that anteceded it.

It is not a coincidence that such a brittle material as glass should become a modern form of aura, watching over the emergence of a new world while encasing the fragments of a lost one. In the Paris of the Restoration, as in Victorian London—the two cities that will set the pace for nineteenth-century metropolitan culture—modernity reproduces the monarchic and aristocratic values that it is simultaneously dismantling. The arcades acted as urban greenhouses for this cultural development to take place, enabling fantasies and memories, then and forever the most sought-after experiences, to flourish side by side and in full view. Trapped between houses and streets as much as between epochs, Parisian glass-covered arcades were truly, as their name in French reflects, passages, places of transit where, nonetheless, time got stuck. It is because of this anachronic quality that the Surrealists nested in the

13. Another key Benjaminian concept; Benjamin goes so far as to propose dialectical images as the only valid reading of history. See Walter Benjamin, "N [Theoretics of Knowledge, Theory of Progress]," *Philosophical Forum* 15, nos. 1–2 (Fall–Winter 1983–84): 1–40.

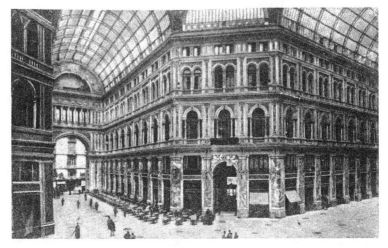

GALLERIA UMBERTO I, NAPLES, BUILT 1887–91. During the second half of the nineteenth century, most of the important European cities built arcades of their own, though often on a monumental scale that had little of the intimacy of their Parisian predecessors.

Passage de l'Opéra more than half a century later, and that Benjamin saw in arcades the cultural prehistory of our time.

Like these "human aquariums,"[14] kitsch is nothing if not a suspended memory whose elusiveness is made ever more keen by its extreme iconicity. Despite appearances, kitsch is not an active commodity naively infused with the desire of a wish image, but rather a failed commodity that continually speaks of all it has ceased to be—a virtual image, existing in the impossibility of fully being. Kitsch is a time capsule with a two-way ticket to the realm of myth—the collective or individual land of dreams. Here, for a second or perhaps even a few minutes, there reigns an illusion of completeness, a universe devoid of past

14. Louis Aragon, *Paris Peasant*, trans. Simon Watson Taylor (Boston: Exact Change, 1994), p. 14. Very impressed by Aragon's book, Walter Benjamin borrows this metaphor when he refers to arcades as "aquarium[s] of primitive sea life," as quoted in Buck-Morss, *The Dialectic of Seeing*, p. 66.

and future, a moment whose sheer intensity is to a large degree predicated on its very inexistence. This desperately sought moment, this secret treasure buried at the bottom of the sea, taints all waking experience with a deep-felt longing, as if one lived but to encounter once again this primal, archaic pleasure of total connection.

Small wonder, then, that while Zola's self-effacing and pragmatic Denise Beaudu rises from the depths of a decrepit arcade to the top of "Au Bonheur des Dames," one of those gigantic department stores that destroyed the fabric of old Paris and with it the culture of arcades, his theatrical and romantic Nana, slowly strolling on the arm of the rich benefactor she disdains, should reminisce in the most famous of such arcades about the pleasures of a lost innocence:

> She adored the Passage des Panoramas. It was a passion surviving from her youth, a passion for the gaudiness of fancy goods, fake jewels, gilt zinc and cardboard with the appearance of leather. When she passed that way she could not tear herself from the window-displays. She felt the same now as during the period when she was a down-at-heel street urchin and used to forget herself in front of the confectionery in a chocolate-maker's, while listening to a barrel-organ playing in a neighboring shop. She was taken especially by the pressing attraction of cheap knick-knacks, requisites in walnut-shells, necessaries in small containers, rag-picker's baskets for tooth-picks, Vendôme columns and obelisks containing thermometers.[15]

Kitsch assures that this lost time is momentarily found, but in order to do so it must die over and over again, paying with its own soul, like Zola's decadent heroine, each granting of a mythical wish.

15. Émile Zola, *Nana: A Realistic Novel* (1880), trans. Charles Duff (London: William Heinemann, 1936), p. 200.

The Crystal Palace

We suppose that in a few months
the glittering palace of iron and glass, the most
unique and remarkable building in
the world, will be as entirely a thing of the past
as the ice-palace of the Empress of
Russia that thawed in the summer sun.

Illustrated London News ON THE
CRYSTAL PALACE, SATURDAY, OCTOBER 11, 1851[1]

THE vast commercial expansion of glass during the nine-teenth century greatly enhanced the modern pleasure of looking and collecting. In England, the glass market changed dramatically after the heavy taxes imposed on its importation from France were lifted in 1845, while in Italy, centuries-old glassmaking traditions underwent an important revival. Besides opening a whole new range of decoration and design, the availability and versatility of glass paved the way for a novel kind of preser-

1. "In the year 1740, the Empress Anne of Russia, caused a palace of ice to be erected upon the banks of Neva. This extraordinary edifice, was 52 feet in length, 16 in breadth, and 20 feet high, and constructed of large pieces of ice cut in the manner of free-stone. The walls were three feet thick. The several apartments were furnished with tables, chairs,

vation and visual display that promoted a highly voyeuristic optical sensibility, starting with the Parisian arcades.

The possibility of observing from a safe distance grants both a temporal remove (the case of natural history specimens and dioramas) and the disengaged but empowering anonymity that comes from being the subject of a voracious gaze whose object is confined and subordinated. This very distance changes the status of the object, which loses its commonness to become a thing worthy of such attention. So, while until now display had basically remained secondary to function—practical, religious or cognitive—with the advent of industrialization the lack of uniqueness of mass-produced objects was offset by the spectacularity of their presentation.

It is very fitting, then, that the first monumental-scale exhibit of industrial products took place in London's 1851 Crystal Palace. Following the arcades' paradigm—which would be emulated throughout the nineteenth century, accounting for covered passageways in London, fastuous galleries in Milan and Naples, and enormous commercial centers in Berlin and Moscow—the Crystal Palace was a gigantic structure of iron and glass dedicated to a new way of looking, that of the potential consumer. With its uninhibited emphasis on display, proliferation and artifice, and the global proportions of its reach as a trade fair, the Crystal Palace pretty much inaugurated the modern era as we know it.[2]

beds, and all kinds of household furniture of ice. In front of the edifice, besides pyramids and statues, stood six cannon, carrying balls of six pounds' weight, and two mortars, entirely made of ice. As a trial from one of the former, an iron ball with only a quarter of a pound of powder was fired off, the ball of which went through a two-inch board, at sixty paces from the mouth of the piece, which remained completely uninjured by the explosion. The illumination in this palace, at night, was astonishingly grand." From "A Palace built of Ice," in Samuel G. Goodrich, *The Cabinet of Curiosities, or Wonders of the World Displayed: Forming a Repository of Whatever is Remarkable in the Regions of Nature and Art, Extraordinary Events, and Eccentric Biography* (New York: Piercy and Reed, 1840), vol. 1, p. 180.

2. Surprisingly, no one seems to mention the arcades as the obvious architectural pre-

Formally the "Great Exhibition of the Works of Industry of All Nations," the Crystal Palace was built as a glittering homage: it was a place where people went to render honor, in the form of amazement and admiration, to the mass production that became Western culture's new form of royalty. Built in a record seven months and located in Hyde Park, the Crystal Palace covered eighteen acres—and six elm trees—with 956,165 square feet of panes of sheet glass. It was the first entirely mass-produced building, using new construction materials and a gridiron plan later to become the basis for constructing skyscrapers.

The first of the great world's fairs (there were fifty-eight international fairs between 1851 and World War I, eleven of which were considered major), the Crystal Palace received six million people, a daily attendance average of 42,831—with reduced cost of admission on certain days—during the six months it remained open, from May through October 15, 1851. It was visited by everyone from Queen Victoria, who went with her children up to twice weekly in the first months and had her own retiring room in the premises, to those that had never before left their villages, such as eighty-five-year-old Dolly Pentreath, who walked almost three hundred miles to the Crystal Palace from her hometown of Penzance, carrying mackerel on her head to pay for lodging.[3]

"Neither crystal nor a palace, it was a bazaar," complained someone of the overwhelming display of over 100,000 articles from 14,000 exhibitors (half of which were British) that occupied eleven miles of stalls.

cursors of the Crystal Palace. Most writers are content to cite the story of how it was designed by a royal gardener, Joseph Paxton, who, inspired by the structure of greenhouses, rough-sketched it on a piece of paper, putting an end to the difficult quest for a winning design for the exhibition. For the history of the Crystal Palace, see Patrick Beaver, *The Crystal Palace, 1851–1936: A Portrait of Victorian Enterprise* (London: Hugh Evelyn, 1970).

3. On world's fairs, see Jane Shadel Spillman, *Glass from World's Fairs, 1851–1904* (Corning, NY: Corning Museum of Glass, 1986). On who attended the trade fairs, Toshio Kusamitsu, "Great Exhibitions Before 1851," in *History Workshop Journal*, no. 9 (Spring 1980): 70–78. Queen Victoria's routine is described in Beaver, *The Crystal Palace*, p. 64,

Besides displaying the most recent products of Western industrial mech-
anization (a hydraulic press, marine and fire engines and locomotives,
many of which were kept in motion with steam from boilers outside the
palace), the exhibit, divided by sections, displayed an unprecedented
accumulation that included raw materials and manufactured goods—
textiles, jewelry and medical instruments—from around the world. The
first international trade fair had something for everyone and a few things
for no one, like the knife with 1,851 blades, a cross between a Christmas
tree and a cactus; the "Silent Alarum Bed," which would throw the
sleeper on the floor at a certain time; and the "talking telegraph," where
a head in a box moved its mouth while code symbols appeared above it
in flags. It also had a "Model Dwelling House" whose design was super-
vised by Prince Albert, the driving force behind the Great Exhibition,
and a model of a floating church, both of which probably paled next to
the model of the Liverpool docks, complete with sixteen hundred fully
rigged ships.[4]

Perhaps no one expressed their feelings about this new era better
than Victoria herself, a woman whose attachment to objects became so
obsessive in her last years that she would not allow any of her innumer-
able possessions to be thrown away or even altered, and if something—
a carpet, a curtain—fell into total disrepair, she would have it replicated
to perfection. When even this was not enough, she had all of her belong-
ings photographed from several angles, and the photos—along with their

and in the following excerpt from the exhibit's catalog: "Whatever may have been the
weather, or however crowded the interior, Her Majesty has devoted, almost daily, until the
close of the session of Parliament released her from attendance in London, several hours
to visits to the Crystal Palace; inspecting each department in succession, and selecting
from many of them such objects as gratified her taste, or were, for other reasons, consid-
ered to possess claims upon her attention." From *The Art Journal Illustrated Catalogue of
the Industry of All Nations* (London: George Virtue, 1851), p. xxiii. The story of Dolly
Pentreath, who even had a meeting with the queen, is told by Paul Hollister, Jr., in *The
Encyclopedia of Glass Paperweights* (Santa Cruz, Calif.: Paperweight Press, 1970), p. 38.
4. Beaver, *The Crystal Palace*, pp. 47–56.

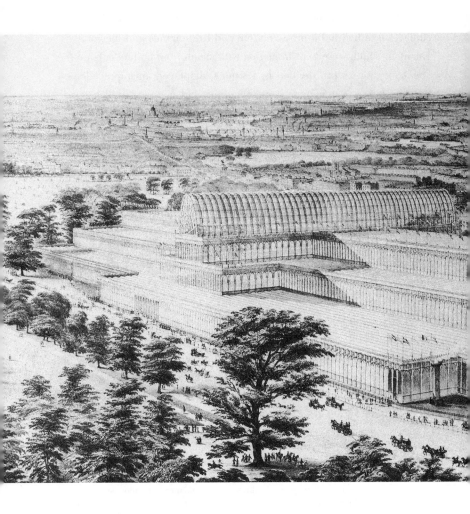

<small>Panoramic view of the Crystal Palace in Hyde Park, London.</small>
From Patrick Beaver, *The Crystal Palace, 1851-1936: Portrait of a Victorian Enterprise*, 1970. Built in a record seven months, the Crystal Palace was designed by Joseph Paxton, formerly head gardener to the duke of Devonshire. Paxton based his iron-and-glass design on the giant Amazonian water lily, whose six-foot-wide leaves are ribbed in such

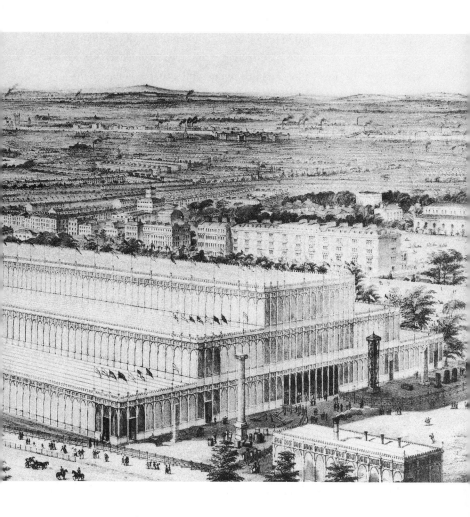

a way that they can bear the weight of a sixty-three-pound child. The Crystal Palace was the first entirely mass-produced building in history, and the extent and amount of glass covering it (400 tons, one pound per square foot) has not been exceeded to this day. Its main arched transept housed several giant elm trees. *General Research Division, The New York Public Library, Astor, Lenox and Tilden Foundations.*

corresponding entries indicating not only the objects' main features but also their exact location in the rooms of her domains—placed in huge albums through which the elderly queen browsed at leisure. More than sixty years before, Victoria had been one of the first to compare the awe that she felt at the magnitude of the Great Exhibition to a religious experience: ". . . it was magical—so vast, so glorious, so touching," she wrote in her diary about the Crystal Palace's inauguration. "One felt filled with devotion, more so than by any service I have ever heard."[5]

An unprecedented opportunity for business competition and expansion, the Crystal Palace also became a meeting place for friends and lovers, an escape for middle-class women and a didactic outing for families, easily merging industrial affluence and leisure time. As such, it was the forebear of those microcosmic universes known as shopping malls and amusement parks; and, in fact, an amusement park of a very special kind the Crystal Palace became, once the Great Exhibition was over and its massive structure was dismantled, relocated and reassembled in 1854 on Sydenham Hill, a half-hour away from the heart of London. During its first thirty years the Sydenham Crystal Palace was visited by about two million people a year, a transit load for which special railway lines were built. The palace overflowed with special attractions that took place inside the building, in its immediate surrounding woods or in the boating-lake: balloon ascents, rose shows, cat and dog shows, trade fairs, art exhibitions, electrical, mining and photographic exhibitions, music festivals, and meetings of societies such as the National Temperance League and the Salvation Army.

A bizarre mix of all kinds of activities, the Sydenham Crystal Palace

5. Ibid., p. 41. On Queen Victoria's object obsession, see Lytton Strachey, *Queen Victoria* (New York: Harcourt, Brace and Co., 1921), pp. 398–401. Victoria's collection, along with the numerous exhibits presented to the exhibition's organizers after it closed, eventually became a substantial part of London's Victoria and Albert Museum, and also gave rise to the Science Museum and Library, the Natural History Museum, the Geological Museum, the Imperial Institute, the Royal College of Science, the Royal School of Mines,

even housed schools of art, science, literature, music and engineering. Among its many spectacles the most popular and dramatic seem to have been the war shows: "Invasion," orchestrated by John M. East, drew about twenty-five thousand spectators for each performance, during which a life-size village, with its shops, church and school, was destroyed by enemy bombs, "the screams of trapped and dying children coming from the ruins," and later reconstructed for the next performance. A nineteenth-century Disneyland, the palace's last and biggest event was the construction in miniature of the British Empire for the coronation of King George V in 1911, complete with a railway on which visitors could tour, among other things, a South African diamond mine and an Indian tea plantation.[6]

Despite its popularity, the Crystal Palace went bankrupt that same year and was confiscated and later used as a naval depot during World War I. Rescued from total oblivion by a private fund set apart for this purpose before the war, for the next twenty-five years the palace sat silent, a shadow of its former splendor, on top of Sydenham Hill, coming alive only on Thursday evenings for fireworks. It is ironic that these never started any accidents, because, melting away as the *Times* had figuratively predicted eighty-five years before, on November 30, 1936, the Crystal Palace was swept by an unrelated fire that destroyed it in less than six hours, its darkened ruins later to be made into a national park.[7]

the City and Guilds College, the Royal College of Art, the Royal College of Music, the Royal College of Organists and the College of Needlework.

6. Beaver, *The Crystal Palace*, p. 110. Charles Brock's fireworks displays were considered the most spectacular of all, with "every naval battle of any importance reproduced in fire on Sydenham Hill. The last one was the Battle of Jutland, which had to be seen to be believed. As huge battleships, outlined in fire, bombarded each other from opposite sides of the lake, the explosions of the shells were reflected in the water as they might have been at sea. Ships blew up and slowly sank. . . ." (ibid., p. 132).

7. For a childhood reminiscence of the palace's old age, see "The End," pp. 141–48 in Beaver, *The Crystal Palace*. The ruins of the Crystal Palace can be visited on Sundays, although little more than steps and broken statues remains. However, there are occasional

Perhaps the most outstanding criticism of the time leveled against the Great Exhibition centered on the eclectic character of its numerous works of art and the massive application of organic design to manu-

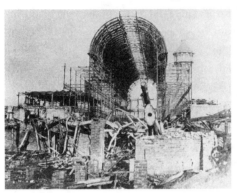

REMAINS OF THE NORTH NAVE, RUINS OF THE SOUTH NAVE, AND BAIRD TELEVISION LABORATORIES. After the 1936 fire, some goldfish were found still swimming in an ornamental fountain in the North Nave. A local newspaper had reported them as "missing, believed boiled." *Photograph by the late Arthur Talbot, by permission of Kenneth W. Talbot.*

facture and industry. Foreign and national exhibits were accused of breaking with "pure" classical form, thus indulging in bad taste, reckless romanticism, narrativity and, worse than anything else, banality, eventually adding up to that most vilified of all artistic phenomena, a profanity so young that only around this time did it acquire a name: kitsch. And kitsch the Crystal Palace had galore, particularly the garden variety, like the bucolic sculpture of the Prince of Wales as a shepherd, or the use of crucifixes and rosaries for product display.[8]

Most offensively for its critics, the design presented at the 1851 exhibition sought to imitate nature, an overabundance of iron leaves, glass flowers and wooden antlers making of the Crystal Palace a sort of immense, transparent winter garden whose fauna and flora were wonder-

walking tours and a great souvenir store run by the volunteers of The Crystal Palace Foundation. In 1853 New York City built its own Crystal Palace, a replica of the English one, in what is now Bryant Park. It also housed the World's Fair of the Industry of All Nations, and burned down in 1856.

8. Beaver, *The Crystal Palace*, pp. 57–59. The word "kitsch" is of German origin and began to be used in the mid-1800s in Munich to degrade certain forms of art. Its etymol-

fully frozen. Making the novel world of industrial production more famil-
iar by shaping it after plants and animals, this mixing of the old with the
new ideologically "naturalized" machinery and manufacture by giving
them the appearance of being products of nature rather than of human
labor. In this combination of the organic and the mechanical, nine-
teenth-century design strived to create those "wish images" where the
world appeared harmonious and effortless—in a word, utopian.[9]

Yet, at an exhibit whose explicit goals included the reunion of aes-
thetics and manufacture, it was not this utopian aspiration that was ab-
horred but the degree to which "the naturalist school of ornament" took
it: unlike previous organic styles, the Victorian ornament was not a dec-
orative element of the object, but became its central feature.[10] This "dis-
astrous confusion of ornament and design" became the target of
condemnation, not only for relegating the primary function of the object
to a secondary position, but also—and perhaps more importantly for

ogy includes *verkitschen*, to make cheap, and *kitschen*, to collect junk from the street. See
Matei Calinescu, "Kitsch," in *Five Faces of Modernity* (Durham, N.C.: Duke University
Press, 1987), pp. 225–62. For the essay that inspired the decades-old criticism against
kitsch, see Hermann Broch, "Kitsch and Art-with-a-Message" (1933), reprinted in Gillo
Dorfles, ed., *Kitsch: The World of Bad Taste* (New York: Bell Publishing, 1968), pp. 49–67;
this is the uncredited source of Clement Greenberg's influential text "The Avant-Garde
and Kitsch" (1939), in Dorfles, pp. 116–26. Broch later expanded his own essay into
"Notes on the Problem of Kitsch" (1950), also in Dorfles, pp. 68–76. See also his *Hugo
von Hoffmannstahl and His Time: The European Imagination, 1860–1920*, trans. and ed.
Michael P. Steinberg (Chicago: Chicago University Press, 1984). Dorfles's anthology has
been a cult classic on kitsch since the 1970s. The anti-kitsch position that it endorses (for
which Broch's and Greenberg's early texts were fundamental) remains to be challenged. I
attempt to do so in practice here, as well as in "Holy Kitschen," in my *Megalopolis: Con-
temporary Cultural Sensibilities* (Minneapolis: University of Minnesota Press, 1992). I also
outline the history of the kitsch debate in a short essay entitled "The Dark Side of Moder-
nity's Moon," in *Agenda*, no. 28 (Summer 1992): pp. 22–25.

9. On Benjamin and the utopian aspect of organic ornamentation, see Buck-Morss,
"Mythic Nature: Wish Image," *The Dialectics of Seeing*, pp. 110–58.

10. John Gloag, *Victorian Taste: Some Social Aspects of Architecture and Industrial De-
sign from 1820 to 1900* (Newton Abbot: David and Charles, 1979), pp. 130–58. Phrases
quoted in this and the following paragraph are from this text.

kitsch—because once function had been thrown to the winds, what followed was an unbounded proliferation that paved the way for another kind of displacement, that of the original by the copy: "Nothing can be worse than art at second-hand, more especially when the associations and feelings of the two sets of workers, the original and the imitators, are totally different." [11]

The Victorian love of "imitation and disguise" went even further, eventually blurring the limits between fantasy and reality in what may be considered either a botched attempt at realism or a fantastic vision of reality, according to one's point of view. This is the case with the use of natural history specimens, which although increasingly popular as collectibles since the Renaissance, became truly massive commodities in the nineteenth century. An integral part of the developing genre of trade known as world's fairs, this booming market was represented in the Crystal Palace by thousands of specimens, including the already extinct dodo bird and three or four hundred varieties of hummingbirds.

In most of these, taxidermy, as it had been developed since the sixteenth century, consisted in the precise rendition of the animals' physical appearance, a radical departure from the ancient embalming methods that had "sought to preserve the substance of the body rather than its form," often with totally unrecognizable results. [12] Full of respect for their dead and for all sacred species, neither the ancients nor the early natural history collectors would have ever dreamt up anything like the anthropomorphic exhibits at the Crystal Palace. Among the most outrageous were Hermann Ploucquet's extremely popular "comicalities"— fifteen hundred in total—where birds, weasels, cats, hares and other

11. Robert W. Edis, "Decoration and Furniture of Town Houses," a series of lectures delivered to the Society of Arts in 1880, as quoted in Gloag, *Victorian Taste*, p. 158.
12. "Taxidermy, and Ethnographical Models," in John Tallis, *Tallis's History and Description of the Crystal Palace, and the Exhibition of the World's Industry in 1851* (London and New York: John Tallis and Co., 1852), vol. 2, pp. 187–91.

ORGANIC ORNAMENTATION AT THE CRYSTAL PALACE. From *The Art Journal Illustrated Catalogue of the Industry of All Nations*, 1851. Cast-iron fountain by M. André of Paris. All elements of the composition were drawn from animals and plants associated with water. Jets of water rose from the mouths of the fish, otter, turtle and frog (on the back), which in turn were surrounded by a water lily, floating reeds and bending rushes.

animals were posed to depict "comical, humorous and interesting scenes in animal life," like the group of ermines sitting at a table sipping tea from teacups while another member of their party plays the piano.[13]

By the late 1800s, stuffed animals and anthropomorphic displays gave way to the rage for "animal furniture," with the representations of animal parts replaced by the animal parts themselves: elephants' feet served as liquor stands, chairs stood on the four legs of rhinoceros or zebras, hat stands were made from antlers, tiger jaws held clocks and ostrich legs stopped doors. This fad was attributed to women's use of entire birds—instead of only feathers—on their hats in the 1860s, which was followed by the craze for tiger and bear claw jewelry, until the jungle effect invaded the entire home. "For some reason, innumerable monkeys were sold to light up billiard-rooms, the little animals swinging from a hoop with one hand and carrying the lamp in the other. After a time people other than those who had dead pet monkeys wanted to possess these unique lamps, so that defunct simians from the Zoo had to be eagerly bought up, and Mr. Jamrach, the famous wild beast importer, was vexed with orders for *dead* monkeys."[14]

Rather than its reaching for a utopian "natural" experience through technology, one could say the Crystal Palace's best-kept secret was its justified fear of losing a world that it loved all too well but was slowly sacrificing to scientific and industrial progress. With the organic standing metaphorically for use value and for production unmediated by technology (and therefore presumably having a more direct relationship to reality), the loss of the organic was perceived as the death of a dimension

13. I owe this reference, and my initial acquaintance with the Crystal Palace, to Miriam Gusevich's "Purity and Transgression: Reflections on the Architectural Avantgarde's Rejection of Kitsch" (Milwaukee: Center for Twentieth Century Studies, working paper no. 4, Fall 1986). Her argument for the ermines as kitsch is consistent with what I will later distinguish as nostalgic kitsch.

14. William G. Fitzgerald, "Animal Furniture," *Strand Magazine* 12 (Sept. 1896): 273–80.

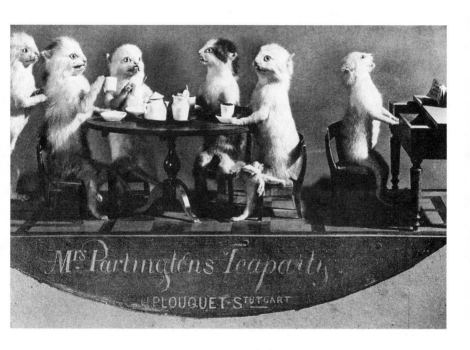

THE ERMINES' TEA PARTY. From Patrick Beaver, *The Crystal Palace, 1851-1936: A Portrait of Victorian Enterprise*, 1970. This was one of fifteen hundred animal "comicalities" by the taxidermist Hermann Ploucquet of Stuttgart. They were meant to imitate "the attitudes, habits and occupations of rational creatures." *General Research Division, The New York Public Library, Astor, Lenox and Tilden Foundations.*

from which Western culture had derived a great deal of its meaning for centuries.

This became particularly discernible at the moment when the organic was dealt a mortal blow by modernization, with ornamental plants and animals quite literally representing a last-ditch effort to retain a sense of belonging to the natural order.[15] While the traditional concept of nature was still topically retained as a nominal assurance that things were not as radically different as they seemed, nature had already moved one degree away from its former status. Whereas it used to provide a model for understanding or organizing a certain sense of the world, now nature became an icon of itself, valid for representing the beauty of a supposedly orderly and predictable phenomenon which humans could refer to for ontological orientation.

The constant overlapping of the scientific approach to nature and organic ornamentation in the 1800s is perhaps the best indication of how ambiguous this new role of nature still was. The attack against the kind of organic ornamentation sponsored by the Great Exhibition was a clear reaction to a modernity that sought to fragment what had been perceived until then as an unproblematic whole—the role of nature in culture, no matter how distorted—while simultaneously attempting to retain part of this meaning under a new guise. Yet, instead of railing against the exhibition's overall objectification of nature (in the use of live plants as "a new and delightful sort of furniture ornament," for instance), the attack focused on only one aspect of this materialization, that which transformed a transcendental notion into industrial décor.[16]

15. As I have been suggesting, the distinction of the natural world as an object of inquiry or collection (as opposed to a symbol) started long before the nineteenth century, which is really the culmination of this process. The history of natural history is discussed below, in "The Organ of Marvelousness."

16. "The Vegetable World," in *Art Journal Illustrated Catalogue*, p. viii. This essay and the one quoted at the beginning of the next chapter, "The Exhibition as a Lesson in Taste," were omitted from the catalog's 1995 reprint by Gramercy Books.

In other words, rather than a critique against the new modes of production and consumption taking place at the Crystal Palace, what surfaces is the struggle between two concepts of nature, both of which claim exclusive ownership over the organic realm: the traditional one, where a theologized view of nature provided culture with symbolic meaning; and the modern one, which destroyed this view by reformulating nature according to rational, scientific paradigms and techniques, while simultaneously and contradictorily seeking to regain through this fragmented emblem what, by its own doings, was permanently gone.

Like the demise of that aura to which nature is inextricably bound as the bearer of a sense of authenticity, the downfall of the natural order triggered an immediate longing for and glorification of what was lost. Consequently, nature knows in the nineteenth century an unparalleled popularity, although always in a role subordinated to human whims: either fossilized in the emerging field of natural history or abstracted in the Romantic sensibility's quest for an immanent spirituality. In both cases, nature's modern role as the mirror of a human-centered cosmos is reproduced in its object status, with science and industry constantly perfecting ways to retain this evanescent realm.

Vegetable Jewelry and Parlour Oceans

Ornament is not a luxury,
but, in a certain state of mind, an
absolute necessity.

ILLUSTRATED CATALOG OF LONDON'S
1851 CRYSTAL PALACE

ESS dramatic than the Irish chair whose arms were shaped like wolves, one with the legend "Gentle when stroked" and the other "Fierce when stroked," was the presence throughout the 1851 exhibition of live plants in glass containers known as "Wardian cases," whose cultural impact would soon far surpass that of all natural history exhibits done until this moment. Forming "a little world of themselves," these cases, casually invented in 1829 by a surgeon named Nathaniel Ward, enabled the transportation and maintenance of live plants in a self-sustaining atmosphere, with the soil's moisture condensing under sunlight and then falling back on the plants at night.[1]

1. Ward did not write his findings until years later: "On the Growth of Plants in Closely

It was perhaps because Dr. Ward's discovery originally happened with a fern (which was still thriving two decades later when shown at the Crystal Palace, itself compared by John Ruskin to an enormous greenhouse), or because this most elaborately patterned plant recalled with its thick vegetation the dense forest atmosphere of exotic landscapes and ruined castles so dear to the predominant Gothic revival taste (according to one author, "the Fern Craze opened as men's clothes, quite suddenly, turned black").[2] One way or another, ferns conquered the collective—particularly the collective female—imagination of the 1840s and 1850s with a fervor that made it known as a passion or mania: pteridomania, the mania for collecting ferns, one of the major fads of the Victorian era.

Variously described as "plumy emerald green pets glistening with health and beadings of warm dew" or "the aristocrats of the vegetable world" (colorful flowers being too crass for the times' somber taste), this veritable "vegetable jewelry" was soon adorning every middle-class drawing room or parlour worthy of the name in any of a number of Wardian-case styles: Gothic cases, Tintern Abbey cases, Crystal Palace cases, Oriental cases, and so on. Like all memorable fads, pteridomania left an abundant derivative production: stenciled patterns (and also albums, where fern leaves were dried between the pages), woodwork and wrought-iron furniture, as well as a good number of those manuals and how-to books that since the 1830s were emerging as part of a new

Glazed Cases" (1842). David Elliston Allen disputes the universal attribution of this invention to Ward in *The Victorian Fern Craze: A History of Pteridomania* (London: Hutchinson and Co., 1969), pp. 8–16. Because the institution of science was still in its establishing stages during the nineteenth century (classifications, professional societies, etc.), it was common for someone to make an invention or discovery and for somebody else to write about it and be given the credit. Much of the scientific establishment's power has always come from its exclusivity, determining who is in and who (like women) is out. See also "Wardian Cases," in *Tallis's History and Description of the Crystal Palace*, pp. 145–46.

2. On ferns and the Gothic revival, see Allen, *The Victorian Fern Craze*, p. 20. Ruskin is quoted in Beaver, *The Crystal Palace*, p. 15.

market born of developments in printing and the formation of a new leisure class.[3]

Given the decorative obsession with grottoes and shells that had been going on since the late seventeenth century, it was only a matter of time—a few years, to be precise—before Wardian cases were turned upside down and domestic aquariums sprung to life, rapidly becoming objects of everlasting fascination. For aquariums, the vital secret discovered by the nineteenth century was that of oxygenation through the introduction of plants. Until then, the goldfish kept in glass bowls had unfailingly died from asphyxia.

Although the credit for the invention of the aquarium is a matter of debate, a good part of it belongs to women. In 1832, Madame Jeannette Power initiated the scientific use of the aquarium with her "cages à la Power," glass cases lowered into the ocean to study marine animals. Somewhat more informally, Anna Thynne discovered in 1846 the secret of aeration by having her maid pour the water of her tank backwards and forwards for half an hour daily. However, it was the introduction of plants—and the repeal of the glass tax—that definitely established the aquarium as such, and the first person to explain and above all publicize this was Robert Warington, whose misspelled "Warrington case" was originally advertised as an "Aquatic Plant Case or Parlour Aquarium."[4]

3. See Allen's "The Break-out" and "High Tide," pp. 35–55 of *The Victorian Fern Craze*. The phrases in quotation marks are from Shirley Hibberd, author of *The Fern Garden* (London: Groombridge and Sons, 1872), as quoted in Allen. Hibberd considers ferns the "quietest regions of vegetable life, a region where flowers are unknown"; see *Rustic Adornments for Homes of Taste, and Recreations for Town Folk, in the Study and Imitation of Nature* (London: Groombridge and Sons, 1857), p. 45.
4. On the history of the aquarium, see Lynn Barber, "An Invention and Its Consequences," in *The Heyday of Natural History, 1820–1870* (New York: Doubleday and Co., 1980), pp. 111–24; Leighton Taylor, "The Nature of an Aquarium: History, Architecture, and Design," in *Aquariums: Windows to Nature* (New York: Prentice-Hall, 1993), pp. 1–12; and Albert J. Klee, "A History of the Aquarium Hobby in America," in *The Aquarium*, 2nd ser., vols. 1–2 (December 1967–October 1968). On the forgotten contributions of Jeannette Power, who belonged to numerous scientific institutions and was greatly

Vol. III. APRIL, 1895. No. 35.

"Books in the running brooks,
Sermons in stones, and good in everything."

A QUARTERLY

MAGAZINE

— FOR —

Students & Lovers of Nature,
Education and Recreation.

50 Cents a Year.
Single Copies, 25 Cents each.

HUGO MULERTT,
BROOKLYN, N. Y.

COPYRIGHT. ALL RIGHTS RESERVED.

Entered at the Post Office at Brooklyn, N. Y.,
as second class mail matter.

COVER PAGE OF *THE AQUARIUM*. The first real aquarium hobby magazine in the world, it was first published in Cincinnati in 1878, and then followed its founder, the German Hugo Mulertt (known as "the father of the aquarium hobby in America" although he also wrote, in 1886, *How to Cook Fish*), to Brooklyn, where it was published monthly until 1897. *General Research Division, The New York Public Library, Astor, Lenox and Tilden Foundations.*

Aquariums followed ferns in a string of natural history "national crazes" that in the decade of 1845 to 1855 alone switched from seaweeds to ferns to sea anemones and in the next to sea serpents, gorillas and Infusoria, so that "by the middle of the century, there was hardly a middle-class drawing-room in [England] that did not contain an aquarium,

a fern-case, a butterfly cabinet, a seaweed album, a shell collection, or some other evidence of a taste for natural history." [5] In the case of aquariums, this taste included extensive beach searches for specimens and a thorough study of types of creatures and their habitats in the corresponding manuals, as

PARLOUR AQUARIUM, 1859. The "Alpine scenery of the submarine landscape," as H. Noel Humphreys described it in *Ocean Gardens: The History of the Marine Aquarium*, 1857. *Mary Evans Picture Library.*

well as "evenings at the microscope" and journal and newspaper columns where the "aquarianists" could debate to their hearts' content on the "growth and reproduction of animals and plants which heretofore we have been wont to make acquaintance with as isolated, mutilated, shrivelled, and dead specimens." [6]

The aquarium craze took place mainly during the 1850s and 1860s, but its legacy was far-reaching, existing as a favorite hobby to this day.

esteemed during her thirty-year career, see A. Rebière, "Madame Power, une naturaliste oubliée," *Bulletin de la Société des Lettres, Sciences et Arts de la Corrèze* 21 (1899): 303–29. Regarding Anna Thynne's discovery, see Shirley Hibberd, *The Book of the Aquarium and Water-Cabinet* (1856), as quoted in Klee, part 2.

5. Barber, *The Heyday of National History*, p. 13.

6. Hibberd, as quoted in Klee, "A History of the Aquarium Hobby in America," part 1 (December 1967), p. 52.

Following the modest opening of the first public aquarium at Regent's Park Zoological Gardens in London in 1853, the public aquariums, or aquarium palaces (most of which were also research centers), made their big splash in the 1870s, starting with none other than the Crystal Palace Aquarium, which opened in 1871 in that building's resurrected Sydenham version with sixty large exhibit tanks containing 200,000 gallons of seawater, although it was outdone the next year by the Brighton Aquarium, for decades the largest aquarium in Europe.[7]

Originally known as "aquavivariums," "cabinet vivaria," or even "paludariums" when they included a surface terrarium, domestic aquariums were from the word go considered an insurpassable ornament, combining learning and entertainment. Anemones, where animal and vegetable seem to blend into one, were often their main attraction—far more interesting than the "drab cold fish then accessible to hobbyists." Accordingly, anemones helped create duly elaborate scenarios:

> ... no animal has touched [the British mind] to such fine issues and such exuberant enthusiasms as the lovely Sea-anemone, now the ornament of countless drawing rooms, studies, and back parlours, as well as the delight of unnumbered amateurs. In glass tanks and elegant vases of various device, in finger-glasses and common tumblers, the lovely creature may be seen expanding its coronal of tentacles, on mimic rocks, amid mimic forests of algae, in mimic oceans. ... [8]

7. One of the most impressive public aquariums that I have visited is the Shedd Aquarium in Chicago, which was founded in 1929 and whose architectural details were inspired by ocean life. The first public aquariums, however, were of a completely different scale and tone than those of the twentieth century: aquariums such as the ones in Brighton and Naples, which still operate and are open to the public, strike the 1990s visitor with their intimate atmosphere. Although P. T. Barnum displayed aquariums as popular attractions as early as 1856, the first public aquarium in the United States was the New York Aquarium, which opened in 1876 on 35th Street and Broadway. The New York Aquarium as we know it, however, opened in 1896 (partly fitted with Barnum's collections) at Castle Clinton in Battery Park, where its visitor count for the first fourteen years exceeded 28 million. It was relocated to the old lion house at the Bronx Zoo from 1941 to 1957, and then moved to its current home in Coney Island.

8. G. H. Lewes, *Sea-Side Studies* (1858), as quoted in Barber, *The Heyday of Natural*

This fascination was furthered by the baroque stands on which the aquariums were set, usually reproducing miniature grottoes or fountains. At other times, aquariums were inserted in cabinets, hung from the ceiling, mounted on one another for a cascade effect, and even used to separate entire rooms in the more luxurious homes which could afford wall-size aquariums.

Despite all of this, the most elegant and sought-after fish were still the goldfish, brought all the way from Japan aboard "ocean-cities," as some of the magnificent ocean liners of the time were called, such as *City of Peking* or *City of Tokyo*. Although a goldfish in a bowl became the modern icon for aquariums, this object dates back at least as far as 1572, when the Swiss alchemist Leonhardt Thurneysser ordered a glass globe that included a glass bird and was filled with water and fish.[9]

One of the most dramatic effects of glass, therefore, was to enable the kind of deracination typical of nascent consumer culture: ferns or anemones were extricated from their natural habitat, relocated into an artificial one, and subordinated to the implicit scopophilia of display. This separation of things from their original—or, in some cases, attributed—context and functions made them into commodities, increasingly susceptible to the projection of cultural desires and anxieties.

The Victorian penchant for collecting live or "natural" matter such as flowers, insects and shells made relics out of things whose value emanated from their intrinsic relationship to life, instead of being derived from a transcendental symbolism like the one ascribed to saints' remains. Nevertheless, there were certain elements of symbolic signification that were retained, however transformed. Their preservation in glass cases, for example, was meant originally to guard relics from any external intrusion. Capable of being seen, but not touched, sacred relics

History, p. 121; the comment on the drab fish is quoted in Klee, "A History of the Aquarium Hobby in America," part 3, p. 47.

9. Letter to the author from Sibylle Jargstorf.

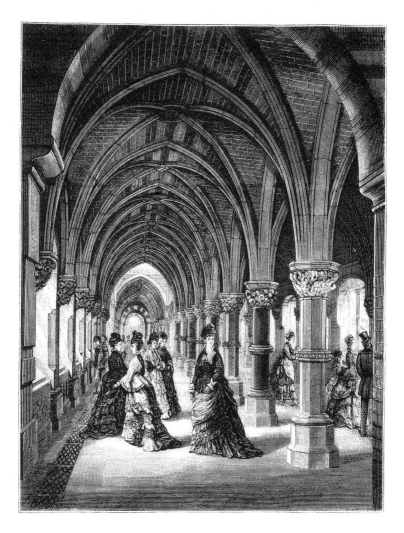

THE BRIGHTON AQUARIUM. The first and largest of the aquarium "palaces," it opened in 1872 and was advertised as "The Largest and Most Beautiful Building devoted to Piscatorial Science in the World. Thousands of Fishes and Marine Animals—many of great rarity. The Tanks and Ferneries nightly Illuminated. Promenade Concerts every Saturday at Three o'clock. Band plays thrice daily." *Mary Evans Picture Library*.

gained the added prestige of physical distance which, together with the translucency and brittleness of glass, created such a strong ethereal aura that glass casing became an essential part of their presentation.

Consequently, the Victorian glass cases used for aquariums or to protect collectibles from dust unwittingly raised them to the status of relics, further increasing their value by emphasizing the perishability of the natural world (often extended to also mean pre-industrial times), which was increasingly becoming a sign of this whole epoch, and which was magnificently represented in aquariums and their still-life counterparts: paperweights, the nineteenth century's most prominent and lasting dream images.

𝔇𝔯𝔢𝔞𝔪 𝔖𝔭𝔥𝔢𝔯𝔢𝔰

*One July morning, Napoleon III sent Madame
de Castiglione eighteen Baccarat weights,
thirty Clichy (weights) and forty-five pieces
by Saint Louis, in order that she might
cool her hands on that torrid day and allow her
gaze to wander among the exquisite images
of flowery gardens and underwater
motifs which are found in paperweights.*

COLETTE DE JOUVENEL[1]

LOWERS stand out among the first items to be massively
treasured and reproduced in glass. Emblems of the most
gratuitous and transient of beauties, flowers were dried
and either pressed under a layer of glass and hung as
portraits, or covered with a glass dome and exhibited as sculptural orna-
ments. Likewise, live flowers, such as orchids, were for the first time
being shipped overseas in Wardian cases, and aquariums were usually
started with anemones, those maritime "flowers" whose blooming
shapes, bright colors and delicate tentacles often made their glass con-
tainers into veritable ocean gardens.

1. "Colette and Paperweights," in Gérard Ingold, *The Art of the Paperweight: Saint
Louis* (Santa Cruz, Calif.: Paperweight Press, 1981), pp. 18–21. Colette de Jouvenel is

Representing in the paradoxical transience of their "eternal" beauty both the intensity and the frailty of human emotions, encased flowers' apparent entrapment of a vanishing reality peaked in the mid-1800s popularization of glass globes where glass flowers and flowery effects made with glass canes (known as millefiori, "thousand flowers"), as well as cameos and vistas, were ethereally suspended like so many memories.[2] Like most true kitsch, millefiori globes had an ostensible practical function, which in this case literally replicated their metaphorical motif and eventually made them popular as paperweights: they held paper down so that it was not carried off by the wind, avoiding the fate of memories. At other times, they held doors, were used as hand-coolers, or served miscellaneous domestic functions, always merging reality and fantasy as a matter of fact: "Mr. X, the famous financier, assaulted by a paperweight which his wife (inadvertently, no doubt) threw at his head on June 12 in his private suites on Rue Murillo, is slowly recovering in his villa at Cabourg. . . ."[3]

Far from being a modern invention, colored glass globes date back to Egypt, where they represented the Sun, and have been attributed magical and religious powers through the ages. They hung from windows as "witch-balls" to ward off the evil eye in northern Europe; they were used

Colette's daughter, and her take on paperweights is far more imaginative than the famous writer's, as can be seen when comparing this text with Colette's own "Presse-Papier," in *Le Voyage égoiste* (Paris: J. Ferenczi et Fils, 1930), pp. 114–18; there, paperweights are treated with the mixture of fascination and condescension typical of kitsch critics.

2. The oldest reference to millefiori may be found in Marc Antonio Sabellico, *De situ urbis venetae* (1495): "There is no kind of precious stone which cannot be imitated by the industry of the glassworkers, a sweet contest of nature and of man. . . . But, consider to whom did it first occur to include in a little ball all the sorts of flowers which clothe the meadows in spring. Yet these things have been under the eyes of all nations as articles of export. . . ." Quoted in Hollister, *The Encyclopedia of Glass Paperweights*, p. 12.

3. Colette de Jouvenel, "Colette and Paperweights," p. 19. For most writers on paperweights, these are intimately associated with childhood memories, much like *Citizen Kane*'s famous "Rosebud" sequence. For an interesting view on the relationship of paperweights to emotions and water, see Suzanne Horer's interview of Aube Breton-

as millefiori beads in Africa to indicate social rank; and as "Venetian balls" they decorated French-style Italian gardens in the seventeenth century, where their color replicated that of natural rocks, according to Antonio Neri, who was ahead of his time in suggesting they be used on desks and in writing rooms.[4]

The passion for what Ludwig II of Bavaria affectionately called "dream spheres" took off during the French Second Empire: the time of the massive Haussmannian renovations that in less than two decades transformed Paris into a modern city—the capital of the nineteenth century, as Benjamin declared—and the period when England was establishing itself as an industrial power, closely followed by the United States. In these three countries paperweights were massively produced during the second half of the century, fully in tandem with a modernity that they melancholically represented as the erstwhile bearers of a time now gone. Of this monumental production (there are reports that already by 1851 paperweights were selling by the hundreds of thousands) millefiori paperweights, the most prestigious and valued of all, were but the tip of the iceberg.[5]

The paperweight boom started at a trade fair, the 1845 Vienna Fair where the Italian glassmaker Pietro Bigaglia displayed one of those millefiori weights whose manufacture saved the French glass houses

Elleouet in Jacques Parisse, *Presse-papiers de prestige, presse-papiers populaires* (Liège: Mardaga, 1992), pp. 148–51. Breton-Elleouet formed her paperweight (particularly snow-globe) collection as a "popular" response to the more "serious" primitive art collection of her father, André Breton. Her collecting taste, from what transpires in this interview, is close to what I will later distinguish as melancholic kitsch.

4. Sibylle Jargstorf, *Paperweights* (West Chester, Pa.: Schiffer Publishing, 1991), p. 9. I am very grateful to Dr. Jargstorf for the information she has directly provided me, as well as for the thoroughness and depth of her work on paperweights. She is one of the few to study the history of paperweights previous to their French production.

5. Ludwig's quotation is in Jargstorf, *Paperweights*, p. 9. Paperweight production figures are discussed in Hollister, *The Encyclopedia of Glass Paperweights*, p. 41. Hollister offers an informative history of paperweight production in "Paperweight Genesis," pp. 7–44.

FEMALE WORKERS BREAKING GLASS, EIGHTEENTH CENTURY. From Diderot
d'Alembert, *L'Encyclopédie*, 1762–72. Women participated in several stages of the glass-
making process, at home or in the workshops that preceded factories. *General Research
Division, The New York Public Library, Astor, Lenox and Tilden Foundations.*

from bankruptcy. Rather than the original producers of millefiori weights, the French houses that made them world-known—mainly Saint Louis, Clichy and Baccarat—were the followers of a long-established tradition of Bohemian and Muranese paperweight makers which not only preceded the French houses and continued working after these folded or discontinued this particular line of production, but whose secondary range of production outdid by far the cultural impact of their fancy French counterparts. For while the latter cranked out large quantities of rather abstract millefiori paperweights, the traditional workshop and cottage workers of northeastern Europe (many of whom were women working at home) made, alongside the staple amount of millefiori, an abundant number of glass globes that often displayed photographs of dead relatives and eventually included those of famous people or places. The scenic weights became the rage with Victorian voyagers, creating "a sentimental geography" that is reproduced to this day as the quintessential travel memento.[6]

Made in the workers' sparse free time and with the leftovers of the official glass production, "frigger" or "offhand" weights were often inscribed with female names or the word "souvenir," which soon came to generically denominate them. Initially exchanged as presents between workers and their families, souvenir weights ranked second to the millefiori, considered worthier although frigger weights could be equally

6. Parisse, *Presse-Papiers*, p. 138. Parisse is one of the few authors to discuss and show souvenir weights. On how Pietro Bigaglia cashed in on the Franchini family's work, see Jargstorf, *Paperweights*, pp. 38–40; this family included a famous woman lampworker, Elisabetta Lazzari-Franchini. On women working in the glass industry, see Sibylle Jargstorf, *Glass in Jewelry* (West Chester, Pa.: Schiffer Publishing, 1991), pp. 33–34; and Elena Bertagnolli et al., *Perle Veneziane* (Venice: Consorzio Venezia Perle, n.d.). The story of Venetian glassmaking is replete with labor-exploitation nightmares, from the customary exclusion/inclusion of women in the labor force according to need (Muranese *impiraresse*, or stringing women, organized an unprecedented strike in 1870) to the family-carried secrets of glassmaking, with glassworkers being forbidden, under penalty of death, to leave the island of Murano.

beautiful and even more singular. This is certainly the case with the millefiori proper, the macédoine or fruit-medley type of weight (as opposed to those with individual flowers like the rose weight or the very popular pansy weight), whose serial character, despite each weight's being one of a kind and often dated and initialed, is quite apparent when contrasted with the quaint personalization of souvenir weights. It is in millefiori's abject relatives, however, that the full splendor of reminiscence can be grasped. Recalling the distortion of the early photographs and lithographs, souvenir weights' often blurry or imperfect quality, together with an abundance of personal references, bestows on them an aura that greatly adds to their emotional load.

It was Bigaglia himself, a consummate businessman, who formally introduced the distinction between "production" and "collection" weights according to their increasing complexity of production. This distinction typifies an early hierarchy within mass culture that displaces the craftmanship of pre-industrial workshops by the standardization of factories that could afford a higher and faster output, eventually leading away from the objects' uniqueness and towards the systematization of their production and marketing. Nevertheless, because they require a large degree of artisan work, glass paperweights occupy that bizarre interregnum between manual labor and serial output which runs alongside fully mechanized production, making of them, also in this very material way, objects oscillating between eras.

Just like the oneiric and mnemonic universes, the underwater atmosphere of aquariums and the crystallized one of souvenir paperweights evoke through visual imagery an intensity of feeling that is otherwise inexpressible: it belongs to the pre-symbolic realm of experience of the unconscious, where events organize and articulate themselves in a nonverbal language sensitive to the most subtle emotional intricacies.[7] Frag-

7. I am using "pre-symbolic" in the Lacanian sense. Lacan proposes several stages of the constitution of the self, of which the pre-symbolic, or imaginary, represents a

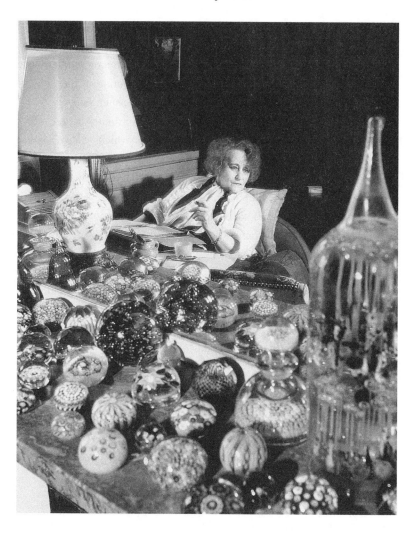

mentary and selective, the unconscious works its messages through condensation, association and repetition, saturating our imagination with memories and dreams. "Dream spheres" provide a unique medium for these evanescent recollections and fantasies, replicating in their glass and water distortions the amorphous state of half-consciousness.

Paperweights' oneiric quality reached an extraordinary degree with the "Victorian snowstorms," or blizzard weights, which when shaken produced a flurry of snowflakes, creating the foremost souvenir. Although it is not known exactly when the "snowflakes" (usually made from sand, sawdust, collophonium or celluloid) were added, glass spheres including a motif, scene or subject (often religious) and filled with water to enhance the impression of the included item were recorded in Europe since at least the sixteenth century. However, the snow globe was probably born as a toy, perhaps in Thuringia, a town famous for its Christmas ornaments.[8] Just like the millefiori before them, snow globes made their first recorded appearance in the context of massive trade, the Paris Exposition Universelle of 1878, where seven French exhibitors of decorated glass showed "Paperweights of hollow balls filled with water,

preverbal stage where the self is still not socialized. Socialization, and the ensuing adoption of a patriarchal linguistic structure, take place in the symbolic stage. See Jacques Lacan, *Écrits* (Paris: Seuil, 1966). For an excellent discussion on these aspects of Lacanian theory, see Kaja Silverman, *The Subject of Semiotics* (New York: Oxford University Press, 1983). As stages of psychological formation, pre-symbolic and symbolic must be distinguished from the symbol as a sign that represents something by relationship, association, convention or resemblance (which is why language is considered symbolic by Lacan). For an in-depth discussion of the symbol as a sign, see Umberto Eco, *A Theory of Semiotics* (Bloomington: Indiana University Press, 1976).

8. Sibylle Jargstorf describes Thuringian nineteenth-century frigger glass globe and Christmas ornament production in *Paperweights*, pp. 91–92. In response to my queries, she confirmed in a letter that the two most likely places where snow globes could have been invented were Thuringia and Bohemia, and that they were originally meant as toys. In a second letter she stated that the direct antecedents of snow globes included religious scenes, with water added for effect. Evangeline Bergstrom, the first American to write a comprehensive text on paperweights, also believes that snow globes were created as children's toys, although she attributes them to the French factories. See her *Old Glass*

containing a man with an umbrella. These balls also contained a white powder which, when the paperweight was turned upside down, falls [*sic*] in imitation of a snowstorm."[9]

This figure with an umbrella is quite intriguing, as very little is known about it. It is a repeated motif in early snow globes, where female and male figurines are found holding umbrellas or balloons in front of castles and châteaux. Although this motif is sometimes referred to as Little Red Riding Hood, the most interesting interpretation suggests it could portray Marie Antoinette in front of the Petit Trianon.[10] True or not, nothing could better represent the French queen's charmed but fateful life, as well as the "mission" of paperweights, than this suspended miniature. After all, Marie Antoinette's story is that of a person whose social rank cornered her further and further into a world of fantasy that came crashing down on the eve of modernization, and whose jaded luxury the French upper classes would vainly attempt to restore for at least another hundred years.

Mechanical reproduction enabled something that had not been possible before: the observation of the minutiae of movement, those infinitesimal and almost identical gestures that until then could only be optically grasped in continuity.[11] While novel techniques such as photography

Paperweights, Their Art, Construction, and Distinguishing Features (Chicago: Lakeside Press, 1940), pp. 39–42.

9. The references to the Paris world's fair come from Nancy McMichael, *Snowdomes* (New York: Abbeville Press, 1990), p. 10; and Connie A. Moore and Harry L. Rinker, *Snow Globes: The Collector's Guide to Selecting, Displaying, and Restoring Snow Globes* (Philadelphia: Courage Books, 1993), p. 15.

10. Bergstrom-Mahler Museum, *Glass Paperweights of the Bergstrom-Mahler Museum*, introduction and cameo incrustations by Geraldine J. Casper (Richmond, Va: United States Historical Society Press, 1989). The reference may be found in the description for item no. 224, a bequest from Evangeline Bergstrom, whose collection helped found this museum. In *Old Glass Paperweights* (pp. 40–42) Bergstrom attributes this snow globe to Baccarat and places its production in the 1850s.

11. Benjamin discusses the optical unconscious at length in "The Work of Art in the Age of Mechanical Reproduction," *Illuminations*, pp. 217–51.

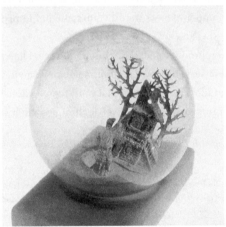

MARIE ANTOINETTE SNOW GLOBE. This mid-nineteenth-century French snow globe, one of the earliest, is shown both at the time of its purchase by Evangeline Bergstrom (1930s) and in its present-day condition. The figure holding a red parasol is said to represent Marie Antoinette standing in front of her chalet at the Petit Trianon in Versailles. *Courtesy of the Bergstrom-Mahler Museum, Neenah, Wisconsin.*

froze these fleeting, almost invisible moments, paperweights replicated them in their artificial portrayal of a permanent instant—flowers in eternal bloom, a duck forever swimming under the snow. This "capturing" of time just when it seemed to become more evanescent with the increasing speed of modernity enabled its immediate mystification: as time became a rarer commodity, crystallizing it in an object turned into a cultural obsession.

Like the arcades where they were sometimes sold (Nana's jealous lover stares blankly at them in front of an arcade stationery store), millefiori's glory soon faded, the remaining luxury production never equaling in quality or number that of the 1845–1870 classic period.[12] "Collectible" paperweights knew a brief but interesting renaissance in the late 1870s with the exhibition of the reptile and rock weights of the French house of Pantin, smaller and less well known than the others, in the Paris Exposition of 1878.[13] The emergence of snakes, lizards and salamanders in luxury weights seems to confirm once more how important the trappings of transience (represented in this case by animals that constantly undergo metamorphosis) are to this particular phenomenon. Although reptile weights had a precedent in garden ornaments, what is different here for them, as for the rock and lava weights that were produced at the same time, is the sense of suspension and containment conveyed by glass globes.

12. Since the 1950s Baccarat and Saint Louis have produced limited annual paperweight runs designed specially for the American market, where luxury paperweights have been actively collected since World War I. Clichy, which presented paperweights at the 1851 Crystal Palace, closed its doors in 1878. See Parisse, *Presse-Papiers*, p. 30, and Paul Jokelson and Gérard Ingold, *Les Presse-Papiers, XIXe et XXe Siècles* (Paris: Herme, 1988), pp. 68–70.

13. The Cristalleries de Pantin remains as one of the mysteries of paperweight production since, among other things, it did not inscribe its weights with identification marks. Geraldine J. Casper is the only specialist who establishes a connection between Pantin's and Baccarat's animal weights and the naturalist craze of the 1800s. See her *Glass Paperweights in the Art Institute of Chicago* (Chicago: The Institute, 1991), pp. 45–50.

Luxury weights were pretty much forgotten over the next few decades. Colette and her friends would buy them in the 1910s for a few francs, making a secret hobby of collecting these "nobly, absolutely useless objects" (or crystal globes to look at the past, not the future, as Colette's daughter, Colette de Jouvenel, would later say) from flea markets or weary superintendents who kept them on mantelpieces or as doorstops. It was not until the 1940s and 1950s that their value as collectibles began to escalate: one of the earliest twentieth-century collections, Mrs. Applewhaite-Abbott's three hundred weights, purchased between 1900 and 1938 for prices between two shillings and twenty-six pounds each, was sold in 1953 by Sotheby's in London for $90,000. Arthur Rubloff's collection of eleven hundred weights, started in 1950, was valued at $4.5 million when he donated part of it to the Art Institute of Chicago in 1978. In the meantime, their poor relatives, souvenir weights, not only continued in full production but also changed opportunely with the times, adopting polyurethane in the 1950s, while snow globes went for one of the most lasting and artificial materials of all time: plastic.

The Souvenir

ITSCH is dead from the moment it is born. Rodney's eternal life is contingent on that brief fatal moment that froze him forever in a transparent bubble. Yet what is left is more than an invertebrate corpse that will never rot or a crustacean that met its demise through an unnatural catastrophe: it is the demiurgic desire for immortality, the secret of creation held in the palm of one hand, the ability to gaze, unfettered, into the unknown otherness of an imprisoned creature that cannot escape in its imposed rigor mortis our voracious demands.

Rodney is a residue of what he once was: sempiternally trapped in the shock of his last agony, he pertains only to the instant when he

ceased to exist, that invisible moment which eludes vision yet is somehow still present in his unanimated carcass. Rodney lives in our imagination, where we vaguely reconstruct his existence according to the predominant narrative in our minds: Rodney the warrior fighting other hermit crabs over shells or territory; Rodney in a crabby mood walking sideways in search of nourishment; Rodney the solitaire retreating to his entitled zodiacal domesticity, peacefully resting in a home he has adorned with pink anemones, all four pincers closed while both pairs of antennae keep track of the world around him. There is only one Rodney, but many of us to see in him a reflection of each of our own lives.

When looking at Rodney in his glass globe, one can indulge the rare emotion of possessing his existence, forgetting he is dead. That he looks alive, with eyes that seemingly stare back, reinforces the utopian aspiration of life beyond death, made possible by the encounter of such disparate registers as the organic and the technical. Insofar as this illusion is maintained, Rodney fulfills the wish image's fetishistic potential: in this case, the desire to surpass death. Yet, simultaneously, the creature has ceased to exist and what we hold in our hands is nothing more than a crab's exoskeleton.

Rodney is the leftover of the urge to trap his vital anima, and his status as a fossil underlines the failure of that attempt. What we acquire when purchasing Rodney the commodity is an extant wish—ours, as participants in a culture that does not accept death and seeks to capture life at whatever cost, even that of sacrificing real life for the sake of a fleeting imaginary perception. It is in this intrinsic contradiction between a desire and the preclusion of its unfolding that the dialectics of kitsch take place, moving between an irretrievable past and a fragmented present, at home only in the certainty of its own impossibility.

According to Benjamin, there are two basic ways of perceiving events in modern time. Both are connected to memory and may be roughly distinguished as the conscious mode, which leads to reminiscence, and the

S<small>ERIES OF CAST CRAB SHELLS</small>. From *Shelled Invertebrates of the Past and Present*, volume 10 of The Smithsonian Scientific Series, 1938. The finest series of cast crab shells known, collected from a single specimen of the English shore crab (*Carcinides maenas*) by Mr. and Mrs. H. J. Waddington.

unconscious mode, of remembrance proper.[1] In consciousness, events are perceived as part of a continuum of time that is merely conventional. The shocking elements of an event are filtered out, enabling it to be lived as a memorable experience—the reminiscence—that does not disturb the delicate balance of consciousness and can be stored as a memory to recall at will. Consolidated into a perfectly flawless version of itself, the censored event becomes a sort of "cultural fossil," the static and idealized blueprint of an experience. Although the reminiscence retains some essential attributes of the original event, it lacks a substantial part of that event's integrity, namely its transitory vehemence. However, this gap is not apparent since the reminiscence is perceived as a continuous whole and therefore capable of reliving the event by sheer repetition.[2]

Within conscious memory, for example, the perception of Rodney automatically excludes an awareness of his death. Instead, it focuses on his life, much like what goes on in museums of natural history, where fossils are simply representatives of species whose traits and habits we are asked to resurrect in our imaginations with the images and information provided. Similarly, the cultural fossil recalls an immaculate memory, continuously regenerating it in ahistorical purity without the annoying distortions brought about by the passage of time—death and decay.

Perhaps the best illustration of this fossilized, conscious perception would be not the dead but the live hermit crabs that were a fad in the 1970s. Rivaling its hundred-year-old parent, the aquarium, the hermitarium became the pet microcosm of the moment, with collectors buying shells and busily watching hermit crabs establish and abandon homes,

1. On the two types of memory, see Benjamin, "On Some Motifs in Baudelaire," and "The Image of Proust," in *Illuminations*, pp. 155–200 and 201–15, respectively, as well as "Central Park," *New German Critique* 34 (Winter 1985): 32–58. The editor's footnotes to "Central Park" help clarify these concepts, particularly footnotes 32a.1 and 32a.2, on page 57.

2. Susan Buck-Morss explains Benjamin's concept of the cultural fossil in "Natural History: Fossil," *The Dialectics of Seeing*, pp. 58–77.

fight over the best domiciles and generally exhibit an attitude far from reminiscent of hermit introspection and solitude. Unknowingly repeating the fashionable mid-1800s turtle strolls, some people took the tiny crustaceans for walks (there are both land and water hermits) and even made them into keyholders. The latter was, however, a risky venture, since the shell's occupant could decide to pack up and take its body elsewhere, abandoning its living quarters—and the key's owners—to their luck.[3] These live fossils allowed the reproduction of an anthropocentric view of animal life in miniature scale, satisfying a nostalgic desire while avoiding the "dirty" complexity of an experience's full reality.

Within unconscious perception, on the other hand, there is no erasure of an experience's actual conditions, but rather the exclusion of consciousness' backbone, continuous time. The perceptual process that eventually leads to kitsch is that aspect of experience constituted by what consciousness leaves out: the intensity of the lived moment. Anachronistic by definition, the unconscious perception focuses precisely on all those distressing sensations that consciousness cannot afford to indulge. This zealous but transitory moment becomes a "remembrance," a piercing, fragmentary recollection that can direct perception to the hidden archives of our individual memories, where experiences are stored as atemporal and mythic.[4] Consequently, the unconscious remembrance supersedes the conscious reminiscence's evocative ability, since remembrance can leap beyond the immediate event into the associated dimension behind it, while reminiscence,

3. See Paul J. Nash, *Land Hermit Crabs* (Hong Kong: T. F. H. Publications, 1976); also Pete Giowajna, *Marine Hermit Crabs* (Hong Kong: T. F. H. Publications, 1978).

4. I am extending the notion of myth (which usually refers to those stories and memories shared by a collectivity and inscribed in a time outside chronological history) so that it applies both to strictly personal stories and memories—constituting a private mythology—and to those which, like kitsch, are collective but experienced as individual. For a relevant study of the way contemporary myths are formed, see Roland Barthes, *Mythologies*, trans. Annette Lavers (New York: Noonday Press, 1991).

THE VOYAGE OF LIFE: CHILDHOOD. Painting by Thomas Cole, 1842. The first in
a series of three paintings by this American artist where the ocean is used to romantically

depict the emotional stages of human life: discovery, struggle and serenity. *Ailsa Mellon Bruce Fund, © 1998 Board of Trustees, National Gallery of Art, Washington.*

trapped in its fabricated temporality, must content itself with repeating over and over a reconstructed event.

The subjective mythical time accessed by remembrances must be distinguished from the cultural fossil's evocation and mystification of something that often never really happened. More than simply being frozen in time like a vestige of an imaginary time, Rodney may be seen as a fragment of time whose artificial preservation is a constant reminder of creature mortality. What matters most for remembrance is what is already gone, that brief instant of splendor where we can envision, through a narrow sliver of our mind, the memories that underlie most daily contingency. As such, remembrance is obsessed by the transitoriness of lived moments and constituted by what ceases to be: loss and death.

Rodney's actual condition is central to this perception, although, as with all experiences, whether he becomes a reminiscence (disregarding his obvious demise) or a remembrance (focusing on the feeling of loss caused by his death) can only be determined by the onlookers' peculiar engagement with this reified hermit crab. That in both conscious and unconscious perception experience is somehow mutilated (of intensity or continuity, respectively) accounts for their finding a common ground in longing. However, the yearning of reminiscence is nostalgic and never really leaves the past, while that of remembrance must be anchored in the present to experience the loss for which it melancholically languishes.[5]

The lost time that unconscious remembrances attempt to bring back

5. I will be proposing a distinction between nostalgic and melancholic kitsch following in part Sigmund Freud's writings about nostalgia and longing in his "Mourning and Melancholia" (1917), *Collected Papers*, trans. sup. by Joan Rivière (New York: Basic Books, 1959), vol. 4, pp. 152–70. For a study of what I call nostalgic kitsch, see Saul Friedlander, *Reflections on Nazism: An Essay on Kitsch and Death*, trans. Thomas Weyr (Bloomington: Indiana University Press, 1984). For a complex study of the different cultural manifestations triggered by longing, see Susan Stewart, *On Longing: Narratives of the Miniature, the Gigantic, the Souvenir, the Collection* (Baltimore: Johns Hopkins University Press, 1984).

is the elusive "spleen" that affected many people during the nineteenth century: an existential state of pure present devoid of all past (history and mythical time) and future (hope and a potential for change). Spleen, where "time becomes palpable, the minutes covering man like snowflakes,"[6] is a typically modern phenomenon that would be unthinkable without industrialization's disruption of the continuous, usually

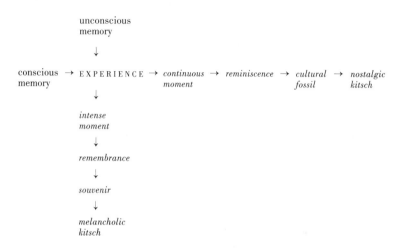

cyclic, flow of tradition. Together with remembrance and reminiscence, spleen constitutes a mode of perceiving modernity's impact, representing that tangible feeling of ephemeral temporality that remembrance longs for and reminiscence avoids altogether. Perhaps Rodney is the

6. Here, Benjamin is explaining spleen through some verses of Baudelaire. He goes on to say: ". . . in the *spleen* the perception of time is supernaturally keen; every second finds consciousness ready to intercept its shock." See "On Some Motifs in Baudelaire," p. 184. In "Central Park," Benjamin describes spleen as "that feeling which corresponds to catastrophe in permanence" (p. 34). In this sense, spleen coincides with Benjamin's catastrophical notion of history, as proposed in "Theses on the Philosophy of History," *Illuminations*, pp. 253–64. He describes history as "one single catastrophe that keeps piling wreckage upon wreckage," and "time filled by the presence of the now" (pp. 257 and 261, respectively).

best suited to evoke spleen, trapped forever in the very concrete moment of his death.

Like corpses, unconscious remembrances inherently carry the mark of passing time; theirs is a fleeting state that can only gain relative durability by way of a second death, that of commodification. When Rodney is set on a small pedestal and labeled as an "educational embedment," he enters the realm of commodities, where the remembrance will be crystallized (in Rodney's case, quite literally) into an object: the souvenir. Emptied of experiential dimension, remembrances are hardened, take second place to an extrinsic function—being educational or ornamental—and lose their singularity upon entering the market as exchangeable items. They have ceased to exist as "live" memories, becoming themselves mortal remains.[7]

However, as souvenirs remembrances are still susceptible to diverse modes of reception, which refetishize them into a wide array of meanings, according to the consumers'—and the market's—needs. Outstanding among these is the notion that an object is capable of transcending the limits of its own signification to represent, partially or fully, the whole event that gave it birth. Souvenirs, for example, condense the supposedly founding elements of a particular situation: a certain landscape or view, a famous person, the "typical" objects of a craft or region, an important moment.

This mode of conveying meaning—representing the whole through one of its parts—invests souvenirs with a large fetishistic potential: souvenirs begin to stand in for events or situations they were contingently associated with or were supposed to represent, gaining a life of their own.

7. According to Benjamin, in the souvenir "the increasing self-alienation of the person who inventories his past as dead possession is distilled." Therefore, the souvenir "is the schema of the transformation of the commodity into a collector's object" ("Central Park," pp. 44 and 55, respectively). This metaphorical death is comparable to the "hollowing out" of an object's meaning which happens in both allegory and commodification, and which is fundamental to Benjamin's analysis of Baudelaire's poetry.

CONSTRUCTION OF THE EIFFEL TOWER, 1888. Built for the 1889 Paris fair, which celebrated the centennial of the French Revolution, the tower was designed, constructed and paid for by Gustave Eiffel, who maintained an apartment inside it and had his expenses met before the fair was over. Having retained the gate receipts for the first twenty years of the tower's life, Eiffel made enormous profits from the technological feat that Parisians bitterly criticized during its construction. © *Photothèque des Musées de la Ville de Paris.*

For me, the corpse of a hermit crab becomes Rodney, an endearing creature whom my friends even say hello to when they visit; for a child, Rodney can be a friend; for a collector, a specimen or object; for a happy couple, a darling little crab to add to the cache of exotica that makes them feel special; for a teenager, Rodney can be seen as gore, a deadly object that fascinates because of its bleakness; for that teenager's parents, aware of this peculiar appeal, Rodney can be seen as morbid; and for the teenager's grandparents, as a sad reminder of their imminent departure.

In all these cases people look into the glass globe without really seeing it, but rather unwittingly gazing beyond it into their own unconscious—the fears and desires that wait silently until the least-expected stimulus triggers their remembrance. Souvenirs transcend the prefabricated wish image of commodities through the personal involvement of their consumers, a personalization that, no matter how clichéd, momentarily "resurrects" the dead possession. Still, the empathic capacity of souvenirs is far from the kind of "awakening" power they would require to become dialectical images and expose the wish image behind them.

The souvenir does not automatically recall the remembrance, conjuring the lived moment and from there unleashing mythical time. Like the cultural fossil, the souvenir is unable to bring back anything beyond the immediate perception that triggers the process of remembrance. Despite being centered around time (*souvenir* is French for remembering), the souvenir's capacity to move within the temporal dimension is limited by that second death—commodification—which attempts to restrict its significance to a specific dream image, hindering the imaginary return to mythical time that remembrances effortlessly achieve. For the latter to happen, the souvenir must wait, perhaps forever, to become part of a personal universe.

Although commodification's fatal blow is aimed more at uniqueness and use value than at temporality, it still succeeds in taking away a good

chunk of the remembrance's intrinsic potential—to move us back in time—while simultaneously reinforcing remembrances' deadly quality. Commodification is like the greedy King Midas, who wanted everything he touched to turn into gold, until he realized that everything really did mean all. He almost died of starvation, unable to caress or pick up anything lest it turn into the cold metal. The souvenir is a remembrance kissed by poisoned lips, savoring the lethal touch even as it races to meet a tragic end.

The Debris of
the Aura

*Those who mix easily with the crowd know
feverish pleasures that will forever be
denied the selfish, locked like a chest, and the
indolent, confined like mollusks.*

CHARLES BAUDELAIRE,
Le Peintre de la vie moderne, 1863

F the souvenir is the commodification of a remembrance, kitsch is the commodification of the souvenir. Upon freezing the remembrance as an active material capable of evocation, the souvenir becomes stultified. Having sacrificed the remembrance's mnemonic power (its use value, with variable meanings according to who remembers) for its immediate iconicity (its exchange value, loaded with the fixed meanings of advertisement), the souvenir reaches a dead end: it can no longer move backward and, by definition, it can't move forward. Consequently, it has nowhere to go.

Before modernity, remembrances produced cultural "corpses," or relics, where death was not only apparent but of primary importance.[1]

1. See Walter Benjamin, "Central Park," *New German Critique* 34 (Winter 1985): 32–58.

Acting as memento mori, these relics broke tradition's illusion of atemporal permanence, yet maintained intact a sense of awe and mystery. Relics, such as saints' body parts or animal remains—horns, eggs, shells—were sacred, tokens of bygone days infused with the iridescence of a special moment in time, objects of reverence to be admired or viewed from afar with the distance due all things that carry such a mythical load.

Beginning with the nineteenth century and the process of commodification, remembrances underwent a second death that made them into souvenirs, "dead" objects lacking mystical charge, secular relics liable to the contaminating touch of the world. Not content with this, modernity struck remembrances a third mortal blow—ironically, one that offered them dialectic movement. The destructive lightning strike was mechanical reproduction, and the shattered remains left after this major electrical storm were none other than kitsch.

Modernity gives rise to two different and even contradictory phenomena which despite all appearances are tightly connected within commodity fetishism. On the one hand, it yields the idea of novelty that is fundamental to sustain its own reproductive mechanism, mass production. To this effect, it has to discredit the culture of maintenance that preceded it and that hinders the speed and quantity of commodity production necessary for capital surplus and profit making. In this sense, modernity is oriented only towards the future, relying on an ideology of progress for which mechanization is basic.

Yet, on the other hand, modernity glorifies all that has been left behind, perceiving in it a metaphysical dimension that is now lost. The preindustrial past, embodied in the notion of the aura, is conceived as a sort of golden age emblematic of everything that is immaterial and ungraspable, and consequently of universal value—the source of all classical authority. Capable of hiding in the folds of memory, where it becomes the mythical time of the unconscious and of poetry, the aura gave nine-

teenth-century Romanticism (and eventually twentieth-century modernism) a good deal of their cultural power.

Tradition's demise began with industrialization, which disrupted the once direct relationship between producer and product with the segmentation of labor in factories, eventually replacing it with mechanization. The latter is the principal agent in the aura's fall, since with the massive proliferation of copies the singularity that guaranteed an object's authenticity was gone for good. With mechanical reproduction, the exclusive experience of sole ownership was threatened by the availability of myriad reproductions to a widening public. Yet, while mechanical reproduction destroyed the illusion of uniqueness on which the whole apparatus of the aura relied for legitimacy, it contradictorily reinforced the aureatic glow of the original, which like a firstborn son is entitled to all the privileges of authority and inheritance.

EIFFEL TOWER PAPERWEIGHT. Signed "L.L. Paris Made in France," this is one of the earliest snow globes. Made for the Paris fair of 1889, it contains a ceramic replica of the Eiffel Tower. Since the liquid has evaporated, dried ceramic flakes surround the tower base. *Courtesy of the Bergstrom-Mahler Museum, Neenah, Wisconsin.*

The disruption/continuity paradox of modernization can be appreciated in the mechanical optics that led to photography, which often produced an image whose object was faintly distorted. This was caused by the process itself—as in the daguerreotype, due to lengthy exposure of the plates—or by its contingencies, such as the fade-out of second- and third-hand reproductions, or even by some of the technique's philosophical underpinnings, like the idea that effects such as soft-focusing pro-

duced a more realistic image. On the contrary, this haziness of the image enhances its dreamlike quality, and ironically, the more reprinted—in other words, the more technologically intervened—an image is, the more diffused it becomes, heightening its mythical load.[2]

Modernization puts to a close the pre-industrial notion that experience is a unified and coherent whole, subject to diverse symbolic representations although in the end bound to repeat itself. It brings this vision of an essential, eternal and basically unchangeable history to a screeching halt, proposing instead a vision of linear progression where cause and effect follow one another in a neat and orderly—that is, mechanical—way.[3] However, the traditional, cyclic view of history doesn't altogether disappear. It remains in the background as a vague referent of a continuum denied by modernity, floating in a collective memory that craves nostalgically

"SAND DUNES" PAPERWEIGHT. Attributed to Baccarat, 1900–1916. Also known as "rock," this paperweight is filled with sand-like glass mottled with translucent green and drawn up in three peaks. *Courtesy of the Bergstrom-Mahler Museum, Neenah, Wisconsin.*

for an experience of wholeness that is no longer possible, and in a notion of art that seeks distinction from everyday living—a split unthinkable

2. "Mythical load," in this context, means a pre-industrial time which the image, by way of blurriness, unwittingly invokes. With modernization, all of pre-industrial time becomes mythical in the collective imaginary. See Benjamin, "A Short History of Photography," *Screen* 13, no. 1 (Spring 1972): 5–26. Consistently, the traces of production present in this early, analog technology imbue its products with an aura of authenticity that is absent—along with any sign of its being a simulacrum—from contemporary digital technology.

3. Benjamin describes the shift from transition to modernity as one where a cyclic

for tradition—situating itself within the aureatic realm. More than anywhere else, mythical time remains in the infinite replicas of those objects, souvenirs, which sought to retain the enchanted halo by blast-freezing it until it shattered into a thousand fragments. Kitsch is these scattered fragments of the aura, traces of dream images turned loose from their matrix, multiplied by the incessant beat of industrialization, covering the emptiness left by both the aura's demise and modernity's failure to deliver its promise of a radiant future.

On its own, the souvenir was unable to make its way back any further than the remembrance, petrified by the same commodification that made it possible in the first place. However, the impact of mechanical reproduction's added death blow succeeded in breaking this paralysis, freeing the remembrance to return, bruised and in pieces, to mythical time. While as a commodified memento the souvenir could barely overcome the aureatic distance between an onlooker and a trapped remembrance, its dispersion in myriad copies provided the necessary bridge for a plural, subjective consumption. In other words, once the halo of exclusivity that the souvenir initially reinforced was destroyed, the pieces of the aura were put up for sale and personal possession became the medium for a fetishized experience of loss. Since the aura's dilapidated state speaks so eloquently about modernity's underlying contradictions, kitsch may rightly be considered as containing the tension proper to all dialectical images: kitsch is the leftover of modernity's own dreams of transcendence, a remnant loaded simultaneously with hopes and the impossibility of their realization, a ruin.

Enclosed in the transparent walls of his lapideous sepulcher, as if

notion of history, upheld by manual labor, communal activities, oral tradition and a sense of integration with the world, is disrupted by the notion of historical progress, promoted in turn by mechanical labor, individualization, the printed word and a detachment from the world manifested in a high degree of self-consciousness. See Walter Benjamin, "The Storyteller," in *Illuminations*, pp. 83–109.

permanently awaiting a magic touch to break the spell of his sempiternal prison, Rodney is a dream image caught alive for the sake of our perpetual admiration. Were he not so small and tender, maybe he would have been allowed to finish his life in the way of most hermit crabs, alone and without splendor. But then there are all those nasty scorpions and piranhas encapsuled in similar conditions, making it apparent how the human fascination with life—and death—leaves no creature above the endless mortuary of permanent exhibition.

Rodney perished not once but threefold. First, his days were over even before the glass enveloped him, when someone saw in him the perfect specimen for curious eyes to behold. Rodney's condition as a remembrance ahead of its time preceded his tragic destiny: the simple fact of being alive infused him with a halo of uniqueness, inspiring

MEMORIAL PAPERWEIGHT. North Bohemia, first third of the twentieth century. The photographic image is enclosed in crystal and set upon a multicolored base. These photo weights were made in large quantities. *Collection of Dr. Sibylle Jargstorf.*

the desire for possession in much the same way that the fire of the gods inspired Prometheus. For the sake of his aura, then, Rodney's mortal being was extinguished, rewriting the Greek legend: the hermit crab not only lost his own vital fire, but also was chained to a synthetic rock.

After his mummification, Rodney gave up his ghost to the homogenizing bulldozer of commodity fetishism, which made him into a souvenir like any other, interchangeable with the scorpions and piranhas.

Finally, the tiny crustacean went out with the ebb of mechanical repro-
duction, whose magnificent replicas of Rodney look-alikes make my
friends wonder whether Rodney is real or just a nice plastic imitation,
taking from Rodney his last bit of hermit-crab dignity. And of course,
Rodney dies every time we forget about him, relegating him to the
netherworld of oblivion and abandonment, rendering his sacrifice futile,
his perennial limbo doubly irredeemable.

Rodney is kitsch. He fascinates with the artificiality of his alert eyes,
the immobile gesture of his sharp pincers, the immense frailty of his
small, imperfect body caught in the perfectly round, smooth, relentless
surface of the glass globe. We watch him in his transparent prison as if
this were a time capsule, instead of an unsolicited safeguard from that
exterior world against which this weary invertebrate always sought to
protect himself, coiling his delicate belly inside shells that he could
carry on his back—a dismantleable turtle, a miniature hunchback. That
his carcass did not decompose does not substantially alter the fact that it
is but a trace of life, made ever more valuable for the organic origin his
rigid bubble attempts to withhold, or at the very least invoke. In his ca-
daveral quality, Rodney speaks, for those who want to listen, about the
hopelessness of attempting to detain life, the vanity of hanging on to
what is gone, the beauty of the marks of time.

Dust

The grey film of dust
covering things has become
their best part.

WALTER BENJAMIN,
"Dreamkitsch," 1927

HILE Rodney is metaphorically resurrected in the fantastic musings that make him a live component of my world, other hermit crabs collect the dust of forgetfulness on the once diaphanous bubbles that became their last homes. In the one short piece where he discusses kitsch, Walter Benjamin employs the metaphor of dust to describe the rundown state of dreams in modernity. Attuned to the fate of the aura, he says, dreams are no longer removed from concrete experience, but tangible and near. They have lost their romantic dimension, their "blue distance," fading into a sad grayness that figuratively represents the disintegration which befalls dreams when they cease being imaginary and enter the polluted atmosphere of everyday life.[1]

Benjamin associates this colorless state with the dust that accumulates on forgotten objects, establishing an analogy between what he calls

1. Walter Benjamin, "Traumkitsch [Dreamkitsch]," in *Ausgewahlte Schriften* (Frankfurt am Main: Suhrkamp, 1966), vol. 2, pp. 158–60.

the extinct world of things (things infused with aura, of course) and the worn-out condition of dreams: both are now in the realm of the banal, that is, of kitsch. What makes dreams and things kitsch, therefore, is their tangibility—the fact that they no longer stand "two meters away from the body," but have become instead familiar and accessible. The connection of kitsch and decay is underscored by their mutual susceptibility to physical touch. And, as is always the case with the aura, the loss of distance is occasioned by technology, which Benjamin likens to bills of currency, in other words, to exchange value: bills and technology stand for the exterior of things, as opposed to their essence. In this way, Benjamin seems to perpetuate the classic opposition between essence and appearance that implicitly underlies the official status of kitsch as a superficial phenomenon and art outcast.

Benjamin's apparent dichotomy between outside and inside, body and soul, assumes that once things have been touched by the deadly hands of commodity fetishism, they wilt like flowers. And truly, only in the faraway dimension of conceptual distance (or of memory) can things remain beyond the mortal trials of time and space, the wear and tear of age and use. This aureatic distance is better understood with the help of what Benjamin distinguishes as "cult value," a traditional relationship to objects whereby these are infused with a sacred quality characteristic of cultures with a magic or theocentric view of the world. In turn, cult value is related to use value, where the worth of things is directly derived from their relationship to human activity, instead of subordinated to the laws of market exchange, or exchange value, as has been explained before.[2]

Although Benjamin longs for cult value, he recognizes its modern disintegration as the breaking down of old hierarchies (such as the one

2. See Walter Benjamin, "The Work of Art in the Age of Mechanical Reproduction" and "The Storyteller" in *Illuminations*, pp. 217–51 and 83–109, respectively. For the explanation of use value and exchange value, see footnote 6 on page 18.

which places essence over appearance) and, consequently, believes technology has a revolutionary potential. Similarly, although for him the novel promotes an individualistic experience that is radically different from the communal one of oral and epic literary traditions, it enables for this very reason a creative understanding of the world (rather than an acceptance of handed-down beliefs) which can open the way for its transformation.

What is most relevant about Benjamin's kitsch essay, therefore, is that it describes the consequence of the shift from a mode of experience based on a sacred distance to a mode based on perceptual proximity. For Benjamin, modernity replaces the cyclic flow of traditional time with a mirage of movement constituted by sheer repetition: the new as the "ever-always-the-same."[3] This condition is exposed by dust, which can slowly accumulate on things given their ultimate immobility, since the proliferation in space does not grant things movement (that is, transformation) in time.

Ironically, or perhaps by some intuitive acknowledgment, stillness was feared by the pragmatic idealism of the nineteenth century, where everything had to have a reason, an explanation, or a function. Victorian interiors, apparently merely ornamental, had a practical purpose: to cover the emptiness left behind by the absence of tradition. Material proliferation was legitimized by the pretended usefulness of things that contained other things—albums, armoires, boxes, glass cases—often protecting them from this era's arch-enemy, dust. Interiors themselves, like the arcades of a few decades earlier, were created to protect objects from the outside, keeping them safe for contemplation.

The vast production of the late 1800s was geared to protecting, showing, holding—an obsession that accounts for this period's fastidious arrangements, where nothing is out of place and all the different ele-

3. Walter Benjamin, "Central Park," *New German Critique* 34 (Winter 1985): 42–43.

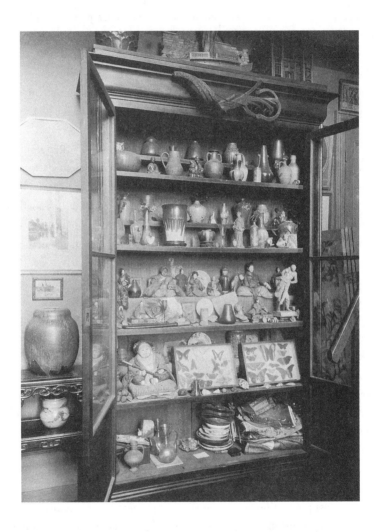

INTÉRIEUR DE MR B COLLECTIONNEUR, RUE DE VAUGIRARD. Photograph by Eugène Atget, 1910. Interior of a nineteenth-century cabinet. *The Museum of Modern Art, New York. Abbott-Levy Collection. Partial gift of Shirley C. Burden. Copy print © 1998 The Museum of Modern Art, New York.*

ments participate in an obligatory meaningfulness. Dust is a cumbersome residue that taints what it touches and must be eradicated: dust is seen as dirt, a persistent contamination exuded by death onto the world of the living. Already the 1851 Crystal Palace featured two devices to combat dust: a structural feature whereby the wooden planks of the palace's floors were left slightly separate so that the dust could fall through them, and a bizarre "vacuum coffin guaranteed to prevent decay." [4]

Eventually, nineteenth-century production surpassed the spaces that so generously embraced it, overflowing them to such a degree that they almost drowned under the weight of their own culture. Satiated, this society then turned around and lashed out against its own abundance amidst self-accusations of superfluity and waste. After all, its objects were no longer connected to anything vital, but were the emblems of a cultural death perpetrated by commodification, the remnants of an aura (however mythical) whose brutal disintegration marked the end of an era. So, while Benjamin's dust metaphor states that dust—kitsch, the banal—is a worthless, extrinsic detritus, at the same time it exposes the cultural condition that made this metaphorical dust possible: the loss of use value and the disintegration of the aura.

This assertion can be extended to suggest that dust grants things a peculiarity that reconstitutes them as a new experience, validating instead of disqualifying them. To this effect, I would like to propose that even though dust—or boredom—settles on things that do not move, dust itself may also be seen as the last breath of tradition, and therefore different from the deadly repetition of modernity. The dust that falls on modern things is the decay of the aura, the decomposition of a previous era that, like the tons of shells and detritus that continuously sink to the ocean bottom, creates a new layer of sediment. The dust of modernity, a

4. Beaver, *The Crystal Palace*, p. 54.

OPENING THE WAY FOR THE AVENUE DE L'OPÉRA THROUGH THE BUTTE DES MOULINS, C. 1877. Baron Georges-Eugène Haussmann's dramatic demolitions of Parisian buildings and streets (he called himself an "artist in demolition") were

photographed by Charles Marville, who was commissioned by the city to record old Paris as it was being destroyed, not so much to keep a memory of the past as to highlight the benefits of modernization. *Photothèque des Musées de la Ville de Paris.*

mix of boredom and death, is the most tangible aspect of the new historical time, a thin patina of shattered moments remaining after the frenzy of multiplication has subsided or moved away.

It should come as no surprise, then, that Benjamin equates dust with kitsch, since both are constituted by what I am distinguishing here as the debris of the aura. What is at stake for kitsch and dust is the transformation of reality from unitary to fragmented, from continuous to chaotic, along with a shift in the way we perceive, which goes from ritualistic to a pragmatic apprehension. The layer of dust makes things into opaque phantoms of themselves in the same way that kitsch is the distorted copy, or brilliant shadow, of a unique original that it transforms while replicating. And insofar as kitsch is like dust—a fragmented reminder of something now gone, a mundane proliferation that infiltrates homes at will, a bizarre form of object appropriation—then kitsch is liable to the same accusations and cleansing operations that dust must endure.

Dust is what connects the dreams of yesteryear with the touch of nowadays. It is the aftermath of the collapse of illusions, a powdery cloud that rises abruptly and then begins falling on things, gently covering their bright, polished surfaces. Dust is like a soft carpet of snow that gradually coats the city, quieting its noise until we feel like we are inside a snow globe, the urban exterior transmuted into a magical interior where all time is suspended and space contained. Dust makes the outside inside by calling attention to the surface of things, a surface formerly deemed untouchable or simply ignored as a conduit to what was considered real: that essence which supposedly lies inside people and things, waiting to be discovered. Dust turns things inside out by exposing their bodies as more than mere shells or carriers, for only after dust settles on an object do we begin to long for its lost splendor, realizing how much of this forgotten object's beauty lay in the more external, concrete aspect of its existence, rather than in its hidden, attributed meaning.

Dust brings a little of the world into the enclosed quarters of objects.

Belonging to the outside, the exterior, the street, dust constantly creeps into the sacred arena of private spaces as a reminder that there are no impermeable boundaries between life and death. It is a transparent veil that seduces with the promise of what lies behind it, which is never as good as the titillating offer. Dust makes palpable the elusive passing of time, the infinite pulverized particles that constitute its volatile matter catching their prey in a surprise embrace whose clingy hands, like an invisible net, leave no other mark than a delicate sheen of faint glitter. As it sticks to our fingertips, dust propels a vague state of retrospection, carrying us on its supple wings. A messenger of death, dust is the signature of lost time.

Indeed, dust is where faded dreams and touch intersect, where the blue horizon fades to gray. Benjamin's distinction between dreams and touch reflects the aura's underlying hierarchy of value. In a time when the manufacturing of objects has given way to their mechanical and mass production, pre-industrial times are considered superior for representing a direct connection between producer/consumer and object; they are granted a transcendental dimension for seemingly bridging the gap between sensorial perception and symbolic apprehension. Within the parameters of use value the aura remains intact; the connotations of authenticity and uniqueness permeating process, object and subject.

Not so with mass production, which replaces use value with exchange value, where the emphasis is on accessibility and pragmatism. Having descended from the Mount Olympus of exclusivity, objects need no longer to surpass their immediate function on Earth, but can be relished instead for their corporeal existence. Like fallen angels, objects lose or rather ruin their auras upon descent, arriving with little more than a crumbling, dusty shadow of their once iridescent haloes. Deprived of supernatural immunity, the shaken-down aura falls prey to all the vicissitudes of earth-bound things: it can be touched, traded, copied and tampered with; it is but a fragment of its former existence. It is kitsch.

THE VOYAGE OF LIFE: CHILDHOOD

—◆—◈—◆—

THE hidden door that leads to paradise opens in a place without fissures where everything radiates, sustained by the mysterious vapor of imagination. It is inhabited by unicorns and charming princes. Suddenly, time folds like a fan: enormous red roses begin to putrefy, ethereal bodies hang like golden skeletons, trees are invaded by stuffed birds and snakes whose skins short-circuit with every kiss. A girl escapes in terror, taking cover under the dry leaves and the barbed wire. She pretends to be an impenetrable rock, concealing herself so she can never be touched, and always be longed for.

Kitsch is a spell to which one succumbs willingly, knowing its delicate fabric can disintegrate with the slightest interference, who knows when to be reconfigured again. An interregnum, kitsch drifts between waking and sleeping hours, half dream and half reality, all memory and desire. It transits the unwieldy space between tangibility and perception with the smoothness of a cat burglar, intruding on us when least expected. Kitsch is the world

as we would like it to be, not as it is; the capturing in a concrete thing of the most ineffable feelings and tenderest emotions.

Kitsch is a flight from the present, a siren's song luring us into a voyage void of time distinctions. It is an enchanted grotto where unknown treasures lie scattered, awaiting the lucky traveler who will rejoice at stumbling onto such wonder. Kitsch is Ali Baba's secret cave finally open before our eyes, confirming an old, deeply hidden suspicion that this fantastic place always existed somewhere in that continually shifting ocean called possibility.

Kitsch is getting lost in an image, wandering into it as through one of Alice in Wonderland's magic mirrors, crossing the threshold of a parallel dimension that is always there, a shadow world, an invisible Siamese twin. It is a garden blazing with fallen stars in the middle of the night, their intense yellow glow beckoning to a small girl who sleeps on a second floor. Transfixed, she flies from her bedroom window and lands among these heavenly bodies, barely daring in her rapture to touch their radiant warmth. Big and small, the golden sky flowers pave grass and walls, transforming the garden into an incandescent particle of the universe.

Kitsch is the key to this secret chamber: a tiny star of metallic paper, a rudimentary constellation embroidered on an old-fashioned cushion, the gleaming streets and buildings of Manhattan seen at night from the cinematic distance of an airplane or the closeness, heightened by an amorous embrace, of the Brooklyn Bridge. It is that unfathomable detail—the texture of a paper, an age mark on a certain print, a plastic flower's faded col-

oring—which resonates in our interior like a silent fire alarm, alerting us to a beloved presence before it disappears in the rough-and-tumble that creates waves and tides in the sea, moving people and objects around as if they were nothing but precarious gadgets in a slumbering store.

Oblivious to the outside world, such miniature bazaars sit dusty and quiet in the basements of stone churches or, in solitary booths among the indifferent displays of newer concessions, offer relics from behind immaculate glass windows—a sphere of bygone years encased between the folds of tired office buildings in a third-world city's downtown corner. Inevitably, these leisurely microcosms are kept by elderly women and men who, with laid-back diligence, manage to make them into veritable sanctuaries of an era that suddenly found itself belonging to the past. The gentleness of these people's manner, and the at times uncertain, at times benevolent, often simply amused demeanor with which they share their forsaken treasures, ease the imaginative traveler whose illusions need protection from the harshness of every-day life.

In this sacred domain a unique intimacy with things takes place. All surroundings are dispelled by a powerful attraction that propels us into objects like a zoom lens focusing on its target, and we enter a bewitched zone where moments and places navigate alongside one another on a slow-motion carousel whose horses shift with each rise and fall. Only the versatility of thrift shops and old discount stores, where things are at the mercy of

those whose lives they constitute, grants forgotten objects the un-precedented freedom of being entirely useless, susceptible to the myriad caprices of curious onlookers, casual drifters and occa-sional solicitors. Then, one day, someone comes along who dis-covers in the iridescence of a vase's bluish-lilac hue, strewn with wide-winged swans, or in the delicate drawing of bright yellow roses on a musical plate, a long-lost sensation, an ancient melody that imperceptibly carries her up above the street, over the city and across the ocean, to that suspended space which, locked for-ever in the imagination, receives her into the full embrace of memory.

Rescuer of discarded fantasies, kitsch is the magic carpet on which we glide towards those mythical regions that, like sub-merged coral reefs coming into view with a low tide, constantly float around consciousness, awaiting the occasion of our interest to dispel their shrouds and appear in their full glory. Island uni-verses suspended in the fog of oblivion, these vanished dreams come forward and glow with the heat of a thousand years—the time to develop interminable specular stories that layer them-selves onto one another like the petals of an ever-blooming rose. Given the least opportunity, our minds race to this constant fold-ing and unfolding of chimeric events, searching for those figures that make of human life an incessant flow of stories and images, each a luminous planet casting light on its revolving satellites, all a mutable constellation traveling through the endless universe of time.

The World That Drowned

*There indeed under my eyes, ruined, destroyed, lay a town,
its roofs open to the sky, its temples fallen, its arches
dislocated, its columns lying on the ground, from which one
could still recognize the massive character of Tuscan
architecture. Further on, some remains of a gigantic
aqueduct; here the high base of an acropolis, with the floating
outline of a Parthenon; there, traces of a quay, as
if an ancient port had formerly abutted on the borders of
the ocean, and disappeared with its merchant
vessels and its war galleys. Further on again, long
lines of sunken walls and broad, deserted streets—a perfect
Pompeii escaped beneath the waters.*

———

JULES VERNE, *20,000 Leagues Under the Sea*, 1870

ATLANTIS, the legendary continent whose dramatic sinking served for centuries as an emblem of supernatural punishment, resurfaced with twice its previous imaginary strength in the mid-1800s. A highly developed culture whose very perfection paved the way for its own demise, Atlantis evokes a fantastic, self-contained civilization, a Greek utopia gone sour, the implosion of rational thinking majestically mirrored in a huge wave that engulfed and swallowed this renegade kingdom.

Hidden away at the bottom of the sea, Atlantis is usually portrayed in popular culture as an intact city encased in a gigantic glass dome, a submarine crystal palace sheltering its inhabitants from the dangers of "the denizens of the deep," or as an elusive series of underwater ruins barely glimpsed on extremely clear days, blotting blurry photographs with unexplainable geometric traces on the ocean's sandy floor. Shrouded in this hazy and volatile magnificence, "the lost continent" represents an empire consumed in its own splendor, a sunken paradise whose descent from the surface of the Earth into the depths of an unknown marine universe was the result of the greed and leisure that often accompany major successes.

Varying slightly in names and locations, the legend of Atlantis is undisputably traced to a text that Plato was working on when he died, adding to the mysterious aura enveloping this slippery submarine empire. The narrative web in which Plato's story is ensnarled (a remnant of oral tradition) anticipates its passing down through the ages. Plato attributes the original, already partial, tale of the lost kingdom of Atlantis to Solon, who heard about it during a trip to Egypt. Rather than placing the story directly in Solon's mouth, however, Plato recounts it through a fourth-generation teller, Critias, whose great-grandfather was a good friend or brother of Solon's and had told the story to Critias's grandfather, who then recited it at a public festival where Critias heard it. Plato adds that had Solon been able to complete the tale of this fallen civilization upon his return from Egypt, he would have been more famous than Homer.[1]

A story twice unfinished, the Atlantean collapse seems to have been doomed from the very beginning to the fragmentariness and repetition

1. Plato tells the story of Atlantis in two Socratic dialogues, *Timaeus* and *Critias*, written about 355 B.C., several years after *The Republic*, to which *Timaeus* was meant as a sequel; *Critias* was never finished. See L. Sprague de Camp, *Lost Continents: The Atlantis Theme in History, Science, and Literature* (New York: Gnome Press, 1954), pp. 3–5; this book

that characterize its different versions. Despite the shifting of names and places—all ancient cultures, from the Chaldeans to the Incas, seem to have a variant of Atlantis, a fact that Atlanteologists sustain as irrefutable proof of its existence—the bare bones of the Atlantis narrative include an ancient people of divine ascendancy, the corrupting power of wealth and material progress, and one full day and night of rain culminating in earthquakes and a gigantic wave under which a magnificent city sinks forever.

The Atlantean empire, which Plato locates in 9000 B.C., antecedes and is eventually defeated by the Greeks, who at the same time are its descendants. Plato emphasizes the importance of this antiquity in Solon's tale, as Atlantis provides the kind of historical grounding that Greece is accused by Plato (through the wise men of Egypt) of lacking. From the onset, then, Atlantis is positioned in a dual relationship to Greek civilization and its heritage, representing both its origins and its potential ending. An icon of antiquity, Atlantis condenses the imagery of the Greco-Roman empire—pillars, temples and togas—while adding a dimension of catastrophe unbeknownst to that colossal culture which, instead of coming to an abrupt end, has maintained a hegemonic predominance as "the cradle of Western civilization" to our day.

Besides the interpretation of ancient legends that tell about a colossal catastrophe (from the Babylonian epic of Gilgamesh to the legends of the Samoan aborigines of the South Pacific to the Biblical account of the Deluge; although none refer directly to Atlantis, some do mention the

provides one of the most interesting early surveys on the Atlantis phenomenon. See also the nineteenth-century best-seller by Ignatius Donnelly, *Atlantis: The Antediluvian World. The Classic Illustrated Edition of 1882* (New York: Gramercy Publishing, 1985). For a contemporary study of the Atlantis myth, see Phyllis Young Forsyth, *Atlantis: The Making of Myth* (Montreal: McGill-Queen's University Press, 1980). The imagery in the first paragraph of "The Voyage of Life: Childhood" (see page 97 of this book) was inspired by a show by the artist Aimeé Morgana, presented in 1991 at the American Fine Arts gallery in New York City.

BABYLON FALLEN. Woodcut by Gustave Doré, 1866. In the 8th century B.C., the once great city of Babylon lay wasted and ruined, "a jungle infested with jackals." It would later be rebuilt to even more splendor. Doré's illustrations for the Bible were so popular that the edition in which they appeared became known as "Doré's Bible."

sinking of an island), the gap between Plato's original account and last century's "rediscovery" of the island continent is almost as wide as the Atlantic Ocean itself. Except for a passing mention in the medieval encyclopedia *De Imagine Mundi* by Honorius of Autun (c. 1100), there are no references to Atlantis from right before "the long night of the Age of Faith closed down upon the Western World," when a sixth-century Egyptian monk called Kosmas dismissed it in his aptly titled *Christian Topography*, until the colonization of the Americas in the sixteenth century.[2]

Rekindled by its appearance as a submerged, ruined city in Jules Verne's immensely popular underwater saga, modern fascination with Atlantis officially took off with the 1882 publication of Ignatius Donnelly's book *Atlantis: The Antediluvian World*, which by 1949 had been reprinted fifty times—almost a reprint per year. Donnelly is credited with having introduced into popular culture a legend that until then had remained "a subject of speculation among intellectuals."[3] As unexpectedly as it had supposedly disappeared, Atlantis resurfaced: explorations, investigative books, novels, and later also comic books and films addressed "the world that drowned" from every possible angle, almost as if the sheer quantity of material on Atlantis could somehow make up for its continuous absence.[4]

Research literature was mainly comparative, establishing connections between different ancient cultures and proposing Atlantis as a missing link that held the answer to many questions about the common aspects of these cultures, including similarities in art, architecture,

2. Sprague de Camp, *Lost Continents*, p. 19.

3. Roy Stemman, *Atlantis and the Lost Lands* (London: Danbury Press, 1976), p. 32.

4. *The World That Drowned* is the title of a short novel by F. C. Painton, Richard Sale and others, that appeared in the weekly *Argosy* (n.d.); its cover is reprinted in Henry M. Eichner, *Atlantean Chronicles* (Alhambra, Calif.: Fantasy Publishing Co., 1971), n.p. Eichner surveys dozens of Atlantean stories, novels and films that have appeared in English since the mid-1800s, and his tone is often quite amusing.

belief systems, legends, and so on. This kind of investigation usually overlapped with a more technical approach that involved archaelogical expeditions, often branching out into the anthropological and biological realms, and was even occasionally weaved in with the many occult revelations that sprung up around the same time, most notably Madame Helena Petrovna Blavatsky's.[5] Numerous theories were produced in which all of the above were reaccommodated like a continuously shifting jigsaw puzzle, yet the kind of substantial evidence that would satisfy everyone beyond the shadow of a doubt—namely, finding the ruins of a city beneath the sea—did not materialize. However, the ongoing discoveries of Pompeii, Troy, the Minoan culture in Crete, and the pre-Columbian empires in South and Central America kept Atlantis a most auspicious possibility.[6]

If nowhere else, Atlantis lived in the imagination of the late nineteenth century. There were two outstanding, although diametrically opposite, schools of thought regarding what had caused Atlantis to sink. In what could be called the "natural disaster" version, an earthly or cosmic phenomenon was believed to have occasioned the catastrophe. This nat-

5. Originally from Russia, Madame Blavatsky founded the Theosophical Society in New York in 1875. Her books include *Isis Unveiled*, 2 vols. (Pasadena, Calif.: Theosophical University Press, 1972), and *The Secret Doctrine*, 2 vols. (Pasadena, Calif.: Theosophical University Press, 1970). Metaphysical interest in Atlantis has been renewed in the last few decades with the New Age approach to spirituality. Sprague de Camp charts the different Atlantean versions by expert ("Atlantist"), date, and interpretation (Atlantic Island, Crete, Mexico, Biblical Flood, Imaginary, Doubtful, etc.) at the end of *Lost Continents* (pp. 314–18). For a contemporary survey of the different theories, explorations and cultures associated with Atlantis, see Stemman, *Atlantis and the Lost Lands*.

6. Based on his archaeological explorations, Charles Berlitz defends the idea of a sunken city in *The Mystery of Atlantis* (New York: Grosset and Dunlap, 1969); the issue in dispute is whether certain underwater formations in the Caribbean are rocks or ruins. Although Pompeiian buildings were first discovered in the late sixteenth century, systematic exploration there did not start until 1748; John Lloyd Stephens first discovered the ruins of Mayan civilization in the 1840s; Heinrich Schliemann made the first excavations of Troy between 1870 and 1890; the Minoan civilization of Crete was revealed by Arthur Evans in 1900.

ural phenomenon ranged from the movement of continental platforms and the ensuing earthquakes, to volcanic activity and gigantic waves, all the way to the cosmic impact of an asteroid or comet succumbing to the gravitational pull of either the Earth (which gained a satellite, the Moon, in the process) or the Sun (with the comet becoming the planet Venus) and the same local consequences of darkened skies, rains of fire and sinking continents. The "human-made disaster" orientation, on the other hand, believed that the catastrophe was entirely brought upon the Atlanteans by themselves, and usually attributed it to their development of solar or laser energy or both, with the well-known effects.

MADAME BLAVATSKY. Having anticipated Ignatius Donnelly's Atlantean theories, and pioneering paranormal techniques of investigation, Madame Blavatsky published what she affirmed were secret texts, classifying Atlanteans into a series of "root" and "sub" races that spanned millions of years. *Courtesy of the Theosophical Society of England.*

Whatever the cause, the fictional accounts that started full-force in the 1880s—lasting all the way up to the 1960s—agreed on one thing: what really mattered for modern times about Atlantis was the disaster, not the golden age—apocalypse, not utopia. Rather than spending time nostalgically glossing over the legendary beauties and riches of the famous empire, these tales went straight to the catastrophe and its ensuing debris, giving free reign to a fantasy of global destruction. To achieve

this, most narratives either started right before the Atlantean apoca-
lypse, briefly setting the stage of greed and corruption for divine punish-
ment; or they enacted a second annihilation that struck the survivors
of Atlantis in their submarine or interplanetary refuges, with the fate of
the doomed continent still reaching out to the present from its watery
grave. In either case, explorers with a mission or unsuspecting tempo-
ral/spatial travelers accidentally find themselves on Atlantis or some
neo-Atlantean enclave, immediately get tangled in very convoluted plots
of good and evil, fall in love with the obligatory beautiful princess (or
occasionally prince, although there's also a lot of double-dating in the
tunnel of time) and escape at the last minute, unscathed, watching
from a safe spot as Atlantis sinks, or its revivalist version is somehow
destroyed.[7]

Two of the earliest modern fictions on Atlantis were *Atalantis* (1832),
an epic poem by William G. Simms about a sea maiden by the same
name who is kidnapped by a demon king from whom she is eventually
able to escape; and *The Atlantis* (1838), by Peter Prospero, in which a
magnificent city hidden among the icebergs in the Antarctic is the ar-
rival dock for famous people after their death. One of the most influen-
tial ones, *L'Atlantide* (1920), was written almost a hundred years later by
Pierre Benoit, inspiring numerous films and books. Atlantis is located
this time in the Sahara Desert and ruled by the beautiful and deadly
Antinea, its last queen, who transforms her lovers into orichalc and later
exhibits them in a long corridor. Many stories were written between
these, most notably Jules Verne's short but crucial 1870 chapter, "The
Lost Continent," with the decade between 1896 and 1905 producing at

7. One of the most hilarious intersexual plots was that by G. Stanley Hall in *Recreations
of a Psychologist (Fall of Atlantis)* (1920), where "millennia of peace had produced an
overabundance of women, who then tried to revise the moral codes so that they might
each have men. They used the trick of abstinence as a whip over the men. The men, in
revolt, went into homosexuality [*sic*], and for over a generation, there were no births."
Eichner, *Atlantean Chronicles*, p. 163.

least sixteen novels. Of these, the story line most pertinent to my own is that of André Laurie's *The Crystal City* (1896):

> René Caoudal is washed overboard from a ship, and awakes to find himself in a city under the sea, attended by a lovely maiden and an old man. After some exchange, he is drugged and re-awakened to find himself on another ship where he learns that he has been found strapped to a barrel floating in the sea. René goes through a series of events to get a wealthy man to build a diving bell so that he may descend into the sea and find the couple he saw on his first awakening. A bell is built, and after many descents, René sees the young lady and old man walking beneath the crystal cover of the submerged city. He returns to the surface to build an even better small submarine, and with this and a friend Kermadec and Dr. Patrice, he ventures beneath the sea again. They reach, and through a series of locks enter the city. The young lady welcomes them. She is Atlantis, and she and the old man, her father, are the remaining survivors of the Atlanteans. She tells René how a small group of Atlanteans were saved by the building of a crystal shell, how they had lived beneath the sea, and gradually diminished until only she and her father were left. And now her father is dying. The submarine suddenly will not function. Just before Atlantis' father dies, he tells René of a tunnel which leads to the surface. He dies and the party find their way to and through the tunnel, to the surface and safety.[8]

While Atlantis' tragic destiny was presented originally as a moral punishment (for "unrighteous avarice and power" in Plato's founding narrative and for generalized corruption in the frequent association of Atlantis with the universal deluge), what is most relevant for the turn of the century's innumerable studies, more or less successful exploratory expeditions and endless speculation is the fact that this fantastic civilization was lost, seemingly existing only in the fluid world of the imagination, where it was metaphorically crystallized inside a bubble. The obsession with finding or "discovering" Atlantis reached such heights of mass hysteria in the late 1800s that in terms of news value it was com-

8. Quoted in full from Eichner, *Atlantean Chronicles*, pp. 168–69. Most of the preceding descriptions of narratives are also taken from his book.

THE VOLCANIC ISLAND OF KRAKATOA ON THE EVE OF ITS DESTRUCTION IN 1883. As well as killing tens of thousands of people, the explosion of this volcano produced the loudest sound ever heard on the planet, a gigantic wave that reached the English Channel, and a cloud of dust that turned sunsets blood-red for a year. *Culver Pictures.*

pared at the time to the second coming of Christ.[9] In other words, even though this legendary cataclysm stood for centuries as a counter-symbol of imperial prepotency, in modern times the mythical allure of Atlantis surpassed this primary "punitive" aspect, emphasizing instead both the grandiosity that the original story sought to restrain and, above all, the very existence of this ill-fated kingdom.

Laden with such wonder, Atlantis is also unwittingly full of conceptual attributes dear to the century of rational dissection. To begin with, it boasts of that microcosmic quality whose self-containment is the basis of both emerging scientific discourse and Victorian interiors, models of nineteenth-century public and private organization, respectively. Most importantly, the lost continent reiterates the polarity between the irrational and the rational, which in the West has been cast as an irreconcilable opposition between the threat of unknown maritime depths (alternatively projected to outer space) and the safety of a sunny, visible surface. This duality, a staple of Romantic thought that in less than fifty years would be systematically articulated in the theory of the unconscious, accounts for both the nineteenth century's sense of boundless entitlement and, paradoxically, its inability to gaze into its own contradictions.

Atlantis' enveloping ocean is a body of tears where the infinite sadness of the nineteenth century was ready to drown, as if with its density the liquid element could replenish the enormous emptiness left by the crumbling of tradition. Permanently suspended like a snow globe that a mere shake immediately brings back to life, Atlantis is the polymorphic image of a century that attempted to eliminate temporal continuity only to succumb to the ensuing dislocation. Mythical Atlantis was born of a similar botched extermination, when Zeus vanquished his father Chronos (the ruler of time, known in Latin as Saturn) after Chronos at-

9. Sprague de Camp, *Lost Continents*, p. 2.

tempted to avoid imminent dethronement by eating his own progeny. Zeus later drew lots for the Earth's distribution with his male siblings, dividing among themselves their defeated father's territory, with the deep sea, where Atlantis was merely beginning its reign, falling to Poseidon.

Atlantean history has it that the legendary continent was first ruled by King Atlas, after whom the entire ocean was called (Atlantis meaning "daughter of Atlas"), and that it was renamed Saturnia after the humbled Titan who, seeking refuge in Italy, brought to it a golden age of peace and prosperity later celebrated every winter as the Saturnalia.[10] That the same figure who devoured his children and whose name represents the planet of melancholy (Saturn, the star of slow, heavy gyrations) should be associated with such lighthearted, joyful festivities is typical of Atlantis' paradoxical character. Inaugurated by the fall of time and inhabited by the god of the ocean depths, Atlantis seems forever trapped in its own metaphorical mechanisms, as if nothing about this legend could escape the continuous duplicity, mirroring and turning on itself that make of its ruins such a tantalizing enigma.[11]

Atlantis' saturnine qualities (its sadness, secretiveness and conceal-

10. See Sprague de Camp, *Lost Continents*, pp. 13–14; Donnelly, "The Kings of Atlantis Become the Gods of the Greeks," pp. 283–307 of *Atlantis*; and Edith Hamilton, *Mythology: Timeless Tales of Gods and Heroes* (New York: Meridian, 1989), p. 45. It is unclear whether King Atlas, who according to Plato was the son of Poseidon after whom both Atlantis and the Atlantic Ocean were named, is one and the same as his grand-uncle, the Titan Atlas, who was punished by Zeus in the Titan–Olympic god family dispute by having to carry the world on his shoulders. Adding to the confusion, Poseidon had a child by Kelaino, one of Atlas's daughters or "Atlantides," which could make Poseidon all of son-in-law, father and nephew of Atlas.

11. There is even a modern county named after the mysterious continent: Atlantida, on the Atlantic coast of Honduras, a country whose Spanish name means "depths." On Saturn and melancholy see the monumental study by Raymond Klibansky, Erwin Panofsky and Fritz Saxl, *Saturn and Melancholy: Studies in the History of Natural Philosophy, Religion and Art* (Frankfurt am Main: Suhrkamp Verlag, 1992). On Walter Benjamin's melancholic temperament, see Susan Sontag's Introduction to his *One Way Street* (London: New Left Books, 1979).

ment) act as a modern antidote to the utopian qualities it was endowed with before the advent of modernization. A product of Romanticism, the rediscovered legend illustrates some of the contradictions that made of the nineteenth century one of the most important transition periods of Western culture. Bound to a past that is dead in time yet lives on in the continuous transformation of its remnants, Atlantis' fate is to be a ruin that acts as a vital memory. In its constant movement between apogee and destruction, Atlantis delineates an unstable spatial figure (here a fantastic city, there a city in rubble) whose mobility is further underscored by its sempiternal absence. Nothing in Atlantis is static or fixed: it rewrites itself over and over, as if seeking in this repetition a final moment of plenitude (a "Rest in Peace") which it has forsaken. This repetitiveness is not the nostalgic fixation on recovering the past, but the pulsating preoccupation with a present far too complex to handle on one unequivocal register.

Like the culture it feverishly mesmerized, the legend of Atlantis is fragmentary and irregular, repetitive and dislocated, luminous and tortured. Instead of a referent to which the nineteenth century turned for utopian illustration, Atlantis is the mythical memory underlying that period's fetishization of loss, its aquatic suspension intrinsically connected to the crystallized imagery of paperweights and the miniature worlds of aquariums. As such, it speaks of a new sensibility, where the residual and excessive, rather than considered worthless and abject, are the main conveyors of signification. Atlantis was a legend waiting to be rediscovered in the late 1800s, when the illusion of a utopian city lying derelict and forgotten at the bottom of the ocean proved a temptation too big to resist.

Allegory and Loss

For many Haitians, everything he [sic] *sees, the*
trees, the rocks, even foreign journalists,
are merely the pale reflection of a real world
which is alive beneath us, under the sea.

DR. JEANNE PHILIPPE, 1994[1]

ITH modernity, then, the legend of Atlantis finally acquired a life of its own, displacing its original symbolic intent with a rewritten version where the moralistic elements became secondary to the fantastic ones. That the late nineteenth century was so taken with the search for the lost kingdom of the sea is perfectly consistent with the kind of scientific inquiry, often a veiled form of neocolonial expansion, that characterized most of its archaeological expeditions. Yet what makes Atlantis infinitely titillating is the romantic stamp of its elusiveness: Atlantis represents the impossible quest, modernity's Holy Grail or Fountain of Youth—the kind of fugitive fetish on which a time's emotional panorama is figuratively inscribed.

1. As quoted in Howard B. French, "Is Voodoo the Weapon to Repel the Invaders?" *New York Times*, June 24, 1994, p. A4.

Loss is the main motif of the modern Atlantis: loss not of riches or knowledge, but of the very materiality of this ancient civilization. Such an obsession with what is no longer there—and possibly never was—points straight to the tortured spirit of this era. In its continuous search for a supranatural essence that could grant a divine dimension to our precarious humanity, Romanticism's mix of fantasy and pragmatism (for example, the legitimation of the Atlantis myth by way of scientific research) would strike as uncanny were it not that it so clearly represents the dilemma of the nineteenth century. Having forfeited a meaningful connection to the traditional and theocentric culture that preceded it, this culture elaborated a new mode of signification from the same modernization that brought about its radical change.

Incapable of fully endowing industrialization with transcendental attributes (this would be the task of the twentieth century, when commodity fetishism prevails), the 1800s desperately sought meaning in the realms of experience that were quickly disappearing: nature, agelong traditions, and the mythical. In this way, what disappeared was idealized as containing an essence whose appeal increased in direct relation to its experiential decrease. This investment of a presumed essence into an object or phenomenon is what makes them into symbols, and it is not hard to see how Atlantis, in its anecdotal condensation of both the Greco-Roman empire—the pillars, temples and togas—and the mysteries of divine (however catastrophic) intervention, could easily come to represent the golden age of Western civilization, as well as its apocalyptic demise.[2]

Made static and glorified, the experience of loss has been replaced with a symbol of what is being lost. This denial enables an evocation

2. The relation between a symbol's so-called essence and its appearance is not spontaneous. It doesn't "naturally" follow that symbols have certain meanings. On the contrary, this association is extremely conventional: the attribution of specific qualities to a sign is the result of a complicated web of social arrangements. By extension, these arrangements are valid only as long as the cultural conditions that made them possible stand. When

proper of what should be distinguished as nostalgic kitsch, often found in the re-creations of the Greco-Roman empire (for instance, in neoclassicism) as well as in the portrayals of an antediluvian, or utopian, Atlantis. A very recent example of the latter is "Atlantis," a beach resort that opened in 1995 in the Bahamas. Here, the legendary Atlantis has been stripped not only of its punitive symbolic value, but also of the signifying elements of disaster: gigantic wave, earthquakes and volcanic explosion. As in the conscious memory of reminiscence, the founding event (the myth of Atlantis, made up of a golden age and its ensuing destruction) is voided of any traumatic aspects (the deluge and sinking of the island) and frozen in a pristine state.

"Atlantis" is an example of nostalgic kitsch, embodied not in an object but in an entire experience: what "Atlantis" represents never happened in the first place, since, whether the lost continent existed or not, its portrayal without a catastrophic ending is incomplete. As such, "Atlantis" the resort becomes doubly imaginary and perfectly safe from the potentially disturbing connotations of death and destruction. Atlantis the myth can then be recovered as a commodity in the full regalia of its most pleasurable attributes—abundance and idleness—which in turn are enhanced by the atemporality proper to mythical time, commodified by "Atlantis" as vacation time—a time for relaxation. [3]

these conditions cease to exist, their concomitant cultural codes become worthless as live, meaningful entities, existing only as referents to a time past—unless they are somehow recovered in the new cultural conditions. I have chosen to use the old-fashioned terms "appearance" and "essence" (a duality that dates all the way back to Plato and his doctrine of forms) because what makes them problematic helps illustrate my argument: they convey attributed cultural values in a way that modern, "value-free" terms such as "signified" and "signifier" try to avoid. For useful analyses of how the sign works, see Umberto Eco, *A Theory of Semiotics*, and Kaja Silverman, *The Subject of Semiotics*.

3. "Atlantis" conveys its imaginary golden era through paraphernalia saturated with the most clichéd Atlantis signifiers, which the resort's brochure boldly sets forth: palm trees and columns interlaced with "a spectacular 14-acre waterscape of sparkling lagoons, grottos and waterfalls, including a three million gallon saltwater habitat" for those interested in what might be under the sea. All this surrounded by a shining ocean (a pointer

A TIDAL WAVE HITS LISBON. A deadly earthquake and tidal wave struck Lisbon on All Saints' Day, 1755, while many of its inhabitants were in church. Most of the city was

destroyed (including thirty churches) and a quarter of the population killed. Theologians debated the symbolic meaning of this catastrophe for years. *Mansell/Time Inc.*

In other words, Atlantis the myth has undergone in "Atlantis" a complicated operation whereby it basically returns full circle to its original meaning as a symbol of utopia, losing a constitutive element—Atlantis as apocalypse—along the way. This is the only possible loss that nostalgic kitsch comes in touch with: the loss of its richness as a signifier, the sacrifice of plurality or potential meanings for the sake of only one aspect. Nostalgic kitsch is a shrunken sign: it has been reduced to its most basic and benign expression. It is a phenomenon that denies both present and past in the interest of its own cravings, the only place where this kind of kitsch can firmly locate itself. Nostalgic kitsch is static, it doesn't move, it just oscillates back and forth between the glorified experience and its subject, without any transformation.

In melancholic kitsch, on the other hand, the passage of time is fundamental, precisely because it is the transitoriness of all things, the continual flight of life into death, that seduces this sensibility. Consequently, for melancholic kitsch the temporal dimension, represented as narrative, shapes the spatial one into a three-dimensional scenography—a diorama, snow globe, aquarium, or submerged civilization—where time, however suspended, is the underlying motif. It is through this peculiar spatio-temporal axis that the nineteenth century registered the saga of its existential loss.

The process at work in melancholic kitsch is equivalent to that of the souvenir: it is the process of allegorization. With modernity, the souvenir is disintegrated as such and reintegrated into a commodity, all the while looking back at the crystallized remembrance that gave it birth. Similarly, allegory moves towards the constitution of a narrative based on a symbol's disintegration, simultaneously erasing and anecdotally main-

to the riches under the sea, which the brochure promises via sparkling silver stars on the crests of the waves) and constant reminders of the place's legendary quality—its main selling point; at a cost of $250 million, this is one of the most expensive renovations for this kind of resort.

taining that symbol's primary meaning. Once a symbol, Atlantis became
an allegory when, after the crumbling down of its original text, it was re-
constructed from its own fragments as a figure of destruction and loss.[4]
In a bizarre trade-off, by determining both the narrative and its process
of signification (the demise of Atlantis as well as that of its symbolic
mode of representation) loss inscribed a new meaning—time and death,
that is, history—on a story that until then had been devoid of specific
temporal associations. In becoming historical, Atlantis loses its former
status as myth, gaining a new one as a tangible cultural artifact, as we
shall soon see.

The allegorical takeover of the symbol does not replace one hierarchy
with another, but rather displaces that attribute of essence which for so
long bound things—as well as people—to origin instead of history.[5] Al-
legories' peculiar dismantling and reconfiguration of symbols enable
them to carry out a powerful demystification, potentially providing a di-
alectical image. In this sense, allegory may be considered an operative
mechanism in melancholic kitsch, since it is through allegorization's re-
constitutive process that one can understand how, after having been
emptied and frozen by commodification, unconscious memories can still
emerge with new meanings.

Allegories are produced during times of crisis, when social standards
and conventions break down. Such a reconfiguration of signs seems to go

4. My discussion of allegory and later of ruins as representative of allegory is inspired by
Walter Benjamin's understanding of allegory, as set forth mainly in "Allegory and Trauer-
spiel," *The Origin of German Tragic Drama*, trans. John Osborne (London: New Left
Books, 1977), pp. 159–235; and in his "Central Park," *New German Critique* 34 (Winter
1985): 32–58. Craig Owens's discussion of allegory as topography was also very influential
on my vision. See his "The Allegorical Impulse: Toward a Theory of Postmodernism," in
Brian Wallis, ed., *Art After Modernism: Rethinking Representation* (New York: New
Museum of Contemporary Art, 1984), pp. 203–35.
5. I espouse an experiential as opposed to an essentialist position. As regards people, es-
sentialism privileges intrinsic attributes, such as gender and race, while an experiential ap-
proach holds that lived experience is equally determinant in someone's life, if not more so.

PARIS UNDER WATER. From L. Sonrel, *Le Fond de la mer*, 1870. A nineteenth-century speculation on the eventual rise of the sea level. *Science, Industry and Business Library, The New York Public Library, Astor, Lenox and Tilden Foundations.*

hand in hand with major cultural transformations, new realities requiring a whole new language through which to be conceived of, perceived and represented.[6] Because of its fragmentariness and mobility (it does not get attached to meaning in the exclusive way that symbols do) allegory is extremely appealing to transitional moments. Most importantly for modernity, allegories are inherently connected to loss, since their whole signifying premise is based on the futile attempt to recover something lost. It is during this failed enterprise that allegories produce a new layer of signification, one that only alludes to the original, symbolic meaning in a tangential way.

The allegorical dissolution of the symbol is relative when compared with the absolute mutilation perpetrated on experience by nostalgic kitsch. In nostalgic kitsch certain meanings are forced out without any attempt to recover them (not even marginally, as a backdrop for the fantasy), while in melancholic kitsch the allegory maintains the symbol as a reference to which it constantly, though obliquely, alludes. In the legend of Atlantis, as discussed above, the allegory comments on the limitations of utopia while simultaneously drawing the picture of its fall: it contains both what is being lost and the reason for its passing away. As long as a plurality of meanings is kept in sight (transitoriness, permanence, myth, reality) the kind of signification that takes place is complex and mobile, allowing dialectical tension.

In true allegorical fashion, the impossibility of recovering what is lost only exacerbates the efforts towards its achievement and, since the desired goal is extremely elusive—loss being a form of escape—the search is guaranteed as a permanent condition.[7] It is through this hopeless search that loss becomes commodified, made to substitute for the real thing through the sheer quantity of books and other Atlantean parapher-

6. Benjamin first studies the allegory in the German Baroque, the period of the Counter-Reformation. See "Allegory and Trauerspiel."

7. See Joel Fineman, "The Structure of Allegorical Desire," *October* 12 (1980): 46–66.

nalia. What first betrays this melancholic sensibility with regard to the Atlantis myth is the obsessive quest to relive the impending loss of the present through a decayed remembrance of its mythical past. If kitsch is the residue of an aureatic dream, of which it eloquently speaks through the commodified ruin of the souvenir, then nineteenth-century Atlantis, a glorified fragment of the experience of loss, commodified in a futile yet overabundant production, is intrinsically kitsch.

Narrative loss by itself is not strong enough to override symbolic meaning, however. In fact, catastrophe and loss could very easily be placed alongside the previous meanings of utopia and chastisement as part of the allegory's mythical content, becoming an integral part of Atlantis' aura—that intangible quality which, representing the pre-modern past, envelops objects and events with a magical intensity. As such, Atlantis would once again be subject to symbolic reappropriation (loss now representing punishment) and the ensuing nostalgic commodification, where catastrophe and loss would be enshrined as independent events, disassociated from the allegorical process of transition and change. Atlantis is saved from this cultural preemption by an aspect of allegory that reinforces the legend's "ruined," or residual, capacity in a non-anecdotal (and even nontextual) way, pointing to how the Atlantean allegory is produced rather than to its narrative elements.

As discussed before, allegories are not autonomous but rather derivative, stemming from a previous body of meaning—the symbol—to which they remain anecdotally connected. Dethroned, the symbol's primary meaning is relegated to a peripheral status; however, as a devalued text, it provides the basis for allegorical meaning, which then adds its own layer of signification, enabling a dialectical reading of its predecessor. While the symbol depends on the allegory for its survival in time, the allegory is contingent on the symbol as a founding text. Like ruins, allegories need a previous text from which to unfold, although their development may unchain a series of new meanings that can ultimately render

THE BATHOS, OR MANNER OF SINKING IN SUBLIME PAINTINGS, INSCRIBED TO THE DEALERS IN DARK PICTURES. Etching and engraving by William Hogarth, 1764. An allegory of the end of the world. *Bequest of Samuel J. Tilden, Miriam and Ira D. Wallach Division of Arts, Prints and Photographs, The New York Public Library, Astor, Lenox and Tilden Foundations.*

this founding relationship incidental, as was seen in the nineteenth century's hypertrophy of Atlantean literature.

Allegories and ruins contextualize their corresponding foundational texts by placing them within the cycle of life and death, that is, within the materiality of history. While as a symbol Atlantis conveyed a fossilized meaning—glory or demise—which could be nostalgically repeated over and over again, as an allegory it piles transitory meaning upon transitory meaning like so many layers of decay, producing an excess of signification. If the symbol took pride in the depuration of its signifying process—one that, quiet, exclusive and abstract, sought to establish a unidimensional relationship between itself and what it represents—allegory is like a chatterbox that continually points to that material process on which the symbol attempts to free-ride. That appearance which you are counting on for your transcendental flight, allegory would seem to tell the symbol, is not inert but rather has a life of its own.

It is this material life that allegory rescues at the expense of symbolic meaning, and in doing so it expands, rather than lessens, the horizons of signification. Allegory brings the symbol down to earth and has been continually reviled for doing so, traditionally considered an inferior form of signification, secondary to the symbol's abstraction. Yet only as a discarded fetish can the legend of Atlantis gain the full scope of its beauty and impact, which has much more to do with the constant passing of things than with their brief moment of glory. By inscribing the symbol in time (that is, subjecting it to a continuous process of change) the Atlantean allegory prevents Atlantis from being completely lost, forgotten and left behind, or, alternatively, from being preserved as an anachronic sign—a mummy that, while escaping the ravages of time, denies its own historicity.

Temporal, residual and connected to death, ruins represent allegories figuratively. Above all, they are very graphic images, and in this capacity are superbly equipped to illustrate a phenomenon like Atlantis,

whose primary impact is visual. Atlantis partakes of the dual character of all ruins: their ability to be inscribed in both space and time. Ruins derive their spatial meaning from time in the form of decadence, their temporal signification from space in the form of accumulating debris. As such, ruins are physically able to render temporality in a way known only to living creatures. In their aging and gradual decomposition, time is indelibly inscribed, leaving its mark as on the concentric rings of a tree's trunk. Ruins speak of death and transitoriness, a loss that is present in Atlantis through the narratives of vanishment and destruction, but that in the image of its ruin becomes pictorially condensed.

Ruins are paradoxical emblems, for in their languishing things attain an unprecedented longevity, as if in this consummation they reached, like falling stars, their brightest moments. That the state of debris and decay is attractive to modernity would seem a contradiction were it not that ruins provide the historical continuity this era so eagerly attempts to erase. The inscription in time conveyed by dereliction stands diametrically opposite to the blank slate that modernity imposes on the past in the name of progress, tainting modernity with the marks of a temporality that it pretends to outsmart. Contradictorily, modernization itself produced the loss that it now struggles to compensate with the intensity of a present permanently dedicated to the future.

Modernity is a displaced time: it wants nothing to do with the past and looks only towards a future constantly receding on the horizon. Yet the past denied by industrialization continually reappears like a littered landscape next to an indifferent highway, in those residues that, fragmented and discarded, refuse to disappear, eroding and stenching the atmosphere with their inevitable decay.[8] In the same way, Atlantis rep-

8. In this sense, Benjamin's oft-quoted vision of "The Angel of History" was, like most of his work, way ahead of its time: "This is how one pictures the angel of history. His face is turned toward the past. Where we perceive a chain of events, he sees one single catastrophe which keeps piling wreckage upon wreckage and hurls it in front of his feet. The angel would like to stay, awaken the dead, and make whole what has been smashed. But

resents those aspects of civilization that somehow failed (sunken ships, abandoned buildings, decaying cosmopolises) but left behind their corpses as witnesses of both the bold attempt at breaking the barriers of time and space, and its collapse.

Atlantis is an attempt to recover a sense of history and belonging in a culture where both are disappearing. This ontological anchorage cannot be found in Atlantis as golden age, but in Atlantis as lost civilization— in those traces of time that nostalgic dreams wish to erase. The nineteenth century's allegorical spirit is revealed precisely in its disinterest in utopias, its endeavoring to collect all the pieces ignored by Western civilization in order to complete the puzzle of its unprecedented being. Dismissing a continuity between itself and preceding times, modernity could only appeal to what had been discarded from history to imagine its own secret identity, one that no scientific discovery or philosophical understanding seemed to provide.

The nineteenth century rediscovered Atlantis not as a lost paradise to dream about, but as a lost paradise to engage with in an existential way. For this simultaneously enraptured and melancholic period, Atlantis' main thrill was its sense of loss, as if Atlantis' fate somehow entailed industrialization's own failure. It is not the ideal Atlantis that the nineteenth century desperately searched for, but the abandoned one through which it could fantasize its own redemption, a redemption denied to modernity because it implies a transcendence of the materiality which constitutes modernity's being. Consequently, the Atlantis fantasy, allegorically represented in its ruin, was invaluable as a fetish—that displaced form of desire to which a subject, individual or cultural, becomes obsessively attached—and as such it was commodified.

a storm is blowing from Paradise; it has got caught in his wings with such violence that the angel can no longer close them. This storm irresistibly propels him into the future to which his back is turned, while the pile of debris before him grows skyward. This storm is what we call progress." From "Theses on the Philosophy of History," *Illuminations*, pp. 257–58.

Melancholia
Artificialis

I'll cavern you, and grotto you, and
waterfall you, and wood you,
and immense-rock you, and tremendous
you, and solitude you.

KEATS'S PREFACE TO ANN RADCLIFFE'S
The Mysteries of Udolpho, 1794

HEN, in his landmark 1854 manual *The Aquarium: An Unveiling of the Wonders of the Deep Sea*, Philip Gosse suggests that novice collectors use plaster to evoke the uneven shape of rocks, he is unwittingly alluding to a tradition that predates him by several hundred years: the saturated and "tortured" rock aesthetic of artificial grottoes, which would eventually give way to the rococo.[1] This long process of artificial landscaping, or imitation of nature, which started at the end of the thirteenth century, culminated in the fake ruins and grottoes of late-1700s fantasy gardens, moving on a few decades later to those miniature underwater scapes reminiscent of submerged cities: aquariums.

1. Second ed. (London: J. van Voorst, 1856), p. 259.

A form of decoration that inspired a whole architectural style, simulated grottoes provided a counterpoint to the light and linearity of the Renaissance's neoclassicism with their darkness and irregularity, countering the rational impulse with an aesthetic based on the sinuosity of organic form. Produced by the gradual erosion of rock by water, the convoluted shape and rugged texture of natural grottoes held the fascination of organic decomposition turned into sculptural landscape, illustrating nature's relative mode of permanence—one of constant transformation. Grottoes' somber, moist and claustrophobic atmosphere provided a unique scenario. Here, decay became imbued with the sanctity of the bizarre, unknown and secret, representing in their full glory those mysteries of nature that were so attractive to the mystical intellect of the sixteenth century. Following a long contemplative and devotional tradition, grottoes were used as meeting places for intellectuals and artists as well as sanctuaries by melancholic princes like Francesco I de Medici.[2]

The grotto aesthetic knew the same contradictions as its namesake, the grotesque, a term usually applied to ornamentation that abounds in foliage and imaginary creatures. Despite having started with paintings found in Roman caves (*pittura grottesca*), whose organic figurativity was naturally distorted by the shape of rocks, the grotesque ironically came to represent quite the opposite of what was considered natural. It stood for the bizarre and fantastic, eliciting that "divine horror"[3] characteristic of the first secular approaches to a nature which until now had remained the exclusive domain of divine—and occult—enterprise, and which would later become the object of endless scientific dissection.

Similarly, for all their apparent cult of nature, many grottoes were far from natural; fake grottoes go back as far as the thirteenth century, to the

2. See Adalgisa Lugli, *Naturalia et mirabilia: Il collezionismo enciclopedico nelle Wunderkammern d'Europa* (Milan: Gabriele Mazzotta, 1983), p. 116.
3. See Edmund Burke, *A Philosophical Inquiry into the Origin of Our Ideas of the Sublime and the Beautiful*, 1754.

Castle of Hesdin in France, whose twenty-five miles of gardens were adorned with artificial caves, the castle itself boasting a "gallerye aux joyeusetés" (gallery of amusements) where hail, snow, rain, thunder and lightning were imitated and demonstrated.[4] Grottoes were adorned in one of two styles, the mountain cave (preferred by hermit types) or the more frivolous and extravagant undersea grotto, which often included fake (or transported!) stalactites and whose surfaces were described by the Renaissance's foremost art theoretician as being covered with "perforated and gnarled objects using small pieces of pumice, or travertine sponge. Ovid called this sponge living pumice and I saw that they placed green wax there to simulate the fibrousness of a cavern covered with moss"; or with shells, producing an underwater effect: "a surface made up of various kinds of shells of oysters and other marine life, some facing out and others making a partition in accordance with the variety of their colors with very delightful artifice."[5]

Having started off as precious collectors' items because of their odd shapes and scarcity, shells were by the seventeenth century a most popular decorative element. While as rarities these polymorphic treasures of the sea had been valued for their uniqueness (which the nineteenth century promptly uniformized into careful categories and selections), as ornaments it was shells' textural irregularity that made them so desirable, since they emulated, when covering large surfaces, the porous texture of rocks, creating the imaginary interior of ocean grottoes. "Rocaille," or rock work, as decoration with shells was called, became the craze of Mannerism and took special hold in England. By the mid-1700s most noble and aristocratic households could boast a room, a wing or even a whole cottage adorned in what could be considered a kind of "Pompei-

4. Francis Bacon, *The New Atlantis,* as quoted in Eugenio Battisti, "Natura Artificiosa to Natura Artificialis," in *The Italian Garden* (Washington, D.C.: Dumbarton Oaks, 1972), pp. 1–36.
5. Leon Battista Alberti, as quoted in Battisti, "Natura Artificiosa to Natura Artificialis," pp. 31–32.

LUDWIG II WITH HIS MOTHER AND HIS BROTHER OTTO, FEEDING SWANS.
From A. Sailor, *Bayerns Märchenkönig*, 1961. The mother of King Ludwig II of Bavaria
collected everything dealing with swans, but had only severity for her son. His brother
Otto, later affected by a hereditary disease, would bark from the windows of the
Nymphenburg Palace, believing he was a dog.

VENUS GROTTO AND SUBTERRANEAN LAKE AT THE CASTLE OF LINDER-
HOF. From A. Sailor, *Bayerns Märchenkönig*, 1961. Watercolor by Heinrich Breling, 1881.
Wagnerian operas were performed here privately for Ludwig, who drifted in a shell-like
boat surrounded by swans. "He lived only for his dreams, and his sadness was dearer to
him than all life itself," said his cousin and lifelong friend Elizabeth, empress of Austria,
as quoted in Claude Arthaud, *Dream Palaces*, 1972.

ian decoration," since its combination of rocklike formations and marine motifs recalled the frescoes emerging from that buried Italian city, discovered in the late sixteenth century.[6]

The artificialization of nature that began with fake grottoes was directly related to the gradual disappearance of a whole realm of signification, that of a natural world infused with mystical attributes by either the Church, where nature represented a monotheistic divine power, or the occult sciences, whose polycentric animism was deeply embedded in popular culture. Displaced by the nascent development of rational methods of inquiry and by their pragmatic modes of operation, these views of nature made way for a new set of meanings where nature gradually became the parameter for social evolution. Once dismantled as a symbol of divine intervention, nature lost the metaphorical vitality associated with Creation, becoming a dead emblem of its former meaning. To this figurative death was added a more literal one as nature—or rather its remnants, as they were compulsively collected by the emerging fields of botany, zoology and geology—became a static illustration for empirical knowledge.

The dethroning of mystical symbolism left nature as an empty representation which, rather than signifying the eternal forces of life, literally enacted their perishability and continuous transformation. It is no coincidence that the sixteenth and seventeenth centuries saw such an explosion of natural history collections and still-life or "nature morte" art. Nature was recognized as an autonomous entity at the very moment when it stepped on the threshold of its cultural demise, admired as a phenomenon just as it abandoned the metaphysical grip of theology and headed towards the pragmatic control of scientific knowledge. It is as

6. On shells and rocaille, see Patrick Mauriès, *Shell Shock: Conchological Curiosities*, trans. Michael Wolfers and Ronald Davidson-Houston (New York: Thames and Hudson, 1994) and Barbara Jones, *Follies and Grottoes*, 2nd ed. (London: Constable, 1974). On the connection between Pompeii and grottoes, see Mauriès, *Shell Shock*, p. 50.

if the threat of modernization forced nature—and the magical universe it once stood for—to seek refuge in the eschatological folds of allegorical representation.

Romanticism attempted to divert nature from this path by providing a scenario where nature could display its waning mystical attributes, a scenario that eventually backfired, dramatically enhancing the cultural transformation under way. Refusing both theocentric and agnostic stances, Romanticism surfaced in the 1800s as a reaction to the loss of the mystico-natural realm, which it resurrected under a guise more appropriate to its anthropocentric philosophy: nature became synonymous with human emotions, in particular with Romanticism's burning desire for a lost sense of transcendence. Rather than a passive object of scientific interest, nature again became an active subject alive with feelings, offering a secular model of divine perfection.[7]

Romantics looked up to the stars, around to the forests and rivers, below to the caves and ocean depths, seeking in all manifestations of natural power a universal correspondence by which to affirm the formation of their secular identity. Fascinated with the occult sciences, whose analogies between nature and the universe infused their keen sense of mortality with cosmic meaning, Romantics also reveled in the mysterious sensations invoked by darkness and decay, favoring the staples of a neo-Gothic sensibility: grottoes and all sorts of natural disasters as well as abandoned castles, churches, dungeons, cemeteries and shipwrecks—in short, any available ruin. These were eagerly incorporated into a paganistic pantheon of death that attempted to substitute the cultural anxiety over material perishability with a supernatural experience.

7. On Romanticism and nature, see Albert Béguin, *L'Âme romantique et le rêve: Essai sur le romantisme allemand et la poésie française* (Paris: Librairie José Corti, 1939). On the Romantic return to medieval philosophies, see Clément Rosset, *L'Anti-nature: Éléments pour une philosophie tragique* (Paris: Quadrige, 1973). Thanks to Josefa Salmón for providing this last reference.

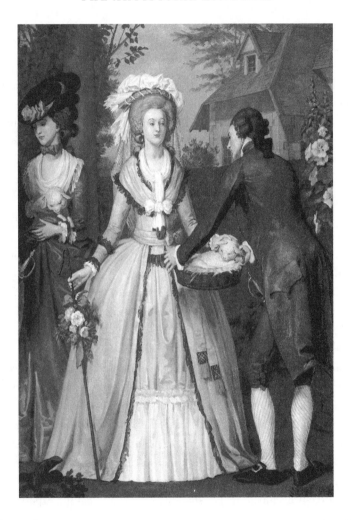

MARIE ANTOINETTE AT THE HAMLET. Alfred Cox, nineteenth century. Bored by court etiquette, Marie Antoinette sought to escape her royal imprisonment in fantasy worlds such as her hamlet, which included nine thatched cottages, a water mill, a dairy, a farm (complete with a family of peasants and a few sheep and goats), an aviary and a poultry farm. Here, the queen could dress down and enjoy the "simple pleasures of life." *Giraudon/Art Resource, New York.*

CUP BELONGING TO MARIE ANTOINETTE. Supposedly molded from her own body, Marie Antoinette's "breast cup" was part of the shepherdess-queen's fantasy dairy, built for her at Rambouillet by Louis XVI. *Sèvres, Musée National de Céramique.* © *Photo RMN-M.Beck-Coppola.*

Ruins' fragmentary and decomposed state re-created perfectly the organic camouflage so fundamental to the grotto aesthetic, and as such they were for a long time its unnatural extension, particularly given the Renaissance's pleasure in artificiality and trompe l'oeil.[8] More than as a naturalization of artifice—the organic takeover of abandoned architecture—ruins entered the grotesque realm as the fabrication of nature, sought after for their successful imposture as rocks. As natural ornaments, ruins immediately gained that final degree of inertia associated with all artifice. Nature was turned into a petrified version of itself and ruins were rendered into second-rate signs, imitators of life—or, more appropriately, of still life, a form of death. It was a dramatic case of "melancholia artificialis"—the longing for artifice.[9]

As models of ideological purity (or even better, the lack of all ideology) nature and ruins were therefore redeemed wholesale in the nineteenth century, but as ornaments they were decried as kitsch. This literal (as opposed to figurative) association of artifice with death is the counterpart of the assumption that nature, because of its life-giving qualities, is also authentic and transcendental, while artifice—and all of culture, for that matter—must be counterfeit and superfluous, since it intervenes in the raw materials of nature, investing them with extrinsic meaning. Such use of nature as parameter of legitimacy and grantor of cultural value ignores that human perception is by definition artificial, requiring the translation of nature into culture—the symbolic conversion of things into representations—in order to understand and act upon the world. Rather than fake or deadly, all artifice (and therefore both the symbol

8. On the play between ruins and grottoes in the late Middle Ages and early Renaissance, see Battisti, "Natura Artificiosa to Natura Artificialis," pp. 29–31.

9. Achille Bonito Oliva uses the term "melancholia artificialis" in his discussion of Mannerism. See *L'ideologia del traditore: Arte, maniera, manierismo* (Milan: Feltrinelli Editore, 1976), p. 17. Thanks to Nelson Brissac Peixoto for the gift of Bonito Oliva's book and for having encouraged, more than a decade ago, my work on kitsch.

THE RUIN IN THE PARK OF BETZ. Engraving from A. L. J. de Laborde, *Description des nouveaux jardins de la France, et de ses anciens châteaux*, 1808–15. The Ruin of Betz was built in 1780 by Hubert Robert. Ruined castles were a favorite among builders of false ruins, and often figured in landscape paintings. *General Research Division, The New York Public Library, Astor, Lenox and Tilden Foundations.*

and the allegory, in their increasing degrees of cultural elaboration) must be seen as "second nature": a sophisticated production of meaning specific and integral to society.[10]

The modern fascination with ruins may be traced back to a bizarre landscaping fashion that took place between 1770 and 1790 in English and French gardens, and whose remnants may occasionally still be seen today. This was the construction of "follies": life-size monuments of diverse historical periods and cultures, among which fake ruins counted as an obligatory fixture. Also known as "psychological gardens," these fantastic miniworlds attempted to unite nature and culture in a peculiar embrace that commodified the former, rendering the latter into an icon of itself: as forests, lakes and caves became objectified, "follies" turned into scenarios where personal fictions could unfold.[11]

Within fantasy gardens, the fake ruin (usually the "remnants" of a Greek temple or Gothic church) was but a contributing element in a universe that inadvertently sought to reproduce the West's view of history. It stood largely as a symbol of tradition, even if a tradition that, given its deteriorated state, might be felt as in decline. Despite the irony of being a produced ruin, the fake ruin conveyed a sense of awe towards the monuments of humankind, which were "quoted," so to speak, in order to provide a condensed panorama of civilization. As such, fake ruins represent nostalgia for a cultural situation whose continuity was threatened by a burgeoning modernity. It is no coincidence that fake ruins sprouted just at the time of the French Revolution and on the eve of industrialization:

10. On Walter Benjamin's ideas regarding the transformation of nature into culture, see Buck-Morss, "Natural History: Fossil" and "Historical Nature: Ruin," in *The Dialectics of Seeing*, pp. 58–77 and 159–201, respectively. On second nature as a new nature (or how the artificial becomes natural), see Bob Hullot-Kentor, "Introduction to Adorno's 'Idea of Natural History,'" *Telos* 17, no. 2 (Summer 1984): 97–110.

11. For a history and discussion of one such folly, see Diana Ketcham, *Le Désert de Retz: A Late Eighteenth Century French Folly Garden* (Cambridge: MIT Press, 1994); for other examples, see Claude Arthaud, *Dream Palaces* (London: Thames and Hudson, 1972).

they indicated historical transformation at a moment when the speed of events disabled such temporal perception, a perception that, on the other hand, the nobility needed desperately to deny.[12]

Fake ruins and fantasy gardens may also be seen as a pre-Romantic reaction to that forebear of modern divisiveness, the Age of Reason or Lights, during whose serious reign they appear and which, in their fantastic capacity, they seem to openly mock. However, rather than questioning or directly commenting on the time when they were created, fake ruins attempted to evade it altogether, transporting their producers and admirers to the higher reality of all decaying monuments: the transcendence of civilization, symbolized in the remnants of its creations.[13]

Fake ruins, then, have the possibility of either emulating or parodying their referents. Which one prevails is contingent on the peculiar practice to which these ruins are submitted and on the cultural strength of what they reproduce. In the case of fantasy gardens, as seen before, fake ruins nostalgically evoke a past in which their creators still ardently believe. This belief undermines the parody and reasserts the original meaning with double strength, since, despite fake ruins' temporary suspension of the hierarchy between reality and representation, symbolic meaning is ultimately reasserted.

12. See Phillipe Junod, "Future in the Past," *Oppositions* 26 (Spring 1984): 43–63. To ensure the West's chronological and totalizing sense of historicity (one that establishes a progression from barbarism to civilization), garden scenography also included tokens of less sophisticated social conditions, such as dairies or chicken farms. Perhaps the most famous of these is Rambouillet, where Marie Antoinette played shepherdess with her friend the princess of Lamballe, spending entire afternoons in the shell-lined cottage whose humble external appearance was as misleading as that of its disguised inhabitants, a detachment from reality that would soon cost the two royals their heads. See Arthaud, *Dream Palaces*, pp. 191–92. The modern sensibility for ruins was very much influenced by Giambattista Piranesi's Roman "vedutes," or vistas, where classical ruins appear both overtaken by nature and fused with the contemporary landscape of that city.

13. Fake ruins often refer back to temples or are simply generic. The ruin of Le Désert de Retz, however, is an exception: being the broken base of a column, it implies a temple of gigantic scale. See Ketcham, *Le Désert de Retz*, p. 21.

MUTILATION OF THE PRINCESS OF LAMBALLE'S CORPSE. Marie Antoinette's playmate at Rambouillet, the princess was so delicate she would faint upon smelling a bouquet of violets. On September 23, 1792, she was given over to the mob by the Revolutionary forces, who hacked off her head with an ax, crowned it with roses and displayed it on the end of a pike in front of Marie Antoinette's prison, to the queen's horror. *Musée de la Ville de Paris, Musée Carnavalet/Lauros-Giraudon Art Resource.*

Like the beach resort "Atlantis," fake ruins illustrate how the simple hollowing out of a symbol's meaning lacks the capacity to subvert it, but instead allows it to recede into its previous signification. If the fake ruins of fantasy gardens give the momentary impression of parodying the West's veneration for its monuments of the past, this impression soon gives way to the realization that, more than mere ornaments—empty signifiers of anachronistic emblems—these ruins are bona fide representations of the classical tradition so esteemed in this culture. No matter how fake, fantasy garden ruins' remitment to classical antiquity (both of the West and of an interpreted Eastern tradition) leaves them in an imitative rather than a dialectical position. It is only when these ruins undergo their own demise—the true subjugation to the passing of time—that they gain the necessary perspective to "speak" of their cultural period and its anxieties.

Ruins replace the abstract totality of historical progression—the inscription of an event in the context of chronological continuity—with the concrete fragmentation of historical decay. In them, the continuum of time is materialized by a transformation in space. This shift from time to space, and unity to dispersion, makes the mythical memory concrete, as it abandons the sphere of intellectual cognition for that of sensorial perception—something akin to how photographs "capture" moments whose temporal evanescence is emphasized by their transcription to a spatial register.

Despite their deteriorated state, however, classical ruins can easily forgo their implications as memento mori. In their nostalgic allusion to an antiquity whose ability to survive supersedes its temporal transitoriness, classical ruins transform their decrepitude into a statement of endurance, making of their resilience a form of transcendence. Watch how we still stand despite all the ravages of time, they seem to claim. Exuding cultural authority, classical ruins appear to be not so much leftovers of bygone eras as their testimony. In looking at classical ruins, we see

past them into the tradition they stood for, ignoring their present state for the sake of the symbolic glory and universal value attributed them.

This denial of time is hampered in fake ruins, where the melancholia of death is exacerbated by its artificiality. Replacing natural decay with its cultural staging, artifice adds an extra layer of loss. The symbolic rendition of natural cycles is allegorically "killed" and replaced with a highly codified narrative. The process of death becomes its own representation in the fake ruin, where there is no possible cycle—only a perpetual final moment that never had a beginning.

Oceanic Architecture

We no longer doom the gold fish to an eternal
swimming mill, without the relief of shade ... in
the centre of his crystal palace we build
him a miniature Stonehenge, wherein he can
play at hide-and-seek, and enjoy a cozy
nap without disturbance, or even observation.

MRS. S. C. HALL,
"A New Pleasure. The Marine Aquarium," 1856

HILE aristocrats chose to enact their exotic fantasies in the bucolic—that is, conducive to leisure—underpinnings of the countryside, with a ruin or grotto thrown in for healthy contrast, the Victorian bourgeois went for the mysterious implications of the marine depths, a largely unknown territory that came culturally alive when underwater cables raised to the surface for repairs in 1860 brought with them starfish and coral formations, dispelling the myth of a barren ocean floor.[1]

The relative novelty of submarine exploration is almost shocking: it was not until 1872 that a truly landmark voyage of deep-sea exploration

1. Rachel L. Carson, *The Sea Around Us* (New York: Oxford University Press, 1951), pp. 37–54.

took place, lasting three and a half years and collecting 4,417 species of animals and plants.[2] And, although the *Challenger*'s finds filled fifty large illustrated volumes with details on seawater, marine life and submarine geology, this still provided a very limited view of ocean life, since samples could only be collected at the time by way of "dredging"—dragging a huge bag through the bottom of the sea.

How to get, and stay, under water was a major challenge for centuries, most underwater activity being limited to "breath-holding" diving, usually for food and products such as sponges and pearls. The oldest recorded underwater glimpse was taken in the fourth century B.C. by Alexander the Great, who, according to the medieval manuscript *Le Roman d'Alexandre*, was "swallowed by the sea" in a large glass barrel where he saw men and women running after fish and "a fish so big it took three days to pass the submerged conqueror." Alexander's conclusion upon surfacing was utterly pessimistic: "Sir Barons, I have just seen that this whole world is lost and the great fish mercilessly devour the lesser."[3]

Alexander's real or imaginary feat would not be equaled for almost two thousand years, until in 1538 a diving bell containing two Greeks and a lighted candle was lowered in front of thousands of spectators in Spain. Its success initiated a slow-spreading use of glass bells to seek sunken treasures; and in 1691, one year before observing the comet named after him, Sir Edmund Halley patented a wooden diving bell. Never tiring of exploring the regions above and below, Halley also offi-

2. Joseph J. Thorndike, ed., *Mysteries of the Deep* (New York: American Heritage Publishing Co., 1980), pp. 298–300.

3. See ibid., pp. 54–83. The legendary underwater sojourn of Alexander III, the Great (356–323 B.C.), was supposedly invented or repeated by Ethicus in the fourth century A.D., and expanded in *Le Roman d'Alexandre*, a French vernacular poem of the twelfth century, and *La Vrai Histoire d'Alexandre*, in the thirteenth century. See the article "Diving, Deep-Sea," in *Encyclopaedia Britannica* (Chicago: William Benton, 1971), vol. 7, pp. 507–10 (Jacques E. J. Piccard); and "Submarine," *Encyclopaedia Britannica*, vol. 21, pp. 335–43 (Stephen Wentworth Roskill).

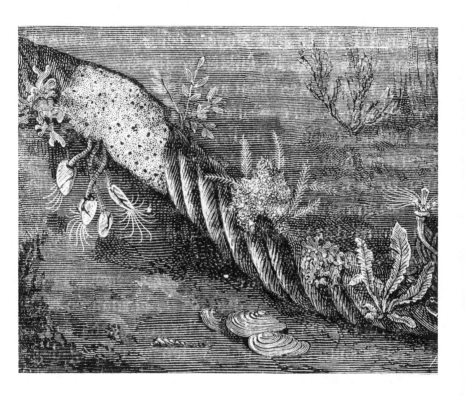

<small>Underwater telegraph cable. From L. Sonrel, *Le Fond de la mer*, 1870. In 1860, a telegraph cable raised from a depth of about 1,000 fathoms near Sardinia was laden with marine life, dispelling all doubt that life could exist below 300 fathoms. *Science, Industry and Business Library, The New York Public Library, Astor, Lenox and Tilden Foundations.*</small>

cially invented a method of renewing the air inside diving bells, commanding from 1698 to 1700 the first scientific sea voyage.[4]

Diving bells' lack of mobility doomed them to be abandoned in the search for adequate underwater gear. They were replaced by experimental diving suits and submarines, neither of which was successful until the 1800s, in the wake of tragic stories of drowned or suffocated pioneers. Even though Leonardo da Vinci had drawn sketches of both diving helmets and a submarine around 1500, only in 1837 did the diving system improve substantially with Augustus Siebe's "closed suit" model, and it still took several decades for the dangerous "rapture of the deep" (nitrogen narcosis, which can cause paralysis and even death) to be effectively dealt with. These discoveries opened the way for the gradual development of the "self-contained underwater breathing apparatus," or scuba, which would be perfected in the twentieth century and made internationally popular by Captain Jacques-Ives Cousteau. As for submarines, several models were attempted beginning in the late sixteenth century, including the *Nautilus,* created in 1800 by the inventor of the steam engine, Robert Fulton, but it was not before the mid-1800s that a submersible craft was successfully deployed, unfortunately for war.

DIVING ARMOR. Although it was patented in the United States in 1830, there is no record that this oversized snorkel for underwater exploration was ever built. *General Dynamics Corporation.*

4. James Dugan, "Man Invades the Sea," *World Beneath the Sea* (Washington, D.C.: National Geographic Society, 1967), pp. 29–48.

Until the second half of the nineteenth century, then, no one had a clear idea of how the ocean bottom looked; or rather, ideas were the only thing anybody had, accounting for the infinitely enigmatic and fanciful status of the underwater realm. Consequently, the ocean—and its domesticated emblem, the aquarium—became a perfect site for the projection of interiority so characteristic of Victorian culture. Seeking to take refuge from the violent reconstitution of the public sphere in the private one, the leisured European middle classes made a gesture quite opposite to that of their aristocratic predecessors, who had created picturesque exteriors to evade the claustrophobic atmosphere of the courts' inner world.

Like the fantasy gardens before them, aquariums provided a unique combination of human-made and natural elements, creating a highly artificial atmosphere where both were rolled into one. Originally, stones had been used to hold down plants and to allow fish to rub against them or hide in their crevices. These practical purposes promptly gave way to decorative urges, however, which started quite modestly with the creation of miniature columns, arches, and the popular cromlechs—two upright pieces supporting a third on their top. Soon considered indispensable, submerged terra-cotta castles and arches as well as lighthouses, swans and even Swiss chalets became an extension of the "Alpine rockery" or "rockwork" that, made with Roman or Portland cement, provided a "picturesque" imitation of rocks.[5] Branching out from the grotto aesthetic where ruins, as ersatz rocks, had become an integral part of the organic landscape, the artificial ruins of aquariums created an underwater scenario of decrepit castles, half-fallen towers and mossy palaces that took to an unprecedented degree the sense of enchantment proper to all ruins.

5. The terms in quotation marks are taken from the popular aquarium manuals of the 1850s. Outstanding among these are Philip Gosse, *The Aquarium*; Shirley Hibberd, *The Book of the Aquarium and Water-Cabinet; or, Practical Instructions on the formation,*

AQUARIUM DISPLAYS AT THE 1900 PARIS EXPOSITION. From *Scientific American* Supplement, Vol. 50 (January–December 1900). Built in 1878 and extremely popular since 1894, the Parisian aquarium featured a replica of a wrecked ship as well as the vision of "sirènes," the latter achieved through the ingenious combination of an

electric moving belt that transported the mermaids in both directions below and behind the glass cases, reflecting them onto the aquariums through a mirror at a 45-degree angle. *Science, Industry and Business Library, The New York Public Library, Astor, Lenox and Tilden Foundations.*

Aquarium manuals were cautious about the extent of such ornamentation (after all, the main mission of these "mimic oceans" was supposedly to educate), often urging their readers to use both organic and artificial matter in a natural and elegant way, which of course was open to ample interpretation. Such containment would not last for long. "In an evil hour," as William Alford Lloyd, superintendent of the Crystal Palace Aquarium at Sydenham, put it in that institution's 1871 official handbook, fantasy took over both private and public aquariums. The Hanover and Paris aquariums were fitted as grottoes, with "rockwork outside tanks, projecting from walls, suspended from ceilings and rising from floors." Worst of all, despite being dirty and dangerous, the exhibits seemed to immensely gratify "inartistically educated lifes."[6]

What may be seen as a representation of melancholic loss, with ruins enabling the atmospheric rendition of a floating sensibility, was read by many as an ignominious loss of something equally elusive: good taste. From their very inception as aquarium décor, artificial ruins were the subject of heated commentary, for being superfluous and, above all, for daring to imitate nature, as had happened a few years earlier with the Crystal Palace. And, although the attack on artifice can be traced all the way back to Plato's founding dismissal of appearance, it had its most prominent nineteenth-century spokesman in the influential art critic John Ruskin. Attuned to the natural theology of his time—to which the

stocking, and management, in all seasons, of collections of fresh water and marine life (London: Groombridge and Sons, 1856); Henry D. Butler, _The Family Aquarium; or, Aqua Vivarium, a "New Pleasure" for the Domestic Circle: Being a Familiar and Complete Instructor upon the subject of the construction, fitting-up, stocking, and maintenance of the Fluvial and Marine Aquaria, or "River and Ocean Gardens"_ (New York: Dick and Fitzgerald, 1858). See also Mrs. S. C. Hall, "A New Pleasure. The Marine Aquarium," _The Art-Journal_, May 1856, pp. 145–47; and C. O. Morris, "The Balanced Aquarium," in _Pet Fish and Home Aquaria: A Collection of Newspaper Clippings and Magazine Articles compiled and arranged by the staff of the New York Public Library_ (1856–1932).
6. W. A. Lloyd, _Official Handbook to the Marine Aquarium of the Crystal Palace Aquarium Company (Limited)_, 6th ed. (London: The Company, 1874), pp. 21–24. Nature,

popular study of natural history paid due respect, considering natural wonders to be such because they reflected the hand of the Creator—Ruskin wrote extensively about the ethical qualities of an art that was true to natural forms, declaring all artifice false and therefore not only bad art but also immoral.[7] A few decades later Hermann Broch would use a similar premise to lay the grounds for a wholesale rejection of kitsch, affirming that its imitative impulse brands kitsch as inauthentic, reducing it to simply seeking truth effects instead of truth itself.[8]

The artificial ruins of aquariums tested these waters in the mid-1800s with predictible consequences: they were a huge popular success. The first Havre Exhibit of 1867 looked like Fingal's Cave in Scotland, and in the second, half the interior was made to "imitate the Israelitish passage of the Red Sea on dry land, the ceiling being modelled to resemble high over-arching waves suddenly arrested in their progress and walled up on each side; the other half is an imitation of a stalactitic cave. . . . Between them rises what seems to be, but is not, a mass of coal left to support the ceiling of an imaginary mine, and externally the building is made to look like a great stratified rock."[9] United by their common element—rocks—aquariums and the emerging field of geology choreographed an "oceanic architecture" that cranked out "geological grottoes that can teach no geology, a blue grotto of Capri, illuminated at a wrong place and with spectators at the wrong end, stalactites lighted with coloured flames, ruined Gothic arches, and many other conceits."

Lloyd, like other aquarianists of the time, was beside himself, although few expounded on the topic with his fervor. Quoting Ruskin,

Lloyd says, never, unless accidentally, "gives anything the character of an excrescence or deprivation."

7. John Ruskin, *The True and the Beautiful*, in *Nature, Art, Morals, and Religion* (New York: Wiley and Halsted, 1859).

8. "Notes on the Problem of Kitsch," in Dorfles, ed., *Kitsch*.

9. Lloyd, *Official Handbook to the Marine Aquarium*. All uncredited quotations in this and the previous paragraph are taken from this work.

Lloyd had two main contentions against this supposedly abominable décor: that it imitates instead of simply representing its object, and that, lacking any purpose, it is a wasteful endeavor. To support his view of how bad imitation and uselessness are, Lloyd attempted to establish that imitation leads to a sense of incongruity between reality and artifice, ignoring in this process the suspension of disbelief fundamental for artistic and fictional appreciation. The extent of Lloyd's shortsightedness is illustrated in his diatribe against what he calls mock ruins, because they "in effect proclaim falsely that time has ruined them, and as the interest of an actual ruin is due only to a knowledge of such effects of time, it is wasteful to make that which can have no other intent than the single one which has been thus carefully eliminated."

Lloyd's argument is weighed down by the same discourse that seeks to elevate it above all earthly delights, a puritanical view that disables any material or aesthetic enjoyment. What is more, this moralistic demagoguery hardly conceals one of his driving motivations: the international competition between public aquariums to be either the largest, the most beautiful or the most scientifically advanced. True, in his overzealousness Lloyd just goes to the other extreme from popular aquarianists like Shirley Hibberd, who saw fish tanks as "beads in our Rosary of homage to the Spirit of Beauty." Yet it only seems poetic justice that a turn-of-the-century reader should handwrite the following comments in the margins of Lloyd's introductory essay: "what a rigid fellow he is," and "the Crystal Palace Aquarium is as plain and unattractive as a barn." [10]

In aquariums, then, ruins' symbolic worth as testaments to cultural tradition is overridden by their most material qualities: it is on the basis of what they look like, of the feeling they elicit, that artificial ruins are

10. Shirley Hibberd, *Rustic Adornments for Homes of Taste*, as quoted in Allen, *The Victorian Fern Craze*, p. 47. As for the comments in the Crystal Palace Aquarium guide, they must have been written between the Crystal Palace's inauguration in 1871 and its burning down in 1936.

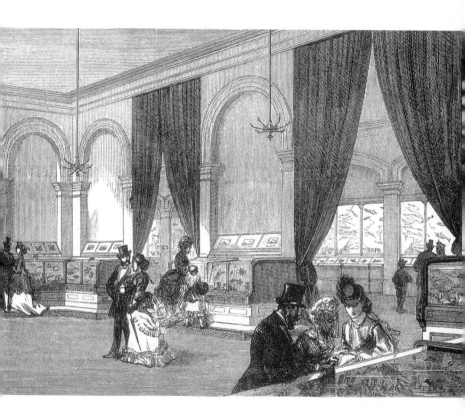

THE CRYSTAL PALACE AQUARIUM. Although it had sixty large exhibit tanks filled with 200,000 gallons of water, the Crystal Palace Aquarium left some of its visitors unimpressed: "It is as plain as a barn," someone complained. *Mansell-Time Inc.*

sought. What is most relevant at this point is not only that ruins have achieved such a degree of removal from their original referents as to become practically autonomous, but that in this process the last inkling of any essentialist notion of causality or authenticity is sacrificed for the sake of representation. Lacking referentiality or symbolism, aquarium ruins are doomed to a permanent state of incompletion, which in turn they allegorically compensate with a threefold reenactment of the narrative of loss: first as ruins, then as fake ruins and finally as artificial ruins with no real referent.[11]

Artificial ruins go beyond fake ruins. They are fake fake ruins: not only are they artificially produced, but their process of signification occurs by default (because they just happen to look like rocks they end up being the perfect aquarium ornaments) and even the secondary referent which they point to as an afterthought, Atlantis, is in practical terms nonexistent. In this sense, the derelict castles and temples of aquariums play an ambiguous role, fictionally legitimizing Atlantis while in fact repositioning it as a myth. This is perhaps why artificial ruins have such a strong evocative appeal, as their enormous popularity makes clear. What they re-create is as strong as what either the simulated or the real ruins of antiquity call forth in their symbolic capacity, if not stronger: the spuriousness of aquarium ruins triggers an experience of intense loss unavailable to those other ruins which, in their direct dependence on reality, can never be truly lost, but only misplaced in our imagination or memory.

11. As such, they are sold nowadays interchangeably as "Sunken City of Atlantis," "Fall of the Roman Empire," "Valley of the Nile," or "Worshipers of the Sun Gods," in a melange of fact and fiction topped only by their availability in either natural or fluorescent colors. (See the Penn-Plax Pet Products 1994/1995 catalog. Located in Garden City, New York, Penn-Plax presents itself as "the leading creative company in the pet industry for over 35 years." Their "Rocks and Ruins Assorted Pre-Packs" named above consist of aqueducts, the Temples of Dario, Edfu and the Jaguar Temple, the Parthenon, Caryatides, Mayan Columns and even an Olmec Head.)

A Topography of the Unconscious

[The] dominion of the senses which stretches over all the domains of my mind, residing in a sheaf of light rays within reach, is, I think, fully shared from time to time only by those absolute bouquets formed in the depths by the alcyonaria, the madrepores. Here the inanimate is so close to the animate that the imagination is free to play infinitely with these apparently mineral forms, reproducing their procedure of recognizing a nest, a cluster drawn from a petrifying fountain.

ANDRÉ BRETON, *Mad Love*, 1937

ARTIFICIAL ruins condense all the motifs of "real" ruins—catastrophe, vanishment, irreparable damage—outside the context of history, making ruins into icons and therefore producing a "style of loss." However, the allegorical impulse does not end with the replacement of the referent by its representation—however ruined—but with the transformation of artifice into second nature, both as a new, multilayered phenomenon, and as a fully integrated cultural sensibility. This condition, where nature and culture merge into one, manifests itself in a hyperstylization that, using decon-

textualization and hyperbole, ends up decorating aquariums with the scattered remnants of a fantastic city.[1]

While souvenirs crystallize an entire experience in one image, aquariums display a narrative scenography that resembles the fluid vagaries of the unconscious. As such, aquariums became metaphorical topographies of this uncharted psychological territory which only in the late nineteenth century began to be recognized as a fundamental part of human experience, and whose enormous complexity was then tentatively—and unconsciously—projected onto one of the most pictorial imageries to be found in nature, that of "the jewels of the sea." Rather than dark and threatening, the second half of the nineteenth century perceived the ocean floor as a magical garden that, slowly surfacing through underwater research and popular interest, inspired an awe which rendered it mythical—the world of dreams and childhood memories:

> We dive into the liquid crystal of the Indian Ocean, and it opens to us the most wondrous enchantments of the fairy tales of our childhood's dreams. . . . Brilliant rosy, yellow, or peach-coloured Nullipores overgrow the decaying masses, and are themselves interwoven with the pearl-coloured plates of the Retipores, resembling the most delicate ivory carvings. Close by, wave the yellow and lilac fans, perforated like trellis-work, of the Gorgonias. . . . When day declines, and the shades of night lay hold upon the deep, this fantastic garden is lighted up with new splendour. Millions of glowing sparks, little microscopic Medusas and Crustaceans, dance like glow-worms through the gloom. The Sea-feather, which by daylight is vermilion-coloured, waves in a greenish, phosphorescent light. Every corner of it is lustrous. Parts which by day were dull and brown, and retreated from the sight amid the universal brilliancy of colour, are now radiant in the most wonderful play of green,

1. The term "style of loss" is from L. Binswanger, *Melancolia e mania* (Turin: Boringhieri, 1971), as quoted in Achille Bonito Oliva's treatise on Mannerism, *L'ideologia del traditore*, p. 23. On the allegorical impulse, see Craig Owens, "The Allegorical Impulse," in Wallis, ed., *Art After Modernism*, pp. 203–35. The epigraph for this chapter was taken from Mary Ann Caws's translation of André Breton's *Mad Love* (Lincoln: University of Nebraska Press, 1987).

CORALS. 1.) *Madrepora rotulosa.* 2.) *Gorgonia briareus.* 3.) *Gorgonia reticulata.* From John Ellis, *The Natural History of Many Curious and Uncommon Zoophytes,* 1786. Ellis was one of the first to understand the animal nature of corals. *Rare Books Division, The New York Public Library, Astor, Lenox and Tilden Foundations.*

yellow, and red light; and to complete the wonders of the enchanted night, the silver disc, six feet across, of the moon fish, moves, slightly luminous, among the crowd of little sparkling stars.[2]

Two of the main fixtures of aquariums were anemones and corals, among the most impressively visual and sensorially versatile of all underwater inhabitants. Anemones' and corals' iconographic richness is enhanced by their mutational abilities—their capacity to camouflage themselves and appear as something else. When at rest, anemones let their tentacles flow freely in the water, seeming in the magnificence of their colors and forms to be maritime flowers, although in reality they are poisonous, carnivorous animals. When threatened, these expansive organisms rapidly retract, leaving no trace of their previous display, appearing instead as millenary rocks that have sat on the same spot forever. Likewise, corals look like inert matter, when in fact they are among the fastest-reproducing micro-organisms of the ocean: coral reefs are made up of their own discarded skeletons which, constantly piling, create fantastic underwater architectures.

Anemones and stony corals (also known as madrepores) even belong to the same animal group, the polyps; but while anemones pass easily for and are often compared to gems, flowers, branches and submarine forests, madreporic formations create the illusion of rocks, ruined palaces and submerged cities. In this way, maritime flora and fauna glide effortlessly into the world of artifice, where natural matter is socially reorganized so as to produce a distorted mirror of human life, a fantasy

2. M. J. Schleiden, "The Sea and Its Inhabitants," last of a series of thirteen lectures Schleiden gave on botany; first published in English in *The Plant; A Biography*, trans. Arthur Henfrey (London: Hippolyte Baillière, 2nd. ed., 1853), pp. 403–5. The American edition appeared later that same year as *Poetry of the Vegetable World* (Cincinnati: Moore, Anderson, Wilstach and Keys, 1853); the lecture quoted here was omitted from that edition. Philip Gosse uses this text to describe the imaginative view of the underwater that prevailed at this time in *The Romance of Natural History* (Boston: Gould and Lincoln, 1861).

SEA ANEMONES. 1.) *Cereus (Bunodes) coriaceus = crassicornis*; 2.) *Adamsia parasitica*; 3.) *Actina (Metridium) dianthus*; 4.) *Sagartia viduata*; 5.) *Sagartia rosea*; 6.) *Cereus gemmaceus*; 7.) *Anemonia cereus*. From *Cassell's Natural History*, 1881. Although corals and anemones are closely related, corals secrete a limestone exoskeleton, whereas anemomes do not have any rigid skeletal support.

vision filled with anecdotal narratives and bizarre phenomena. This is facilitated by the simultaneous reification of underwater creatures—literally considered things in the nineteenth century, when writers referred to them as "living objects of the sea"—and their anthropomor-

phization, which can be appreciated in the nomenclature still applied to the ocean floor, a term that itself indicates a spatial configuration determined by cultural coordinates.[3]

Sea anemones, for example, which for a while were considered the missing link between plants and animals (the scientific term for them, zoophytes, combines the Greek roots for both) dis-

LONGITUDINAL SECTION OF A SEA ANEMONE. From Urich E. Friese, *Sea Anemones*, 1972. Drawing modified by Helen M. Friese after Keith Gillett.

played "ogre-like attributes" loaded with feminine implications: "These curiously beautiful Zoophytes... are not flowers, but animals—sea monsters, whose seeming delicate petals are but their thousand Briarean arms, disguised as the petals of a flower, and expanded to seize the unconscious victim as he passes near the beautiful form—fatal to him as

3. The bottom of the sea is seen as a continuation of the human—or mammal—anatomy (pink-hearted hydroids, redbeard and eyed finger sponges, dead-man's fingers, blood starfish), the alter ego of surface animals and social or cosmic categories (sea porks, starfish, sun stars, moon snail shells, dog whelks, sea horses, and horseshoe, hermit and lady crabs), or outright as terrestrial food and culinary implements (sea peaches, sea cucumbers, sea colanders), as well as miscellaneous objects (sand dollars, razor clam and boat shells, sea vases).

the crater of a volcano; in which he is soon engulphed by the closing ten-tacles of his unsuspected enemy."[4]

The survival skills of sea anemones as "engines of war" were only relatively rivaled by the reproductive powers of starfish, whose self-destructive tendencies intrigued aquarianists: "For sentimental perfor-mances we have the Sea Cucumber and the Starfish. Some of the former, when irritated, deliberately commit suicide by expectorating the whole of their intestines, leaving their empty shells behind. Some of the lat-ter . . . suddenly explode themselves into fragments, as though filled with gunpowder, and touched off by electricity."[5] Last but not least among the preferred cast of aquarium characters was that "stepchild of Dame Nature, the homeless 'gamin' of the shore," Rodney's kin—the hermit crab, whose domestic antics made him comparable to "a dealer in old clothes," and who "never leaves his shell except when sick, or suf-fering from impure water in a tank, or approaching death, when he al-ways vacates his borrowed house, as if he did not wish to be found 'in extremis' with stolen goods upon his person."[6]

Rather than a place in its own right, the submarine region was seen as a fabulous set where human-like dramas were constantly being played out. This happened through the isolation of certain qualities, such as color, made familiar by the use of comparisons but described with such lavishness as to render them unusual by sheer excess. Nature became artificial, a magnified version of itself, and the ocean bottom a true trea-sure trove: "the visitor to the sea-side, looking over that wide tremulous expanse of water that covers so many mysteries, would feel, like the child taken for the first time within the walls of a theatre, an intense

4. H. Noel Humphreys, *Ocean Gardens: The History of the Marine Aquarium* (London: Sampson Low, Son, and Co., 1857), pp. 13–14.
5. Butler, *The Family Aquarium*, pp. 101 and 19–20.
6. William E. Damon, *Ocean Wonders: A Companion for the Seaside, Freely Illustrated from Living Objects* (New York: D. Appleton and Co., 1896), pp. 100–106.

anxiety to raise the dark-green curtain which conceals the scene of fairy wonders he is greedily longing to behold and enjoy."[7]

A bizarre panorama made of transitional states and corporeal debris, the underwater scenario also acted as the final chapter of the rocaille aesthetic, which replicated with the perishable material of shells the callous surface of grottoes. Both illustrate the workings of culture from different angles. Rocaille was an intentional imitation of nature, a mix of organic and manufactured elements that artificially reconstructed the dense interiors of underground caves. The bottom of the ocean, on the other hand, rather than directly manifesting human action, shows the extent of cultural interpretation. A tautological panorama where death is the main signifier, madreporic formations appear to the human eye as rocks and are often mistaken for ruins. Since ruins are by definition human-made, these submarine "ruins" offer us

their organic coun-
terpart. In human ruins,
nature erases the marks of
culture, emphasizing its ulti-
mate subordination to the forces of time; in organic "ruins,"
culture gives figurative life to the otherwise inert matter of
rocks and coral formations.

An extreme example of this interplay between culture and
nature may be found in one of the nineteenth century's most
traumatic calamities and an outstanding source of submerged
ruins, shipwrecks. Substantially increased by the rise in ocean
traffic between Europe and America after the discovery of gold
in California in 1848, the recurrence of nautical accidents and
mysteries reached such critical proportions in the late 1800s
that Lloyd's of London began keeping records of all missing
vessels in 1873. Eventually reaching several thousand
entries, the number of lost ships in the initial years of
these records averaged

nine per month, with half as many by the end of the century. Although most of these vessels sunk to the bottom or ran ashore (the Strait of Magellan became the largest maritime cemetery), a seven-year survey ending in 1894 found 1,628 hulks floating in the North Atlantic Ocean, many bottom-up, others eerily wandering about as ghost ships.[8]

Littering the ocean floor, shipwrecks accidentally became part of its process of continuous stratification, a process whereby the constant falling of organic debris (fish corpses, shell fragments, dead plants) as well as the occasional manufactured remnant (anchors, ropes, nets, crafts) is comparable to a permanent snowfall that makes the bottom of the sea into a massive, always rising graveyard.[9] Furthermore, in the manner of underwater jungles, barnacles cover the carcasses of sunken ships until these become part of the rocky submarine scenario, unrecognizable as texture yet discernible in the faint traces of their straight lines from the baroque contortions of the natural realm.

Ruins that pass for rocks, rocks that recall ruins. Second nature is the realm of artifice, characterized by an ambiguity and constant crossover of constitutive elements that enables the unprecedented fusion between nature and culture just when they are veering further apart. Ironically, nature, which usually stands for what is alive and thriving in opposition to the "dead" stillness of artifice, is represented in this peculiar exchange by its most lifeless matter, rock, although even rocks occasionally undergo fundamental transformations, such as recrystallizing or

7. The quotation on pages 165–66 is from Humphreys, *Ocean Gardens*, pp. 3–4.

8. Thorndike, ed., *Mysteries of the Deep*, pp. 178–205. For the role of shipwrecks in the popular imagination of the early nineteenth century, see Alain Corbin, *The Lure of the Sea: The Discovery of the Seaside 1750-1840*, trans. Jocelyn Phelps (London: Penguin Books, 1995), pp. 234-49. Corbin's book offers a thorough study of the changing cultural attitudes towards the ocean, particularly as they are expressed in art and literature. Thanks to Dr. Leighton Taylor for pointing out this reference and suggesting how to access some illustration sources.

9. Carson, "The Long Snowfall," *The Sea Around Us*, pp. 74–81.

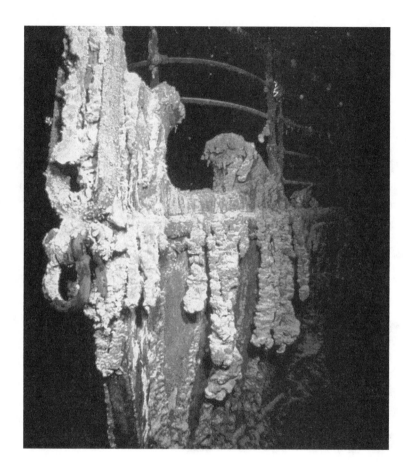

THE TITANIC'S RUSTY PROW. Covered with barnacles, the phantasmagoric ruins of the *Titanic* have become part of the oceanic landscape. Shipwrecks have littered the ocean floor with treasure and debris. © *1986 Woods Hole Oceanographic Institute.* (ABOVE)

KELP ORNAMENT. From Donald Culross Peattie, *The Rainbow Book of Nature*, 1957. Illustration by Rudolf Freund. (PAGES 166–67)

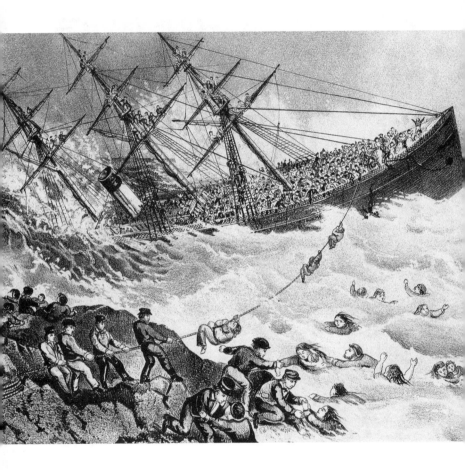

SHIPWRECK OF THE ATLANTIC, 1873. Shipwrecks were one of the nineteenth century's worst nightmares, spawning a whole genre of catastrophe art and literature morbidly fascinated with disaster. Often, people congregated on the shore to watch the rescue efforts, a spectacle considered a prime tourist attraction. *Culver Pictures.*

changing their chemical composition, in which case they are known as "metamorphic rocks."[10]

What brings together fantasy grottoes and madrepore formations is that their constructions, cultural or natural, occur through the accumulation of organic debris—shells or polyp skeletons—whose obsessive repetition mimics the uneven texture and shape of rocks. Lacking a life of their own, rocks serve in turn as platforms for both the natural architecture of anemones and corals and the social sculpturing of buildings and monuments. Yet, while submerged rocks help produce the delusive and undulating effect of the ocean floor, "dry" rocks are used to construct a straightforward and stable space. Rocks are therefore engaged in a double, and seemingly contradictory, dynamic of meaning, whereby they connote both mutability and its nemesis, permanence.

The key to this apparent quagmire lies precisely in ruins, which, made from rocks but existing in a constant state of decay, manage to condense both. For, while rocks are seamlessly assembled in monuments and buildings, conveying the steadfastness and unchangeability of all that is "solid as a rock," ruins, the crumbling of such constructions and their corresponding symbolism, return rocks to the state that culture first found them in. This secondhand fragmentariness, whereby rocks partially regain their natural state via the unmaking of cultural constructs, all the while producing new meanings (such as the transitoriness of human endeavor), places them in a new light, fully locating them, as ruins, within the domain of allegory.

It is only in allegory that rocks' role in the social quest for permanence—a desire satisfied in fossils but challenged by the transience of ruins—can be understood in its specific relationship to memory as it is commodified in souvenirs. For, in their disintegration from rigid social constructs into ruins, rocks become part of that experience of loss which

10. See "Mineralogy" in *Encyclopaedia Britannica*, vol. 15, pp. 501–11 (Donald Munro Henderson).

simultaneously contains and surpasses them. Such versatility is nowhere more literally displayed than in the elusive remains of Atlantis. Rocks' convergence with ruins establishes a metaphorical link between organicity and artificiality, further heightening the camouflagic impact of the underwater scape. Floating in the suspended time of myth and memory, the ruins of Atlantis are the perfect emblem of this peculiar connection—now a submerged city that beckons incredulous pilots from its submarine depths, now an unusual rock formation that weary scientists cannot explain.

The constant interchangeability between corals, rocks and ruins paved the way for their final allegorical mutation, making of the ocean floor an artificial kingdom that surpassed in the nineteenth century all legendary descriptions of Atlantis: "If the aquarium does not actually place us where our foot-prints may be seen among the jewelled corridors, the many-pillared halls, the shining temples, the pebbled grottoes, the incomparable gardens where time's ravages are unknown and eternity seems stamped on all that is matchless in its grandeur, it gives us, at least, a faithful copy, in little, of those enchanting scenes, for our leisurely perusal and admiration." [11] Filled with symbolic allusions, this fantastic image of the ocean floor conceived as a palace imprisoned in the aquarium is that residual piece of the aura still radiating a little of its mythical glow. Reified and commodified, this final embodiment of the Atlantis legend is not a reconstructed reality; it is a hyperreality that materializes once symbols have died and can only be rescued as icons of their former selves. It is in this final manifestation of the symbol that the importance of second nature can be fully appraised. Second nature is a new reality. It contains the traces of a former existence, but surpasses it by creating not a duplicate, but rather a distorted mirror where that predecessor dissolves to reappear anew.

11. Butler, *The Family Aquarium*, p. 11.

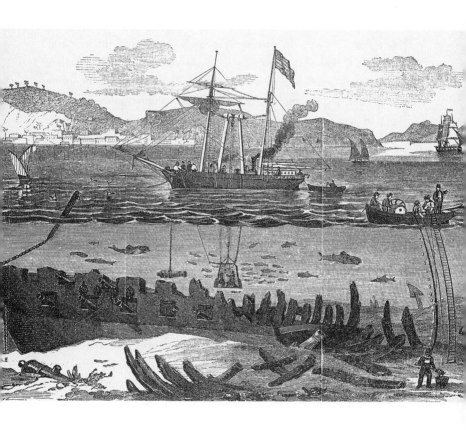

DIVERS SALVAGE THE SHIPWRECK OF THE SAN PEDRO DE ALCÁNTARA. Sinking off the coast of Portugal in 1786, this warship took down with it 128 women and men of different races, as it was carrying Peruvian prisoners from the Indian rebellion led by José Gabriel Tupac Amarú. *Culver Pictures.*

Similarly, artifice is far more than the frivolous contrivance it is often made out to be: artifice is the transformation of reality into forms that never took shape before. In achieving these fantastic states, artifice speaks as much of a restricted notion of reality as of its own limitations. Yet it still succeeds in creating the unthinkable and, in so doing, expands the realm of possibility. A basic cultural operation without which no artistic expression would exist, artifice forms a part of our experience that is so taken for granted we do not even recognize it as such. That part is our own second nature, which, merging material reality and dreams, is able to understand the language of things.

Anemones and madrepore formations constitute a loaded and baroque panorama, a place where emotions take the shape of a petrified nature that somehow keeps shifting form, a constant metaphor of itself. Kitsch is this ability to surpass essential belongings and rest in more superficial ones, to create an imaginary landscape through accumulation and camouflage, and to crystallize the continuous movement of life in the permeable disguise of fantasy. It makes perfect sense that Atlantis should reemerge as a forgotten ruin sunk in the middle of the ocean precisely in the 1850s, along with aquariums and their "still" versions, snow globes, with which the lost continent entered from that moment a permanent exchange. All three embody Western culture's irreversible shift from nature to artifice, a phenomenon that, covered with layers of longing like a margaritiferous substance enveloping an annoying grain of sand, slowly produced the extraordinary pearl of kitsch.

The Furnished Man

*The original way of living was not in a house, but
in a shell that carried the imprint of its
inhabitant. Dwellings eventually become shells.
Like no other, the nineteenth century was
morbidly attached to the home. It conceived the home
as the safeguard of man, placing him
inside it with all his belongings in such an
entrenched way as to remind us of a compass case,
the instrument set as usual with all its
accessories against deep grooves of purple velvet.*

WALTER BENJAMIN,
"The Interior, Traces," 1927-29

ANY-chambered spiral shells with pearly interiors, nautiluses are the perfect abodes for beings that like to carry their homes wherever they go, but that also like to travel at fast speeds and descend to great depths—a bit more adventure than the hermit crab's domestic spirit can stomach. A quiet life filled with daily scavengings of the ocean floor pleases hermits no end, while larger enterprises do not appeal to its sedentary spirit. Uniting the hermit's solitary roamings and the nautilus's indefatigable sailing, a fictional figure with blazing dark eyes and a

somber disposition appeared in 1870, ready to destroy the world that had abused him and to reign, uncontested, over the vast liquid domain that comprises four-fifths of the globe.

The product of a culture in transition, Jules Verne's Captain Nemo sought refuge from Western civilization in the "bosom of the waters," where he created a unique version of his time: the *Nautilus*, metaphor of a self-contained society that turns inward, like the hermit crab, for preservation while floating, like the nautilus, by the constant redistribution of gas in myriad compartments. Quiescent or erratic, hermits and nautiluses partake of a solitary bent, a tendency to withdraw and hide from view: hermits by covering themselves, their large right pincer forming a trapdoor behind which they hide and resemble a closed shell; nautiluses by preferring as they have for hundreds of millions of years the dark ocean bottom, rising on moonless nights to search for prey.[1]

Like these secluded creatures, Captain Nemo retired from the surface of the earth into the depths of the ocean, creating a man-made nautilus to serve him as his very own hermitarium. Neither mollusk nor crustacean, Nemo had no built-in carapace wherein to recede, only a private sphere where he could be the sole, or main, inhabitant. Like a voyeur wandering amidst a sea of faces, Captain Nemo found safety in the enormousness of the ocean, doubly protected from any foreign gaze inside the perfect bourgeois interior of the *Nautilus*—a home within a home. And, like those sea and land crustaceans who throughout their

1. Published in 1870, *20,000 Leagues Under the Sea* was first translated into English in 1872. I am using the complete text as translated by Philip Schuyler Allen and published by Reader's Digest (Montreal, Canada) in 1990. All references and quotations in my text are from this edition. *20,000 Leagues* was first made into a film in 1916 (Universal Studios, written and directed by Stuart Paton), making history as the first fictional film to feature extensive underwater photography. Filmed in beautiful sepia tones, it is almost impossible to follow, as it conflates *20,000 Leagues* with its sequel, *The Mysterious Island* (1875), in which Captain Nemo reappears, apparently by popular demand. Walt Disney's 1954 version (directed by Richard Fleischer in gorgeous technicolor) was this studio's first science fiction production. All cinematic references in my text are to Disney's film.

lifetime borrow shells for their transitory residence, Nemo voluntarily decided to carry his home forever on his shoulders.

This extreme domestic mobility, this readiness to pick up and transport an abode at will, confers on his character a feeling of continuous eradication, of permanent transition, a "transcendental homelessness," as it were, that cannot find peace anywhere but in the ongoing quest for a mythical hearth of which there are left only a few magical remains.[2] It is these remains that Nemo gathers in his submarine: both factual and imaginary tokens of Western culture, endowed with an extraordinary fetishistic power. In the practical context of the *Nautilus,* they are useless, ornamental at best. But without them, Nemo wouldn't have a sense of identity: the Captain's books, along with his collection of pearls and seaweed cigars, hold the essence of his persona.

Unable to find a place in modern society, Nemo reinvents the ocean depths into a home (a source of identity and a safe place for the self) that has impressed generations of readers and viewers, both in the labyrinthine intricacies and engineering feats of the *Nautilus,* which constitutes a secluded space that demarcates inside and outside—vessel and water, surface and depth, culture and nature—and in the acculturation of that quiet immensity which he treats as his very own estate. Nemo's colonizing effort produces a double transformation of that which is alien into the known, creating a niche for him in two areas that until

2. The term "transcendental homelessness" was used by Georg Lukács, in his *Theory of the Novel,* to describe the importance of time for the novel: "Time can become constitutive only when connection with the transcendental home has been lost. Only in the novel are meaning and life, and thus the essential and the temporal, separated; one can almost say that the whole inner action of a novel is nothing else but a struggle against the power of time. . . . And from this . . . arise the genuinely epic experiences of time: hope and memory. . . . Only in the novel . . . does there occur a creative memory which transfixes the object and transforms it. . . . The duality of inwardness and outside world can here be overcome for the subject 'only' when he sees the . . . unity of his entire life . . . becomes the divinatory-intuitive grasping of the unattained and therefore inexpressible meaning of life." As quoted in Benjamin, "The Storyteller," *Illuminations,* p. 99.

the nineteenth century were very foreign to human beings—the underwater realm and technology.

Nemo himself is presented as an alien being. Dressed in heavy underwater gear, he is capable of comfortably strolling the bottom of the sea; a sort of robotic humanoid, he is already somewhat of an aquatic creature whose human attributes barely coincide with ours. In this light, his unabashed submarine quest appears as only another eccentricity of this very bizarre character, whose eclectic living style—he manages to be a dilettante, a leader with military precision, an accomplished musician and a pseudoscientist, all in the unexplored depths of the ocean—fails to strike as uncanny, but rather endears him to readers, who can

ARGONAUTA ARGO, OR PAPER NAUTILUS. From *Cassell's Natural History*, 1881. Although the *Argonauta argo* and its relative, the *Nautilus pompilius*, are the only members of the octopus family that secrete external shells, these are very different. The *Argonauta*'s delicate white shell, as Madame Power first discovered, is really the protective egg case of the female (the males go around naked); the shell of the *Nautilus* (a true inhabitant of the deep which, unlike the *Argonauta*, rarely rises to the surface of the sea) is heavy and porcelaneous.

project themselves on any one of the myriad registers he so easily traverses. If not seduced by the technical prowess Nemo so proudly displays in the functioning of his submarine, one falls for either the Captain's contradictory respect for the artifacts of Western civilization or the intimate relationship he holds with the sea he claims as his family.

The ocean becomes an extension of Nemo's imagination, and the ingenious vessel in which he penetrates it is but a prosthetic device geared to facilitate all those activities denied a terrestrial being: with the *Nautilus*, Nemo can live underwater, comfortably breathing, eating and moving around at his heart's desire. This submarine is the intermediary agent that enables the dual "civilizing" task to which Nemo is obsessively dedicated: the violent destruction of the social machinery of war on the one hand, and the subjugation of the aquatic realm on the other. Nemo doesn't take refuge in the ocean to surrender his hatred, but to sublimate it in the domestication of the marine kingdom:

> The sea supplies my every want. Sometimes I cast my nets in tow and draw them in ready to break with their great draught of fish. Sometimes I hunt in districts of this element that are inaccessible to man, and there I quarry the game that dwells in my submarine forests. My flocks, like those of Neptune's ancient shepherds, graze fearlessly on the vast prairies of the ocean. I am owner of a property immense beyond the power of computation. I cultivate it myself, but it is always sown by the hand of Him who created all living things.

As part of Nemo's private domain, the oceanic fauna and flora exist only in the measure that he can reshape them to satisfy his needs. Rather than a maritime delight in its own right, his food is an elaborate imitation of European cuisine: dolphins' livers that taste like ragout of pork, cetacea milk and anemone jam. Nemo's underwater existence is a grandiose simulation of Western society: decorated in the finest Victorian style, the social spaces of the *Nautilus*, devised for the Captain's exclusive leisure, are loaded with valuable relics of high art—music, paintings, books—as well as captive specimens of that sea which he

admires comfortably from his observation room as one would regard a spectacle from the balcony of a magnificent theatre.

Through the eyes of the story's narrator, the admiring Professor Aronnax to whom Nemo proudly but partially reveals his secrets and who acts as the Captain's "socialized" alter ego, we watch Nemo with the same fascination as he beholds the sea, foreign entities observing another's habits as if in a museum display where the subject and object of spectatorship have become blurry and confused. The Captain takes the Professor on an underwater tour that travels through all three oceans, examining and collecting every kind of submarine creature—described in detail along with their full classification in Latin—and witnessing a vast array of marine phenomena in what amounts to an ambitious display of that little-known world. This panorama is cinematically presented through the enormous observation double-glass located at the front of the *Nautilus,* which acts as its eyes, and, together with the library and nautical charts located right behind it, constitutes the submarine's "brain."

Opening and closing its eyes, roaming the ocean at different speeds and angles, surfacing daily to breathe, lying down on the sandy bottom to scavenge for food or send out exploratory missions, the *Nautilus* circulates freely as an ersatz aquatic monster. As such, it catches underwater life at its most quotidian, a plentiful universe busy with the constant activity of myriad schools of fish, lit by microscopic organisms that transform the sea into liquid gold or a second Milky Way, traversed by deep rivers and currents, abundant in coral gardens, sargasso jungles and kelp forests, at times littered with the remnants of shipwrecks—or, at the shores of India, corpses religiously cast onto the sea—at others rocked by volcanic eruptions and tornadoes whose huge tidal waves

CAPTAIN NEMO AND HIS CREW TAKE AN UNDERWATER STROLL. From the original 1870 *20,000 Leagues Under the Sea*; woodcuts by Alphonse-Marie de Neuville and Édouard Riou. One of the most striking images of the story which has fascinated readers since its appearance in the late 1800s. *Corbis Bettmann.*

DECOMPRESSION CHAMBER. From Paul Bert, *La Pression barométrique*, 1878. Divers learned the hard way that the return to the surface from a very compressed atmosphere must be gradual and that sometimes decompression chambers must be used for the process. Bert's groundbreaking study included this illustration of a two-chamber cylinder showing the therapeutic effects of low pressure. *Science, Industry and Business Library, The New York Public Library, Astor, Lenox and Tilden Foundations.*

shake the placid element, occasionally convulsed by the unfriendly encounter of predators.

Like one such predator, Nemo appropriates the mythical fearsomeness of underwater foes and becomes the terror of the seas, striking warships whose few survivors are convinced they were attacked by some kind of prehistoric marine monster. Having taken to a voluntary exile as both a rejection of and a revenge on the society that humbled him and killed his family, Nemo is a bitter, solitary wolf fighting the evils of colonialism. Assisted by a loyal, however mute and mechanical, crew, Nemo repeatedly vents the fierce anger that fuels his life, ironically reproducing the same paradigm on which the system he loathes is founded: a patriarchal individualism based on invisible labor and aggression.

The *Nautilus*'s versatile identity (it is both submarine and museum, a pragmatic/voyeuristic duality that traverses the whole of the nineteenth century's production) is a metaphor for Nemo's paradoxical mission. As an instrument of mediation between two disparate worlds—the terrestrial and the aquatic—the submarine features qualities of intrusion, perusal, camouflage, adaptation and finally domination, given that its ultimate goal is to both emulate and subordinate the natural world, translating it into the symbolic language of culture so as to render it serviceable to human desire. In other words, Nemo devises the *Nautilus* in order to separate himself from the human world and to further justify his attack on it, yet he remains aloof from the underwater world he has freely adopted, ultimately submitting it to the same social exploitation he claims to despise.

This contradictory movement is the key to Nemo's ultimate homelessness: he is a man who cannot find a place to nest because he is at odds with the very culture that constitutes him. Like Nemo himself, this culture is caught between two antagonistic social orders: an organic model of evolution that lends credence to the belief in an ultimate connection between society and nature, and the destruction and eventual re-

placement of that model by an increasingly mechanized one where the symbolism of organic rootedness is untenable. A fish out of water, Nemo fiercely battles this new direction, usurping the appearance and tactics of an underwater creature, yet ultimately using this mimicry as a platform for annihilating the same world he claims to thrive on.

Captain Nemo confronts the social dysfunctionality brought upon him by capitalism (alienation, the internal estrangement that occurs when people are no longer meaningfully connected to their actions) with a violent retreat into the recesses of his mind, the bottom of a sea where only he is lord and master. In this way, he acts consistently with the order that he defies, counterposing distance with even more distance. Disconnected from any sense of belonging, Nemo seeks his self in utter isolation, furthering an already extreme deracinated condition when he turns to the outside as one gigantic mirror on which to project his desperate saga, rendering the outer world inexistent as a differentiated entity.

It is in this peculiar interface between interior and exterior that Nemo can best be appreciated, for he exercises that anthropomorphism already seen as typical of Romanticism and furthered by modernity: the interpreting of everything as a reflection of the human sphere, as furnishings of the human body or mind, a way of being that simultaneously erases and glamorizes, subordinates and aggrandizes the world in front of our eyes. Nemo can then be properly called a "furnished man," that uniquely modern specimen whose psyche is intrinsically constituted by its surrounding objects.[3] This furnished condition is a cultural state, a

3. This is a Benjaminian concept: "That which we used to call art begins at a distance of two meters from the body. But now with kitsch the world of things moves toward man; it presents itself to his touch and ends up forming figures inside him. Modern man retains within himself the quintessence of old forms; what emerges from confronting the atmosphere of the second half of the 1800s, in dreams as well as in the words and images of certain artists, is a being who could be called 'the furnished man.' " Benjamin, "Traumkitsch," *Ausgewalte Schriften*, vol. 2. This translation is a combination of several translations from the German original, one of Benjamin's most cryptic texts.

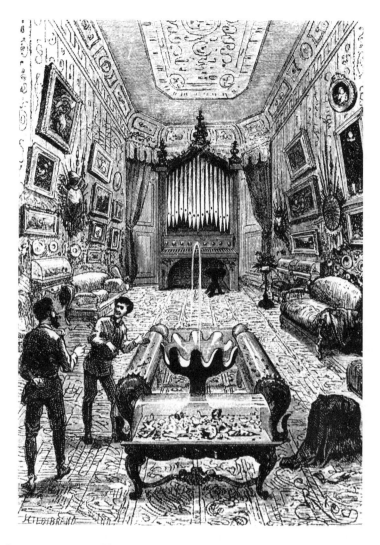

INTERIOR OF THE NAUTILUS. From the original 1870 *20,000 Leagues Under the Sea*; woodcuts by Alphonse-Marie de Neuville and Édouard Riou. Despite having forsaken the evils of civilization, Captain Nemo decorated the social spaces of his submarine in the best Victorian tradition. *Corbis Bettmann.*

change in the way we perceive ourselves, manifested in our relation to the objects around us: it consists in an inability to perceive life directly and the ensuing need to recover that lost experience from the material traces it has left behind.

In the nineteenth century, the experience of reality was made discontinuous by the repetitive aspect of mechanical reproduction, and distant by the increasing role of exchange value, becoming fragmented and arbitrary. Consequently, this period forfeited its already shaky connection to nature and the mythic, which was replaced by a materialist vision well suited to the production surplus of the middle to late 1800s. Only within the parameters of this new mode of existence could a character like Captain Nemo emerge, representing the major conflicts of his time in his contradictory persona. Nemo's obsession with containing or possessing the whole world is the logical extension of the process of reification, where something that is not material is treated as if it were. If things come to substitute for experience (that is, not only to "represent" experience, but to "contain" it in a fetishistic displacement) and human beings are constituted by their experiences—real or imaginary—then it follows that people identify with things.

That is why the *Nautilus*, besides being Nemo's uterine refuge, is also the lair where he accumulates all those things that speak to the Captain about himself. While in his collection of Western culture he sees the man he was (and still is, as his colonizing attitude makes evident), in his commodified view of the underwater through the *Nautilus*'s observation glass, Nemo sees the man he believes himself to be—alienated and dead-alive, reflected like a mirror image in the encapsuled specimens he so carefully gathers and exhibits behind glass. Outwardly aggressive and destructive, the *Nautilus* functions inwardly as a gliding secret cave replete with treasures from the emerging field of natural history, a mode of collection legitimized by the West's unparalleled quest for dominion and possession:

Under splendid glass cases, held together by copper rivets, were classified and labeled the most precious productions of the sea which had ever been presented to the gaze of a naturalist. My specialist's delight can be conceived. The division containing the zoophytes offered positively unique specimens of the two groups of polypi and echinoderms. And a conchyliologist whose nerves were not made of iron would have swooned before other more numerous cases in which were classified the specimens of mollusks. These were collections of inestimable value, and I would fain describe them minutely, but I shall spare my reader and content myself with saying that there was here spread out before me every kind of delicate and fragile shell to which science has given an appropriate name.

More than existing as a live creature, Nemo replicates in his compulsive accumulation and radical entrenchment the condition of these sea specimens he so carefully collects: a life suspended only for the pleasure of unbounded observation, although for the captain, as opposed to the captured creatures, this suspension is a voluntary one. As so many objects, these specimens become interchangeable with Nemo's tokens of Western civilization, except that the former contain within them the very notion of death which has been erased from the latter. While Nemo's collection of literature, music and art is really a consensus of leftovers, mementos of a world that is dead and now re-created as an atmosphere of leisure, luxury and accumulated knowledge, the captive specimens serve as "roadkills" whose explicit death points directly to an industrialization that uses them to advance its methods and goals. Much like the ermines' tea party and Rodney himself, Nemo's encapsuled specimens constitute an ongoing discourse on death that metaphorically represents the demise of traditional experience and its replacement by modernity: natural history, the arresting of the flow of time and life in a showcase that simulates both.

It is in this sense that Captain Nemo so accurately portrays his time; for, alienated by an industrialization that enslaved and separated him from those he loved, he attempts to recover a personal, pre-social—that

is, "natural"—paradise in the virgin organicity of the underwater realm. In so doing, the Captain is exercising an unbounded longing for a time when cultural mediation was not apparent: a pre-modern time when the supremacy of tradition lent a character of regularity to actions and events, which were perceived as natural and often compared with an organic flow: life was seen as a continuous cycle of growth and decay, seasons and years following one another in a predictable manner. Nemo's submarine is a perfect emblem of his epoch, a floating interior replenished with treasures from both above and under water, a roaming eye whose prism transforms everything it has seen into yet another fossil to add to its collection.

Nemo's underwater museum, finally, contains the two types of collection that make up a good part of nineteenth-century interiors, both private and public: first, the vestiges of a "classical" culture whose main value resides in the representation of a mode of living; and then, the prototypes of life itself, quite literally suspended. As complementary manifestations of a process of vital disruption or transformation, these two collections are bound by the same performative operation, functioning within a system of display that subordinates everything to the equalizing language of exchange. As fragments of the larger body of a collection, both the tokens of Western legacy and the natural history specimens lose their intrinsic meaning, gaining instead the extrinsic one conveyed by the acts of selection and organization. As the main signifiers of a discourse based on what is no longer there, tangential but lifeless, most of these collections' value resides in their visual and palpable presence.

Bereft of the ability to invest the material world with his emotions, Nemo would have been unable to view the marine realm as an extension of his own self. Similarly, by bringing together both the classic and the organic icons of his cultural heritage, and the technology that would eventually displace them to a secondary status, Nemo involuntarily carries out the project of modernity: the substitution of progress for

tradition; the replacement of continuity by speed and repetition; the emergence of a universe of objects that soon would prove far more engaging than the conceptual one of ideas. The *Nautilus* is a literary version of that hermit crab which, trapped forever in a glass bubble, eventually made its way to my desk. Both were made possible by the fast-paced industrialization that swept through the nineteenth century like a hurricane, dismantling the foundations of a culture that was crumbling stone by stone, sucking it up in its ruthless whirlwind and finally scattering its fragments onto a novel landscape that passionately mixed the old with the new.

A Living Tomb

*Indeed, this faculty for delusion, if I may
say so, constitutes for civilized man
an insurance against the inclemencies of fate,
as necessary as insurance against
the perils of fire and impoverishment.*

GEORG HIRTH, *The German Room*, 1880

N order to achieve the necessary conflation between himself and the submarine realm, Captain Nemo must first imaginarily break with the surface world, which he does by subjecting himself to a radical estrangement from social life and confessing to be "as effectively dead [as those] who are sleeping beneath six feet of earth." In this dead-alive condition, this transitory state that makes him float in a limbo apparently devoid of cultural parameters, Nemo attempts to reconstitute himself through an endless psychological projection, filling the sea with the affective substance he has been emptied of.

In Disney's 1954 film, the first glimpse of this mysterious character is, quite appropriately, at an underwater funeral: dressed in heavy underwater gear and enveloped in a bluish haze that suggests the sea as

much as it emphasizes the oneiric quality of this bizarre sequence, Nemo and a few members of his crew, displaying a Christian cross, carry a shrouded corpse across the marine scape. They are in the process of burying a fallen mate in a coral cemetery, where "the polypi undertake to seal [the grave] for eternity," coralline corpses in passing solidarity with human ones. The slow motion and loaded silence that envelop this episode are reminiscent of the first walk on the moon. The scene's cinematic quality is further underlined by its double spectatorship, that of the Professor and his companions, who have just surreptitiously entered the *Nautilus* and are watching the burial from its observation deck, and that of the film's viewers. All watch this scene with the fascination of voyeurs witnessing a secret ritual.

By immersing himself in the ocean, Nemo fulfills a fantasy of deterritorialization or disembodiment; in this sense, alienation can be an imaginary form of freedom, the ability to extricate oneself from the constrictions of regular life. Yet instead of converting him into a marine creature, Nemo's plunge in the sunless depths transfigures the underwater into a spectacle—a place for the taciturn Captain to observe and consume, a vast world circumscribed by his fierce gaze and redefined by his every action. Rather than as an exterior zone that is forayed, invaded or transited, remaining ultimately alien and distinct from the self, Nemo treats the ocean abyss as an interior that is intimately occupied, translated into an easy domesticity or the challenge of an individual undertaking, indistinguishable even in its most threatening moments from the subjectivity that has decided to permeate it.

The underwater realm becomes Nemo's personal aquarium, an extension of the lonely Captain's own history—past, present and future. Such an "interiorization" of the outer world renders it familiar and therefore susceptible to imaginary control. This domestication is further facilitated by Nemo's feminization of the ocean, which he sees as a complaisant mother that not only protects and nurtures him but is infinitely

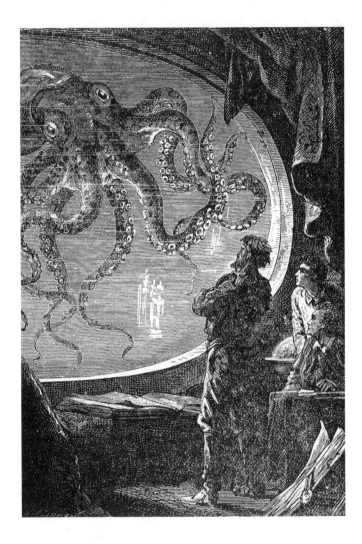

Nemo observing an octopus from the Nautilus. From the original 1870 *20,000 Leagues Under the Sea*; woodcuts by Alphonse-Marie de Neuville and Édouard Riou. The *Nautilus*'s huge observation glass enabled Captain Nemo to comfortably study underwater life at its most quotidian. *Corbis Bettmann.*

malleable to his caprices, providing him with every opportunity to act out his conflictive desires:

> ... the sea itself is nothing but love and emotion ... in her alone is supreme tranquillity, the peace that passeth understanding. The sea does not belong to despots. Upon its surface men can still exercise unjust laws, can fight, tear one another to pieces, exercise every known terrestrial horror. But at thirty feet below its level the reign of men ceases, their power disappears, their influence is quelched. Ah, my dear Professor, live—live in the bosom of the waters! There alone is independence. There I recognize no master. There I am free.

By denying the symbolic world of surface authority, Nemo seeks entry into the pre-symbolic realm of the imagination—represented by the fluid and "free" underwater matrix—where all his fantasies can be safely played out. Not surprisingly, the only factual appearance of a woman in the whole 356-page narrative is a repetitive vision of his "primal scene": the decaying corpse of a young woman, tied to the deck of a sunken ship with her child in arms, both victims of an attack similar to that which took away Nemo's wife and two children. The impact of this eerie underwater apparition is so strong that it is immediately recorded as a conscious memory, avoiding the full experiential blast: it is described by the narrator as "a scene drawn straight from life and photographed in its last moments indelibly upon the minds of us watchers."

The importance of this vision is confirmed later in the book, when we finally get a glimpse of Nemo's family precisely in a photograph, right after the Captain has completed another act of vengeful destruction on a warship and is pouring his lugubrious heart out over a pipe organ, "his preference [being] for harmonies in the minor key." His name recalling the goddess of memory, Mnemosyne, Nemo's photographic reminiscences constitute a core part of his being. As his hidden motivation, however, they remain in the netherlands of his consciousness, floating

loosely in the atemporal space of lost moments like those classical Muses who inspire men to action but lack all direct agency of their own.

Consistently, while women are encased in Nemo's mind as animating, albeit lifeless, memories, the female—or feminized—force of the sea becomes a medium for the re-creation of his traumatic loss. The ocean fills the vacuum left by the violent annihilation of Nemo's family with an underwater world which he experiences as his own unconscious. Here, he obsessively maps out and relives his emotional drama of completion and bereavement, torn between a sea which takes care of him but which is also, as for the young drowned mother, a tomb: the final scenario of his family's extinction. Like a photograph, the sea acts both as an agent of death and as the mythical repository of the last precious moment of life.

Consequently, Nemo's ocean reproduces the duality of a life-giving yet voracious mother, further complicating his already tenuous relationship to culture. Having pitted himself against the symbolic structure of social authority, he has no recourse but to turn to the amorphous versatility of the liquid element, a space whose imaginative freedom comes at the expense of the erasure, or metaphoric "drowning," of himself as a differentiated entity. Unwilling to comply fully with this maternal demand yet also tempted by it, Nemo deploys an aggressive strategy that enables him to engage with the sea on his own terms: he maintains the war machinery as a cultural anchor, with the language of destruction allowing him to weave the text of revenge and power on which he bases his oscillating sense of identity.

The compulsive and exalted character of Nemo's submarine attacks betrays this egotistic impulse, which is never quite satisfied in the annihilation of surrogate targets. What Nemo secretly longs for is his own destruction as a way of achieving in death a permanent fusion with that Mother Nature from which he, as a member of the revolutionized, industrial culture of the nineteenth century, is increasingly detached. Nemo's death wish is apparent in the risks to which he continually subjects him-

self, along with the crew and guests of the *Nautilus*. Such perils often involve yet another degree of intrusion—besides his occupation of the sea—a sort of "going deeper inside" reminiscent of psychological quests, particularly since they usually imply a fatal danger. A typical risky scene takes place in a remote underwater cave that conceals a seven-and-a-half-foot-wide shell whose mammoth pearl, the size of a coconut, Nemo is patiently nursing. Like most of the Captain's belongings, the $2.5 million treasure can be appreciated only at a distance, as is made clear when he starkly forbids Professor Aronnax to reach into the mollusk's folds. Upon leaving the cave, Nemo engages in a body-to-body fight with a gigantic shark to save the life of a pearl diver who was swimming nearby and with whom the Captain identifies in the name of "the oppressed of the world."

IDA LEWIS (1842–1913). A lighthouse keeper who saved the lives of twenty-two drowning men throughout the years, Lewis won a Congressional Medal of Honor for her feats. "Are we to believe that it is 'feminine' for young women to row boats in storms?" demanded *Harper's* magazine in 1869. "Is it 'womanly' to tug and strain through a tempest, and then pull half-drowned men into a skiff?" *Reproduced from the Collections of the Library of Congress.*

Acting as the book's narrator and Nemo's conscience—and simultaneously enthralled and terrified by the Captain's daring, as his almost comical fear of sharks portrays during this episode—the Professor's main condition for staying aboard the *Nautilus* is to respect the limitations set by the Captain. He can roam around Nemo's library and museum quite freely (these are, after all, the civilized or

Louis BOUTAN

PROFESSEUR DE ZOOLOGIE A LA FACULTÉ DES SCIENCES D'ALGER
DIRECTEUR DU LABORATOIRE DE BIOLOGIE ET D'AQUICULTURE DU GOUVERNEMENT GÉNÉRAL
INSPECTEUR TECHNIQUE DES PÊCHES EN ALGÉRIE

LA PERLE

ÉTUDE GÉNÉRALE DE LA PERLE
HISTOIRE DE LA MÉLÉAGRINE ET DES MOLLUSQUES
PRODUCTEURS DE PERLES

Figure 1. — FILLE DE LA MER (PLONGEUSE JAPONAISE).

PARIS
LIBRAIRIE OCTAVE DOIN
GASTON DOIN, ÉDITEUR
8, PLACE DE L'ODÉON, 8

1923

TITLE PAGE OF LOUIS BOUTAN'S *LA PERLE*, c. 1923. Women pearl divers on the coasts of Japan. *Science, Industry and Business Library, The New York Public Library, Astor, Lenox and Tilden Foundations.*

rational spaces), but the Captain determines what the scientist gets to see from the observation deck (Nemo opens and shuts the glass windows at will); when the two of them can engage in philosophical arguments or technical disquisitions (Nemo deprives his famous guest of the pleasure of his company for weeks at a time for no apparent reason); and, most important, how close Professor Aronnax can get to Nemo's secret motivations.

Regaling the Professor with the full benefit of a direct experience that only the unconscious can afford, on another occasion Nemo takes the *Nautilus* straight into a submerged volcano in full eruption. This feat raises the temperature of the submarine to such an unbearable degree that the poor Professor almost boils alive like a lobster, and it is the only time Nemo confesses to placing his vessel at risk. However, as the Captain's conscience, the Professor is put to sleep during Nemo's attack on a warship, an event that the meticulous scientist later unravels slowly and painfully. The second such attack, which he witnesses in full detail and which also spurs Nemo to a last suicidal attempt, finally persuades Professor Aronnax to abandon the *Nautilus*, and the fantastic knowledge adventure it provides him.

This final event takes place after another nearly fatal episode, the most extreme of them all. Soon after Nemo becomes the first man to set foot on the South Pole, declaring this territory his own with a flag inscribed with a golden *N*, nature, unfazed by Nemo's conquistador games, plays an unexpected trick on him. As the *Nautilus* speeds out of the frozen seas, an iceberg suddenly turns over and traps the submarine between blocks of ice. Surrounded by glittering crystals at nine hundred feet below the surface, the *Nautilus*'s men engage in their fiercest struggle, fighting against an indifferent nature that almost becomes, as the chapter's title warns, "a living tomb."

The situation uncannily evokes the suspended life of glass globes, with the imminent dangers of asphyxiation or petrification lurking over

the Captain, his crew and his guests as they desperately try to dig a hole through which to escape the rapidly encroaching ice and lack of oxygen. In the Professor's words,

> Half-stretched upon a divan in the library, I choked and sobbed in the early stages of actual suffocation. My face was purple, my lips blue, my faculties almost suspended. I neither saw nor heard. All notion of time had gone from my mind. My muscles could no longer contract. I shall, of course, never know how many hours passed thus, but I was conscious of the awful agony that was finally coming to me. I felt that I was dying.

Stuck in a remote, floating ice palace, paralyzed in the midst of action, Nemo comes within moments of being embedded in the frozen water, united with nature through death like those members of his crew who added their bones to the skeletal sculpture of the coral cemetery. Unlike them, however, Nemo would have avoided the ultimate metamorphosis of carnal disintegration, remaining instead a rocklike fossil, that "nieve penitente" (penitent snow) which is condemned to its solid version, unable to peacefully dissolve back into water.

In this state of permanent suspension, Nemo would have been trapped forever between who he was and what he could have become, tangibly representing in death, like a souvenir of himself, what his tortured schism was when alive. However, Nemo manages to skip this gruesome if appropriate ending, and his self-sacrificing demise in a Swedish maelstrom soon after his last fateful attack on a warship—as his conscience, Professor Aronnax, is literally ejected from the *Nautilus*—is never given as a fact, enabling the Captain to retain a mythical dimension as the narrative of *20,000 Leagues Under the Sea* comes to a close.

HERMIT HABITS

by Miss Mary Spencer, 1872

———●+)●(+●———

AN instant retreat, a constant refuge, a safe haven from real or imagined enemies, the sea conch, specifically the gastropod shell, is a convoluted residence that seems made to facilitate hermit life. Like the crab's delicate belly, this univalve has a dextral whorl: it curls to the right, fitting the hermit's body like a chitinous glove. Once coiled inside the smooth, rounded walls of this miniature spiral, a hermit can dedicate itself to investigating its surroundings at ease, knowing full well that the least sign of danger will always find it ready to retreat, and that the worst problem it can face in its daily scavenging of dead starfish and mollusk morsels is one of space shortage.

Seasoned homebodies, hermits are continually on the prowl for more suitable quarters—a shell that will provide the required room along with the necessary features of mobility and aesthetic satisfaction, with the ornamental factor sometimes weighing—literally—more than the practical one. After all, who wants to be seen in an unbecoming setting? Not the hermits, mind you, who will go through a lot of trouble to find a caracole that suits their taste, and absolutely relish the occasional anemone who gently

stations itself on their movable dwellings, exchanging its flowery beauty for the swift protection of two pair of sharp pincers in the best tradition of medieval princesses.

A big part of hermit life consists in this constant search for a better carry-on dwelling. Yet for all their attention to form, these decapods can be quite impractical when it comes to other matters. For one, never judge size by outward appearance: an enormous whelk may be nothing but a smokescreen for a tiny invertebrate who, although totally threatening and proud in this otherwise cumbersome habitat, can barely move its residence from one place to another.

Shells are for hermits discardable identities that can be taken or left at will. Free to continually change their minds on such a delicate issue as residence, hermits make the most of this condition by being very fussy about what kind of house they adopt, often establishing preference by looks rather than comfort or simple efficiency. Here, as everywhere else, crab criteria run on a peculiar track not necessarily in tandem with other live creatures. Hermits are so extremely idiosyncratic in the choosing of shells that this selection would seem almost a matter of personal taste, greatly reducing the likelihood of pincer warfare, to the delight of all those involved.

Not surprisingly, these tiny gypsies have the uncanny ability to be independent from their very source of survival: there are a lot of potential homes out there, and no hermit is tied to just one. Because they are continually growing, these crustaceans must be

careful to find spacious habitats, at the risk of getting cramped and succumbing to an infection: many a hermit has reached the end of its days for being obstinately fixated on one shell, unable to go with the flow of change and adapt to its body's requirements. Even for hermits the adage that what gives you life can kill you runs true: despite its domestic zeal, knowing when to give up an old residence (maybe passing it along to other generations of leggy shellfish) and taking on a new one can spell the whole difference between life and death for this shy *karkinos*.

As to their capacity to make good and fast decisions, well, hermits can really take their time when it comes to trying on houses. No hermit worthy of the name is going to settle for the first husk that it finds lying around: careful trials for size, fit and weight are executed in a ritual that can take up to several days full of indecision and anxious sprints between possible homes. When the new lodgement has finally been settled, the hermit is once again free to wander and engage with the rest of the world, secure in the steadfastness of this inner sanctum, at peace with the vulnerability that fates it to carry, like Atlas, the weight of its world forever on its shoulders.

For all their withdrawing tendencies, hermit crabs are not solitary beings turning their hard backs on an evil world. On the contrary: they can be quite sociable, and an excellent occasion for manifesting such gregariousness is precisely when they are looking for a new abode. Entire congregations of hermit crabs assemble for days at a time to engage in a frantic swapping—

a delirious shell game where the variety and quantity of both homeowners and residences certainly make up for the unusually high stakes at play. Apparently hermit, or warrior, crabs have been named more after a human interpretation than for a crabby disposition. True, they draw back if touched, will not reproduce in captivity, and adore musing in seclusion, but then again, should this be a reason to imagine these busybodies as arrogant exiles, self-ostracized from the rest of the animal kingdom?

What is most unique to hermit crabs is not a fictitious isolationism, but rather their dual relationship to a habitat that they can't live without, but whose transitory characteristics are exactly opposed to the permanence associated with a home. Nomadic while domestic, simultaneously mobile and territorial, the hermit is a walking bundle of contradictions that moves sideways, zigzagging its way through the multiple obstacles of the sandy ocean floor. Hermits' lives are a continuous juxtaposition of inside and outside: with half their bodies—two of five pair of legs holding and maneuvering the shells—always concealed, they relate to the world in a semiprivate manner, using the home as a protected interior in which to hide from external aggression. When hermits are threatened, they completely retract to the inside of their shells, closing the entrance with their large pincer, the operculum, so as to create a perfectly sealed armor, an invulnerable fortress immune to all enemies.

There are moments of great danger in a hermit's otherwise relatively secure existence, and one of them comes precisely when

it must crawl out of its safeguarded domicile in order to climb into another. Such movement renders its soft pink abdomen vulnerable, and hermits often perish in that brief exposure for which there is no outside protection. But witty decapods that they are, hermits have contrived a unique system of moving that enables them to carry out this activity at minimal risk of becoming crabmeat: they place the old shell face-to-face against the future residence, securing themselves from the eyes and claws of other hungry arthropods lacking in fraternal solidarity.

Moving in tail first, antennae wiggling alertly to detect any possible attacks, the hermit retrieves its natural habitat with the relief of one who has placed all bets on the same place and managed to emerge intact. Leaving its lodgement if only for a few seconds is this invertebrate's most feared experience—far worse than engaging in a fierce pincer-to-pincer with a rival over a mutually sought shelter or getting stuck upside down between a rock and a hard place, and having to spend several hours patiently moving back and forth every which way, seeking to regain balance and grounding without damaging the precious pod.

Yes, coming out is no small thing for a hermit—its survival contingent on its ability to accept the inevitable fact that crustaceans must molt every six weeks, shedding their exoskeletons in order to grow into larger carapaces. On these occasions, there is no shell trick available for these covert decapods: they must rapidly hide from view, a feat difficult to accomplish when the need to get rid of that old skin takes over and everything else—

onlookers, hideouts, demureness, fate—becomes secondary, forcing the invertebrate in question to stop dead in its tracks and disrobe. Alas, how many hermits have lost their precious lives to this basic necessity! One would think Mother Nature would prepare them better, but it seems she did her share in providing infinite shells, leaving up to the hermits the antics of how, where and when.

While the discarding of the old and the consolidation of the new lasts, this change of skin absorbs the crustaceans' last ounce of energy: they lose their appetite and consequently all desire for exploration and movement, looking like limp, lifeless flowers that have gone without water and sun for too long. Molting is a rite of passage for which nothing provides enough preparation. No matter how strong, big or old the crustacean, the ejection from the old carapace has no guarantee of success: often our dear *karkinos*, already detached from inside its crust, lacks sufficient muscular potency to get rid of the rigid skin that used to protect it and has now turned into its worse enemy, trapping the hermit at its weakest moment, choking the former host who, debilitated by the removal of what once served as a dutiful shield, must now engage with it in an unexpected and unequal battle for survival.

This life-and-death combat leaves one of two corpses: a rotting crustacean or, most probably, an empty cortex that, like a perfectly embalmed mummy, bears silent testimony to a previous history. As if they were spoils from a violent war, hermits will often eat their old exoskeletons, seeking in them those same hardening properties that almost finished their lives.

The Organ of
Marvelousness

For everyone who has philosophized, now or in the past,
has been motivated only by wonder. Now, wonder
is defined as a constriction and suspension of the heart
caused by amazement at the sensible appearance of
something so portentous, great, and unusual, that
the heart suffers a systole. Hence wonder is something like
fear in its effect on the heart. This effect of wonder,
then, this constriction and systole of the heart, springs
from an unfulfilled but felt desire to know the
cause of that which appears portentous and unusual . . .

———

ALBERTUS MAGNUS (1200-1280),
Commentary on the Metaphysics of Aristotle

THE nineteenth century's reification and obsessive collecting of nature was really the culminating point—the swan song, so to speak—of a cultural process that had started more than four centuries before. Characterized by culture's separation from the organic world (and the latter's ensuing artificialization), this gradual severance established the beginning of the modern era in the broadest sense, distinguishing it from both the classical and the "dark" ages, where nature and culture were inextricably bound. Its most

astonishing production, the Renaissance "wonder chambers" where massive compilations of natural specimens and artificial objects were mixed without a care, offered a visual staging of natural history next to which nineteenth-century dioramas pale. Immersed in a perspective of the world that saw in both organic and human creations the physical manifestation of a mysterious cosmic force, the "age of wonder" anchored all transcendental implications to their earthly correspondents in such a way that, for almost three hundred years, things enjoyed an unprecedented autonomy as purveyors of the enigmas of the universe. This material epiphany was to die at the hands of its own creation, the rational discourse of science, only to be later unapologetically resuscitated, despite the irate complaints of contemporary critics, by Romanticism.

A happy interregnum between theology and science, the age of wonder began in the late Middle Ages with the display of relics and "mirabilia" (marvels both natural and artificial) by local churches.[1] Infused with divine attributes, relics were kept in *camere auree*, aureatic chambers—secluded viewing places. The pride of their respective towns and the goal of extended pilgrimages, relics were exhibited once a year to a mainly male public (women were generally barred from this ritual) that basked in this visual closeness to the sacred remains. Relics were rarely actually seen, however, ultimately protected from direct ocular contact by their containers, which were often natural wonders, or "naturalia," such as coral branches and ostrich eggs, considered marvelous for their unusual shape or size. A constant source of mysterious things, the ocean would remain for centuries the main provider of naturalia.[2]

Organic marvels' mere proximity to the relics infused them with the

1. Krzysztof Pomian, *Collectors and Curiosities: Paris and Venice, 1500–1800*, trans. Elizabeth Wiles-Portier (Cambridge, England: Polity Press, 1990), p. 64.
2. Adalgisa Lugli, "Cabinets di reliquie e di curiosità," in *Naturalia et mirabilia: Il collezionismo enciclopedico nelle Wunderkammern d'Europa* (Milan: Gabriele Mazzotta, 1983), pp. 11–36. Lugli's book is a fundamental source for the history that I trace here, particularly as regards relics and natural history collections; much of the information on

latter's sacred aura, establishing an aureatic chain that extended beyond the confines of the Church and sacralized anything associated with the relics, as is often the case with devotional souvenirs. In this process, the organic matter not only gained in wonder quality but also, having given up its natural role to function as an item of display, became a cultural object and was beheld as an artifice—as much of a creation as the artificialia (paintings, metalwork) which sustained and reproduced the Church's iconographic trove.

As medieval marvels, naturalia such as the popular unicorn horns or the ceraunic stone, claimed to be the concretization of thunder, engaged the main registers on which the encyclopedic collections of the Renaissance (themselves exhibited in what were called wonder, rarity or art chambers—Wunderkammern, Rariteinkammern and Kuntzkammern, respectively) would later be based: scopophilia, or the pleasure of looking; and anecdote, the fragmentary narrative most conducive to fantastic tales.[3] The sensorial intensity of scopophilia and the imaginative allure of anecdote were further tied and amplified by the principle of analogy, which links by association the visible and the invisible, establishing naturalia's ultimate connection to the universe. This produced that awareness of human insignificance in the face of cosmic magnitude known as the feeling of awe or wonder, best described as a state of suspension, of "held breath"—a literal arresting of the emotions.[4]

Although natural marvels have always aroused interest, the age of

"rarities" is taken from her exhaustive research. For an in-depth historical analysis of wonders, see Lorraine Daston and Katharine Park, *Wonder and the Order of Nature, 1150-1750* (New York: Zone Books, 1998). Since this study was published after my book went to production, I could not incorporate its findings here.

3. On the role of the anecdote in wonder, see Stephen Greenblatt, *Marvelous Possessions: The Wonder of the New World* (Chicago: University of Chicago Press, 1991). The nomenclature used for wonder chambers is due to collections' origin in the Low Countries, at that time the center for sea trade with the West and East Indies.

4. Greenblatt, *Marvelous Possessions.* On analogy, see Pomian, "The Collection: Between the Visible and the Invisible," pp. 7-44 in *Collectors and Curiosities.*

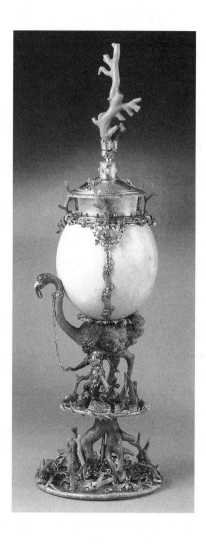

OSTRICH-EGG CUP WITH CORAL-BRANCH ORNAMENT. Clement Kiklinger (Meister 1571-1617 Augsburg). Since the Middle Ages, ostrich eggs adorned with coral branches have been used as sacred reliquaries. *Kunsthistorisches Museum, Vienna.*

wonder was greatly impulsed by those events that marked the beginning of the modern era in the fifteenth and sixteenth centuries: the voyages of discovery, the colonization of America and the rebirth of a classical past that had been forgotten for almost a thousand years. A time when the universe was still—if residually—alive with magic feelings, every creature and thing the source of infinite amazement, the age of wonder indicated in its childlike openness the beginning of a new cultural era. It was a moment when the West perceived the world as an object of contemplation and spectatorial delight while readying its mercantile profitability and intellectual consumption.

For what distinguishes the age of wonder is precisely that naturalia shifted from being vital elements of an everyday life imbued with spirituality to becoming isolated and commodified as objects and compulsively collected in a "colonization of wonder."[5] The corralling of natural marvels into viewing chambers where they could be admired at leisure eventually extinguished their vital flame, leading to their dissection and classification as common elements of natural history during the Enlightenment, which otherwise discarded them as mere curiosities. In the three centuries where wonder ruled, however, naturalia gradually went all the way from being oddities to occupying center stage as fantastic fragments of the universe in the encyclopedic collections of the sixteenth and seventeenth centuries.

Among the earliest natural marvels that modernity inherited from the Middle Ages were embalmed crocodiles, brought to a wide-eyed Europe as part of the Crusaders' loot and promptly "baptized" as miracles by the Church in an attempt to diffuse the growing popularity of bizarre phenomena. Torn away from their original context and endowed with a symbolism that rendered them a product of divine intervention, the crocodiles were tied with chains and hung from church ceilings—and

5. The phrase is Greenblatt's; see *Marvelous Possessions*, pp. 24–25.

later from those of Wunderkammern—where they acted both as signs of the mysteries of divine power and as guardians that could thwart all other evils, a status further enhanced by the elaborate tales surrounding their capture.[6]

Christianity's medieval co-optation of wonder went beyond simply stretching the meaning of mirabilia to include miracles, with Saint Augustine declaring that all of creation was the product of divine intervention.[7] This shrewd effort to reduce the uniqueness of wonders by raising the mundane to the level of the unusual also affirmed that everything was contingent on a single will that monopolized, as it were, all the mysteries of the universe. Such strategies of appropriation and deflection, however, did not succeed in diminishing the immense attraction of the extraordinary, as witnessed by the massive pilgrimages of the period, from which the Church itself greatly benefited, and by the eventual emergence of the "sciences curieuses."[8] This is because marvels' appeal lay in their peculiar mix of the unknown and the mythological, whose poetic impact superseded the religious meanings that Christianity attempted to impose on them, freeing mirabilia to ride on the wings of imagination to the most esoteric meanings their novel appearances could inspire.

Set back in the name of singularity and later of its opposite, scientific uniformity, Augustine's doctrines continued nevertheless to underlie a

6. Lugli, "Cabinets di reliquie e di curiosità," pp. 11–21.

7. From Augustine, *De civitate Dei* (The City of God) and *De vera religione* (Of True Religion), as quoted in Lugli, "Cabinets di reliquie e di curiosità," pp. 20–21.

8. According to Pomian, "sciences curieuses," were the forms of learned knowledge that rose, alongside the "occult sciences" such as alchemy, against or despite the Church's restrictions during the sixteenth and seventeenth centuries in Europe. These forms of learned knowledge included those studies (such as the studies of naturalia) which were still in the process of becoming systematic, and were therefore not yet properly scientific. "Sciences curieuses," or "vain sciences," usually referred to "a great traveller, scholar or the author of fine experiments but also someone who has filled rooms with the rarest, most beautiful and most extraordinary things he has been able to find." As quoted in Pomian, *Collectors and Curiosities*, p. 57. Although curiosities include both artificialia and naturalia, I will be discussing only the latter here.

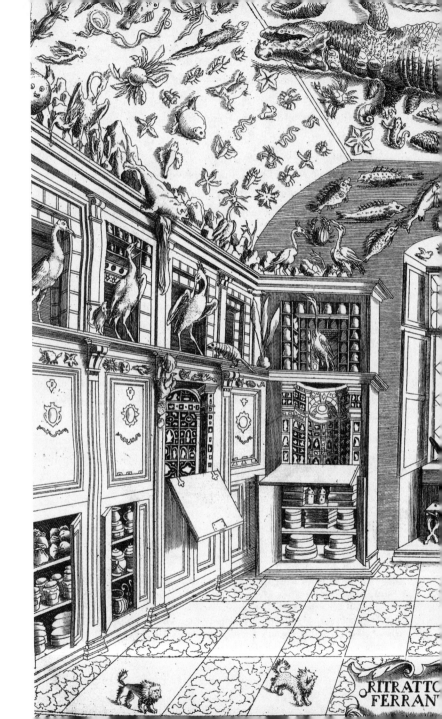

RITRATTO
FERRAN'

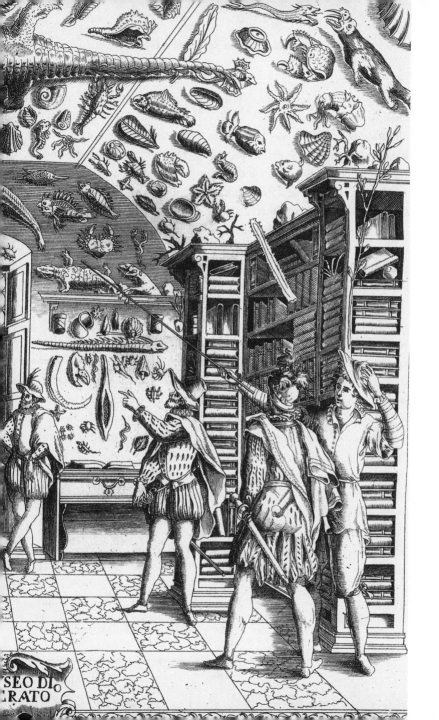

more general belief in the world as a divine creation and in humankind as its privileged spectator, mirror, and hopefully, emulator. Consequently, artistic production inherently carried a trace of this divinity and all study of the world was justified as enhancing its admiration. This human mediation between the abstract and the concrete hinged on nature's central role as a model of divine creation, making it the obligatory inspiration of artifice and the compulsory goal of knowledge while sacrificing its own, intrinsic, functions.

No matter how rooted, this stance was heavily challenged in practice during the age of wonder, which privileged what has been called an "artificialist" view whereby nature—and by extension, the world—was perceived, explored, collected and reproduced as a cultural construct whose complexity, doomed to be gradually rid of mystical attributes, was itself the object of fascination.[9] In this way, the religious meanings to which naturalia had been subordinated became, as usually happens with allegories, a part of their anecdotal fare, with symbolism taking a back seat to spectacularity and to the myriad possibilities of a universe still laden with occult meaning. This artificialism eventually found its rational manifestation in science and, despite being constantly embattled by the "naturalist" view, did not face any major challenges until its revival in the Romantic era.

The encyclopedic collections that articulate during the sixteenth and seventeenth centuries the dramatic rise and fall of naturalia grew directly out of the compilation of sacred objects, relics and rarities in Schatzkammern, royal treasure chambers. In a constant gift exchange with their churches, local princes coveted the relics whose possession gave them concrete proof of the divinity with which they nevertheless

TITLE PAGE FROM FERRANTE IMPERATO'S NATURAL HISTORY, 1599. A wonder chamber in all its magnificence, the ceiling replete with marine curiosities. *Rare Books Division, The New York Public Library, Astor, Lenox and Tilden Foundations.* (OVERLEAF)

felt endowed. These included primarily anything related to Christ—from a piece of the cross to a piece of his navel or his foreskin, the body always the foremost relic—or to the saints, virgins or martyrs (even the hand of a military leader who lost it in battle), moving along to more esoteric pursuits such as the mirror of the Queen of Sheba or a crow's sneeze. In turn, these rulers would donate some of their own holdings to the churches—Louis XIV gave the entire body of an "Innocent" (one of the firstborns of Bethlehem massacred by Herod), encased in a crystal shrine, to the Church of the Innocents in Paris—along with personal items, such as shields or vases, to be placed next to the relics, enhancing the process of "laicization of relics and sacralization of objects" that characterized later collections.[10]

The shift from the Schatzkammern of the late Middle Ages to the Wunderkammern of the Renaissance was about a hundred and fifty years in the making. In the early stages, collections were extremely fanciful, responding to the arbitrary desires of their respective owners. One of the best documented is that of Jean de France, the Duc de Berry, who amassed in the early 1400s a collection whose fantastic underpinnings expose its medieval view of the world. In a time when many marvels were obtained through traveling traders who went from court to court selling curiosities and narrating dreams and exotic stories, the Duc de Berry is considered a "merchant collector," his accumulation of fabulous things extending beyond relics and antiquities, yet not quite articulating a microcosmic vision of the universe in the way humanist collections would soon do.[11]

In a way, the Duc de Berry is a bridge between the Middle Ages and

9. For the philosophical history of the concept of nature from antiquity to the present, see Clément Rosset, *L'Anti-nature*.

10. Lugli, *Naturalia et mirabilia*, p. 24. Regarding Louis XIV's present, see Johan Huizinga, *The Waning of the Middle Ages*, trans. Herfsttij der Middeleeuwen (Garden City, N.Y.: Doubleday Anchor Books, 1954), p. 148.

11. Lugli, *Naturalia et mirabilia*, pp. 61–67.

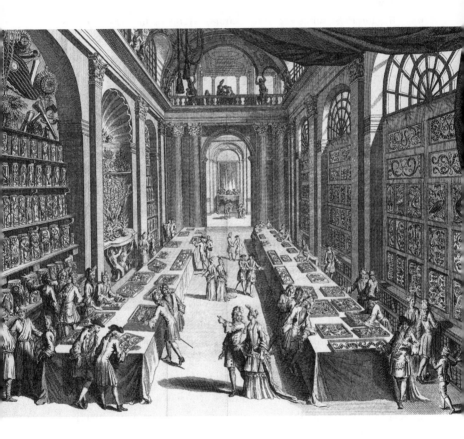

CABINET OF NATURAL SCIENCE. From Levinus Vincent, *Elenchus Tabularum*, 1719. Although it closely resembles the earlier wonder chambers, this palatial cabinet shows a symmetry and harmony that, although decorative, suggest the oncoming classifications of science. *The Bancroft Library, University of California Berkeley, call #QH71-V5-A3.*

the Renaissance, the former more inclined towards a sensorial experience of the world, the latter towards an intellectual apprehension of the same, its obsession with knowledge finding a perfect expression in the encyclopedic collections. Consistent with its conception, rather than attempting any alien form of classification, Berry's collection is grossly divided according to economic worth in its detailed 1401 catalog: the duke's numerous items of jewelry and the rest. Naturalia, such as a petrified egg, snake tongues, two horns of flying deer and shells, were considered curiosities of little value. Given the emotional and aesthetic worth attributed to every item in a collection that privileged artifice and fantasy above all, Berry's monetary division is practically irrelevant; nevertheless, it shows how curiosities and naturalia were regarded as secondary to art and jewelry in early collections, a situation that would dramatically change in the course of the next three centuries.

What matters here, though, is that every object in Berry's collection refers to an imaginary world filled with exotic peoples and fabulous creatures, with artificial curiosities and naturalia acting interchangeably as a tangible proof of their existence. In this context, the presence of flying-deer horns attests to a realm of possibility that reaches beyond the confines of the duke's world but that he attempts to recover and reproduce in the random accumulation of its remains. The fragmentary aspect of these remains (as of all collectible naturalia) is fundamental for the imaginative projection that accompanies them, since fragments carry an implicit invitation to be restored to the totality from which they came. While this totality is unknown, it can be reconfigured at will, and in the late Middle Ages this usually meant analogically conflating the unknown with the magical, producing such poetic results as flying deer.

As marvels or curiosities, then, naturalia are read allegorically as the fragments of an extraordinary narrative which is in fact constituted in the continuous repetition of its anecdotes. Each repetition, like every new owner, adds a new layer of glamour to something that was already very

lightly attached to reality, with marvels' value increasing according to the varying degrees of bizarreness of their stories, the difficulty of their acquisition, the prestige of their owners, the importance of the other items in the collections, and so on. All these elements contributed to the formation of the marvels' aura in a universe where worth was measured mainly by objects' ability to stimulate the imagination.

In this sense, and given marvels' tendency to create meaning through correspondence or contiguity (similarity or proximity), the anecdote was the perfect vehicle through which to establish a natural marvel's genealogy. Having been stripped of their organic origin (which at the time was often ignored, the typical case being fossils, which the Duc de Berry mixed with his precious stones in a confusion that would last another two centuries), naturalia are not seen as belonging intrinsically to nature but rather as independent manifestations of cosmic powers. Attributing these powers to divine will was far from satisfactory: what made marvels so titillating was the vague intuition that something other than an abstract authorship was at work, since many of what were once considered marvels were in fact the products of an undeciphered nature that would stop being so when its mechanics began to unravel. Until then, natural marvels were perceived as intrinsically connected through wonder with artificial or human-made ones, all differences of provenance subsumed under the more important category of effect.

Considered encyclopedic because they represent the desire to accumulate all there is in a universe still viewed as finite, Wunderkammern subordinate all concerns to visual pleasure, the feeling of wonder providing the connection to the universe that the Renaissance so persistently sought. As such, they confirm looking as the foremost mode of intellectual apprehension and retention, continuing the Augustinian tradition of a didactic nature contingent on visual impact and formally establishing the eye as that "organ of marvelousness" which Leonardo called the father of the senses.[12] The chambers were organized so that all physical

space was covered with "wonders" (in the natural history ones, the larger animals hang from the ceilings while shells and mollusks cover the walls and smaller specimens fill cabinet shelves and drawers), producing the effect of a microcosm whose depth can be felt in the slow caressing of every object with the look, myriad stories galloping to flourish in this transitory encounter, each arrested by the next.

This tactile gaze is all the more striking since it values objects strictly as surfaces, all the nuances of size, texture, shape and color contributing to establish a cluster of meanings whose very elusiveness makes their momentary visual apprehension infinitely enjoyable. It is the "oculus imaginationis,"[13] the eye of the imagination, that is at work here, impassive to anything that does not immediately attract it, dilating its pupils and sending emergency messages to the brain and heart. Encyclopedic collections live for this moment, blissfully ignoring the difference between fantasy and reality, as witnessed by the immense traffic in fake marvels and stories like that of the "ave manucodiata," those birds of paradise whose legs were cut off to fit their legend as legless creatures. It is the time when grottoes are covered with shells or fake stalactites and gardens are filled with Bernard de Palissy's ceramic insects and reptiles, themselves popular collectibles in the nineteenth century.

The forerunners of modern museums, Wunderkammern further attest

12. I have extended the phrenologist's belief in "organs of marvelousness" to the eyes. Phrenology is the study of the skull as indicative of mental faculties and traits of character, and was very popular from the beginning of the nineteenth century until well into the twentieth. It was discredited by scientific research. On Leonardo's comment, see Lugli, *Naturalia et mirabilia*, p. 138, n. 59. The universal desire represented in Wunderkammern is satisfied not only in their spatial configuration, but also in the possession of artificialia representing microcosms, such as the "glass sphere with scenes with figures, birds, and animals" belonging to the Medici collection that could very well be one of the oldest glass paperweight predecessors. See E. Muntz, *Les Collections des Médicis au XVe siècle: Le Musée, la bibliothèque, le mobilier* (Paris and London, 1880), pp. 58–96, quoted in Lugli, p. 52.

13. R. Fludd, *Utriusque cosmi maioris scilicet et minori metaphysica . . .* (1617), quoted in Lugli, *Naturalia et mirabilia*, p. 79.

the desire to contain the whole world in their careful reproduction of every item in detailed catalogs, the illustrations professionally executed by artists who sometimes even accompanied the exploratory missions. One such catalog, that of Ferrante Imperato (the first to understand the animal nature of anemones and corals, thought to be inanimate until well into the eighteenth century), provides on its title page the oldest graphic document of a museum's interior.[14] Laden with the nascent empirical observations that eventually will become their demise, catalogs record naturalia as objects of both scientific inquiry and aesthetic contemplation, a double role that is perfectly consistent with nature's Christian mandate.

The erudite collections of the sixteenth and seventeenth centuries gradually align themselves according to the growing distinction between naturalia and artificialia (which, together with far/near, animate/inanimate and sacred/secular, are beginning to form predominant categories),[15] although many will continue to have both. The collections exclusively dedicated to naturalia began to appear in the early 1500s, often branching out from professional compilations of what until then had been considered "materia medica," such as herbs and minerals, whose live versions were the rapidly emerging botanical gardens. What establishes the relevance of the naturalia collections from this early stage is that they introduce the element of classification, the notion of a systematic organization radically altering the character of all collections, which until then had been composed following emotional or aesthetic criteria.

Natural collections followed the classification models available to

14. Ferrante Imperato, *Dell'historia naturale di Ferrante Imperato napolitano libri XXVIII, nella quale ordinatamente si tratta della diversa condition di miniere e pietre, con alcune storie di piante e animali sinora non date in luce* (Naples, 1599). The reference to Imperato's foreknowledge is in John Ellis, *The Natural History of Many Curious and Uncommon Zoophytes* (London: Benjamin White and Son, 1786).

15. Pomian, *Collectors and Curiosities*, p. 49.

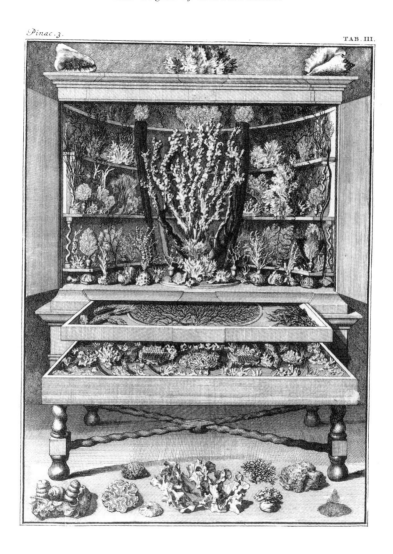

CORAL CABINET. From Levinus Vincent, *Wondertoonel der Nature*, 1706. This magnificent coral cabinet may be seen as a predecessor of the eighteenth- and nineteenth-century cabinets. *By permission of the Houghton Library, Harvard University.*

them, mainly the medieval *arbores scientiarum* and *ars memoriae*, chains of facts whose memorization was considered a form of knowledge.[16] Also very influential was the *Natural History* of Pliny the Elder, an ancient work which proposed that the sea contains the forms and shapes of all animals and earthly things, a theory brought back to circulation by Guillaume Rondelet's *Libri de piscibus marinis* (1554). Far from the compulsive breaking down of differences that characterizes later scientific discourse and its laws based on uniformity and recurrence, the natural classifications of the sixteenth and seventeenth centuries are still imbued with the idea of the unique and rare as representative of the diversity of nature, rather than as exceptions to a rule. Here, eclectic compilations gather all the elements of the universe for observation, while classification enables a delimiting of objects within the predominant realm of analogy.

This is why, despite their claims that the emerging field of natural history is a science, zoologists like Conrad Gessner, who in 1555 wrote the *Catalogus de rebus noctu lucentibus et lunariis herbis*, portraying nature as a fantastic world with luminous night plants, animals like stars on the sea and earth, and gems that illuminate the rings of ladies, and who includes the legendary basilisk in his *Historiae animalium* (1565); or his colleague Ulisse Aldrovandi, who extends his discussion on plumage to the "ars textilis o plumaria" such as the feather mosaics brought from the Americas, have been best described as philosophers, rather than scientists, of nature.[17]

16. Lugli, *Naturalia et mirabilia*, p. 75.
17. Ibid., pp. 84–91.

𝔓etrified 𝔑ature

Every gallery and museum, whether it belongs to a prince or
to a personage renowned for his nobility, writings, feats
of arms or wealth, is now required to contain a large showcase
filled with fish, crustaceans and other petrified marine
specimens found in the mountains. As the intrinsic value
of most of them does not justify so honourable a position, it
would seem that their owners consider them to be of a rare
merit, encouraging those in search of the key to nature's secrets
to determine the origins of these deposits of the sea, by
what fortune they were carried from the sea to the mountains
and what enchantments, if we may put it thus, changed
them into stone, making eternal the memory of the exile which
forced them to die in lands so strange to them.

ABBOT ANTON LAZAR-MORO,
De crostacei e degli altri marini corpi che si trovano
su'monti libri due, VENICE, 1740

ERHAPS the best illustration of the transition from won-
der to science is the discussion about the origin of fos-
sils, which involved the sticky issue of the genesis of
the Earth and which would not be definitively settled
until the mid-1800s, long after natural history collections were pushed
aside and torn apart by the Enlightenment. Petrifications, as fossils (and
sometimes shells and corals) were usually called, had figured promi-

nently as curiosities in natural collections, where the distinction be-
tween the organic and the inorganic was unclear and the process in be-
tween was simply ignored: fossils were popularly believed to be the
bones of giants or dragons, if not exhalations from the earth or seeds
fallen from the stars.[1]

Containing the animate in inanimate form, petrifications were dan-
gerously close to the territory of Creation, becoming particularly suscep-
tible to mystical interpretation, as witnessed by the piece of watermelon
that Saint Benedict turned by miracle into stone.[2] As long as these kind
of explanations were viable, fossils enjoyed a fluid role as relics, *pretiosa*
or even nature's art. However, once fossils began to be understood as the
remains of marine creatures (an origin the Greeks had elucidated long
ago), their location in deep strata suggesting that Earth had undergone
severe changes in times past as opposed to being neatly created in seven
days, all hell broke loose, with Christianity attempting to pre-empt any
consequences by staunchly declaring that the Earth was six thousand
years old, with Genesis beginning at exactly 8 P.M. on Saturday, October
22, 4004 B.C.[3]

This emergence of temporality forced the interpretation of fossils into
the realm of the speculative in quite imaginative ways, and, rather than
being deflated, Christian fervor was only ignited by each new geological
discovery. In their stubborn denial of evolution, the Diluvialists re-
sponded to the findings of deeply buried fossils by attributing them to
the universal deluge, whose swampy aftermath had drowned animals,

1. Richard Carrington, "The Book of Earth History," *Mermaids and Mastodons: A Book of Natural and Unnatural History* (New York: Rinehart and Co., 1957), p. 102. For the con-
cept of culture as "petrified nature," see Walter Benjamin, "Central Park," *New German Critique* 34 (Winter 1985): 32–58, and "Allegory and Trauerspiel," *The Origin of German Tragic Drama*, pp. 159–235.

2. Pomian, *Collectors and Curiosities*, p. 103.

3. According to the Irish archbishop James Usher's interpretation of the Old Testament,
cited in Carrington, *Mermaids and Mastodons*, p. 98.

Ninety-million-year-old fish fossil. Soon after the fourteen-foot *Gillicus arcuatus* attacked and swallowed a six-foot *Xiphactinus audax*, it died, leaving this record of fatal gluttony in the American Midwest, most of which was once covered by a shallow sea. *Courtesy of the Sternberg Museum of Natural History, Fort Hays State University, Hays, Kansas.*

mixing species from different regions in a kind of gigantic maelstrom that after settling had sunk them into the Earth. Furthermore, the gases emitted from these decaying corpses supposedly had formed bubbles which then solidified as caves, thus solving paleontological and geological enigmas in one fell swoop.[4] For their part, the Catastrophists attempted to strike a balance between the Scriptural belief that the earth was only six thousand years old and the growing evidence to the contrary with the theory of multiple creations. Here, each divine beginning was eventually destroyed by a catastrophe that in turn was followed by a new creation (one geologist, a certain Alcide d'Orbigny, counted twenty-seven such cycles), thus accounting for geological strata, fossils and vanished species, the last conveniently packed off to those continents lost in the upheaval of such a frustrating creative process.[5]

As the idea of a single cataclysm gave way to the possibility of a longer and more complex formative process, Plutonists and Neptunists argued about the volcanic or marine constitution of the fossil deposits, while Catastrophists followed Baron Cuvier's compromise of not one but four Creations. This was all put to rest by the theory of uniformitarianism, which postulated in the 1830s that no divine punishments were needed, given a period long enough for evolution to take place. Still, as late as 1857 none other than Philip J. Gosse, of aquarium and anemone fame, busted his otherwise brilliant career by asserting that fossils were fake evidence planted by God to give humans the illusion of an older Earth.[6]

The fossil debate, which occupied much of the eighteenth century, is symptomatic of the gradual shift from a mystical to a rational approach to the world, and as such it is not surprising that it climaxes at the moment when the Enlightenment begins to question the usefulness of ency-

4. Carrington, *Mermaids and Mastodons*, p. 100.
5. Barber, "A Casualty of Science," *The Heyday of Natural History*, p. 219.
6. Ibid., pp. 239–50.

FRONTISPIECE FROM DEZALLIER D'ARGENVILLE'S *LA CONCHYLIOLOGIE*, 1757. Drawing by François Boucher. A celebration of the passion for shells, this book was very successful and was reprinted several times during the eighteenth century. *General Research Division, The New York Public Library, Astor, Lenox and Tilden Foundations.*

LADY'S SHELLWORK BOX, MINORCA, C. 1800. From Louise Allderdice Travers, *The Romance of Shells*, 1962. The fashion for shell decorating (ranging from entire walls to small household ornaments) has survived to this day, mainly in the form of mass-produced souvenirs.

clopedic collections and to dismiss their pre-Linnaean classifications as chaotic. It also introduces time, an element that shatters these collections' basic premise, organized around spatial paradigms that presented a fixed—however marvelous—universe whose main movement was the creation of radical diversity rather than gradual, continuous change. Imagination and analogy were pushed aside, their marvelous contrivances receding from the blinding light of the Enlightenment. Wunderkammern started to fold, their wonders stored out of sight or dispersed. It was the age of disenchantment.[7]

The fossil debate not only marks the final transition from a mystical to a scientific view of nature (the latter ironically bringing back to life those creatures the early moderns had believed to be dead or inanimate) but also helps to illustrate its underlying process. For in the development of the natural history collections we can trace how the perception of nature as a live whole shifted to become that of a compilation of dead fragments. In other words, and in a similar way to that of the souvenir, nature ceased to be an experience and became a memory. No longer capable of living nature as a meaningful connection to the universe, culture attempted to retain the organic experience through its remains, fetishistically endowing them with metaphysical attributes. The move from a symbolic mode of representation, where nature is perceived as a live though incomprehensible force, to an allegorical one, where this life is more latent than manifest, helps us understand why fossils were for so long considered to be inanimate. In the realm of the collections, life was a secondary attribute: what mattered most was not the vital flame but the shell that contained it. Bereft of context and autonomy, this

7. "The disenchantment of the world" is discussed by Max Horkheimer and Theodor Adorno in *Dialectics of Enlightenment*, as quoted in Rosemarie Garland Thomson, "Introduction: From Wonder to Error, A Genealogy of Freak Discourse in Modernity," in Garland Thomson, ed., *Freakery: Cultural Spectacles of the Extraordinary Body* (New York: New York University Press, 1996), p. 4.

corpse could easily be inscribed in the universe of the collection and subjected to the collection's own set of meanings.

Once reified, the organic experience was commodified as the fast-growing market of naturalia, which became an item of exchange along with the other collectibles of the time—the coins, paintings and sculptures usually referred to as artificialia—furthering the ongoing conflation of nature and art, which made the former into artifice and the latter into an extension of our natural being. Consequently, both petrifications and the natural history collections that contain them may be considered allegorical, for, deprived of a signifying context—a mystical universe whose authority is beginning to dissipate—they establish a new set of meanings that is intrinsically associated with their materiality: while petrifications are confused with precious stones, the collections plaster wonder chambers with embalmed crocodiles, fish, crustaceans and shells in order to graphically reproduce a supernatural universe that is gradually disappearing.

The allegorical quality of naturalia is further enhanced by their underlying deadliness as organic ruins. Despite their being endowed with mystico-magical attributes and used as props for a cosmic scenario, naturalia's state of permanent suspension—the implicit promise that they may wake up from a prolonged hibernation, perhaps more apparent in the fossils—is never displaced by the attempt to make them come to life again. In this sense, they are melancholically imbued with the knowledge that theirs is a bygone life of which only the corpses remain.

Although encyclopedic collections bit the dust, natural history itself did not, surviving in its new scientific form as a purveyor of knowledge. Adapting to the times, its collections turned from the extraordinary to the common, from uniqueness to series; rarities were displaced by insects, shells and stones. These were, nevertheless, cherished as curiosities and displayed in the more contained format of "cabinets de roi" or "cabinets curieux" which, in increasingly smaller proportions, even-

tually became the curio cabinets of the nineteenth century. No longer exhibited in palatial rooms as the exclusive privilege of nobles, clerics and scholars, natural history began to infiltrate the homes of the bourgeoisie, of money dealers and artists, displacing art collections in the second half of the eighteenth century, when shells were favored over medals in a symptomatic takeover.[8]

This increase in the number of natural history collections has been attributed to economic reasons, their elements being far easier to obtain than antiques, but also to a cultural shift, from collectors who sought to acquire or promote their social status through their art collections, to those who saw in natural history a mode of knowledge and education. In the city of Verona, long a bastion of fossil collections be-

CARP PAPERWEIGHT. Origin unknown, probably St. Louis, 1848–55. Colorless glass encases a three-dimensional sulphide carp within a circle of salmon/green millefiori canes. *Gift of Mrs. Florence Gosselin Marsh in memory of her husband, Raymond Clark Marsh, 1976. Courtesy of the Bergstrom-Mahler Museum, Neenah, Wisconsin.*

cause of the nearby Volca sediments, collecting objects in the nearby countryside (a 1785 expedition even "going so far as to take a number of ladies into the mountains in search of fossils"), discussing geological topics, and attending courses on natural history for nobles and citizens were popular, if learned and privileged, activities.[9]

By the late 1700s, naturalia had traveled all the way from the sacred to the profane, from being wonders obtained with great difficulty and expense to being items that amateurs could find in the outskirts of their

8. Pomian, *Collectors and Curiosities*, pp. 61–64; Lugli, *Naturalia et mirabilia*, pp. 118–121.
9. Pomian, p. 218.

cities. The great collections were soon forgotten, many of them eventually becoming the basis for the nineteenth century's museums of natural history, themselves quite secondary to art museums and to an empirical science more interested in live creatures and experimentation than in those monumental compilations of bones, shells and fossils that a seventeenth-century collector called "cemeteries filled with corpses."[10] Banned and despised by the experts, the remaining naturalia gradually trickled into curiosity shops and Victorian interiors, finding their new home among an increasingly wider public that treasured them as cultural relics.

For, after being the fragments of a magical universe collected by the scientifico-mystical vision of the Renaissance, naturalia became the scattered debris of that vision, their allegorical impact doubling as the dust of forgetfulness began to cover them with the allure of a world—and a whole way of life—now most definitely gone. As such, naturalia became more artificial than ever, their simple origin as products of nature completely buried under the overlapping layers of their myriad cultural lives: medieval relic, Christian miracle, Renaissance marvel, scientific reject and bourgeois curiosity. It is these organic ruins first transformed into fragments of the aura by natural history that the nineteenth century obsessively gathers, reproducing them in paperweights filled with lava, minerals and glass reptiles, or bringing them back to life in aquariums whose temporal suspension makes them into miniature—and live— wonder chambers. In this way, Romanticism crowns a melancholic attitude towards nature that started with the very onset of the modern era, since even during their heyday from the 1500s to the 1700s, naturalia were never other than imaginary constructs in the eyes of their stunned beholders.

10. Ibid., p. 45.

The Missing Link

All men have an indelible mark that reveals their
origin in the sea. Just look at their skin
with the help of one of those recently invented
microscopes, which can enlarge a grain
of sand so that it becomes as big as an ostrich egg:
you will see how the skin is covered
with little scales, just like that of a carp.

BENOIT DE MAILLET, *Telliamed ou*
Entretiens d'un philosophe Indien avec un missionaire
François sur la diminution de la mer..., 1745

WHILE science was busily discrediting the natural history collections that had brought it to light, and before they resurfaced in nineteenth-century museums, the organic collections of the Renaissance knew an intermediate public stage as "natural curiosities." Dethroned from their ancient glory as marvels yet still defiant of the Enlightenment's rationality, these curiosities were often merged with the millenary tradition of the freak show and exhibited with great public success. This combination of inanimate curiosities and live beings is far from gratuitous: natural history collections had from the outset treasured relics such as bones of giants as signs

of wonder, an attitude popularly reflected in the display of giants, dwarfs, Siamese twins and other "monstruous" bodies in taverns, on street corners and at fairs since the Middle Ages.[1]

The difference between those exhibits and the later ones resides in their character, which shifted from being occasions of sacred awe, with monsters as signs of the mysteries of divinity, to secular amusements, medical oddities or even cultural exotica, a concept fostered by neocolonialism and its displays of foreign peoples as rarities. It is not surprising that in the mid-sixteenth century the French surgeon Ambroise Paré conflated hermaphrodites and Siamese twins with giraffes, elephants, unicorns, mermaids and even comets in his *Des monstres et prodigies* (1573), initiating the gradual secularization of freaks.[2] This separation of abnormal beings from the religious or supernatural realms was propelled less than fifty years later by Francis Bacon, who in his aptly titled *New Atlantis* (1620) proposed that monsters linked the natural with the artificial.[3] In so doing, Bacon helped maintain the ongoing connection between these two realms, which would last for at least another two hundred years, as we can still find it in the many nineteenth-century exhibitions and books of "natural and artificial curiosities."[4]

Attempting to account rationally for all phenomena, the 1700s and

1. See Leslie Fiedler, *Freaks: Myths and Images of the Secret Self* (New York: Simon and Schuster, 1978); and Paul Semonin, "Monsters in the Marketplace: The Exhibition of Human Oddities in Early Modern England," in Rosemarie Garland Thomson, ed., *Freakery*, pp. 69–81.
2. Garland Thomson, ed., "Introduction: From Wonder to Error—A Genealogy of Freak Discourse in Modernity" *Freakery*, pp. 1–19.
3. Semonin, "Monsters in the Marketplace," p. 71.
4. A good example is Samuel G. Goodrich's *Cabinet of Curiosities, Natural, Artificial and Historical*, which lists churches, pyramids and ruins along with "atmospherical phenomena" (ignes fatui and mirages) and "miscellaneous curiosities of nature" (the "fascinating power of snakes" and the "transformation of insects"). Darwin's theory of evolution, proposed in 1859, put a dramatic end to all these extraordinary convergences. In a way, the *Telliamed*, quoted in this chapter's epigraph, may be seen as a distorted anticipation of this theory.

1800s produced a mixture of science and fantasy that kept alive many of the old beliefs under the new guise of empiricism. In this vein, modernity recast those legendary aquatic creatures, mermaids, who underwent in the nineteenth century a peculiar transformation similar to the allegorical recovery of Atlantis, often assumed as their native kingdom and portrayed as an underwater palace with crystal walls. While natural and artificial curiosities were united in that floating wonder chamber which was Captain Nemo's submarine, they were literally fused in these popular maritime figures who, instead of being the authors of collections and exhibitions, were precisely the objects of such displays.

Seeking through human love the eternity of the soul, mermaids gave up that underwater realm so dear to Nemo, who sought in its material conquest liberation from humanity's chains. Ironically, they not only gained another life, but also garnered unprecedented amounts of attention by way of two recurrent phenomena: mermaid sightings and the exhibition of fake mermaids. While the former had been a constant part of mermaid lore for centuries, the latter is a uniquely nineteenth-century concoction whereby the display of curiosities joined forces with the mermaid knack for metamorphosis, producing a hybrid creature totally consonant with this era's desire for a tangible—and collectible—proof of those mythical creatures who still held sway over the popular unconscious. In so doing, the 1800s were unwittingly continuing a tradition of artifice that in previous times had been applauded for its ingenuity and craft.

One of the most salient features of mermaid stories, metamorphosis requires at least one physical transformation. According to Ovid, the winged Greek Sirens were Proserpine's maidens who went looking for their mistress after Pluto abducted her, having pleaded for birds' bodies in order to search more effectively. Other versions have them as daughters of the Muses of music, or born in the very act of metamorphosis, when their father, the river Achelous, changed into a bull during a love

duel with Hercules and one of his horns was torn, pouring out the Sirens as "daughters of blood." Endowed with beautiful voices and musical talents, they challenged the Muses to a fateful contest, whereupon their feathers were plucked by the cruel victors. Vanquished and featherless, the Sirens abandoned the airy realm and threw themselves into the ocean, becoming mermaids.[5]

Promising to share their knowledge of all things, the Sirens of antiquity supposedly lured sailors to their destruction. If their spell failed, as when Orpheus played over their singing, they would jump into the sea in defeat and change into that endless source of oceanic camouflage, rocks. Nevertheless, Sirens were also intrinsically associated with the spirit (music being the classic vehicle for all higher enterprises) and were said to lead the souls on their way to heaven: Plato portrays them as holding the harmony of the world, and for the Egyptians they were symbols of wisdom. Christianity emphasized mermaids' sexual aspect, presenting them as evil temptresses and reducing their complex mix of material and spiritual attributes to its minimal expression. Celtic and Germanic folklore rescued mermaids in the Middle Ages, associating them with the gentler water nymphs and popularizing the modern mermaid figure whose influence was felt all the way to Africa, where since the fifteenth century she has been known as "Mami Wata," mother of the waters.[6]

Sirens and mermaids tend to grant wishes and even engage in pacts with humans. Perhaps the most famous is the Middle Ages' Melusine,

5. According to Ovid as quoted in Georges Kastner, *Les Sirènes: Essai sur les principaux mythes relatifs a l'incantation* (Paris: G. Brandus and S. Dufor Brandus, 1858), p. 7. Despite their differences, sirens and mermaids are constantly confused. In the Romance languages they are referred to by the same term, a derivation of the Greek *seiren.*
6. For the history of mermaid mythology see Meri Lao, *Las Sirenas: Historia de un símbolo* (Mexico, D. F.: Ediciones Era, 1995) and Kastner, *Les Sirènes.* For a description and analysis of Mami Wata in African popular culture, see David Hecht and Maliqualim Simone, "Mermaids and Other Things," *Invisible Governance: The Art of African Micropolitics* (New York: Autonomedia, 1994), pp. 56–75. According to some versions, Mami Wata was taken to Africa by the inhabitants of Atlantis.

THE ABDUCTION OF AMYMONE. Lithograph from the original plate by Albrecht Dürer, 1471-1528. One of the fifty Danaids, who did not want to marry and, when forced to, killed their husbands on the wedding night. They were punished by forever having to carry water in jars filled with holes. Abducted before the fatal event by a satyr, Amymone was rescued from him by Poseidon. *Musée du Petit Palais, Paris.*

who was a serpent from the waist down, but who, able to adopt full human form for days at a time, married a human and bore him children. Melusine's only condition was that she should have Saturdays for herself; on this one day, she would retire to her castle, privately bathing and recovering her original body for a few hours. When Melusine's husband discovers her secret, she leaves with great sadness her human family. Hans Christian Andersen's Little Mermaid (in the 1837 story by that name) enters a similar pact, except that hers is with a wicked underwater witch who not only cuts out the adolescent princess's tongue to secure her exceptionally beautiful voice as payment for changing her tail into human legs, but does so at the price of excruciating pain, since the mermaid feels like she is walking on knives. Ultimately, the Little Mermaid's wish to obtain an immortal soul through human love can, and does, backfire: if she fails to inflame that love, she must die. Because her goodness is such that she forgoes the possibility of killing the desired prince and recovering her underwater life, the mermaid princess is transformed into a daughter of the air, becoming a candidate to win a soul as long as she puts in three hundred years of good deeds—surely a feat that few human beings could achieve.[7]

It is perhaps their capacity to change back and forth between human and animal—or to be both at the same time—that has gained these mythical figures such suspicion and fear in Western culture, so given to fixed, patriarchal categorizations. The mermaids and Sirens of antiquity united in their proteiformity both the spiritual and the material, the transcendental and the sexual. Their more recent transformation into human beings is only a rite of passage for their gaining a soul that had never before been at issue. In order to access the symbolic structure that gives meaning to this act in the West, mermaids must leave behind the amor-

7. See Sabine Baring-Gould, "Melusina," in his *Curious Myths of the Middle Ages* (Philadelphia: J. B. Lippincott and Co., 1868, second series), pp. 206–58.

phous space of the imaginary, where they can afford to have a hybrid condition, and assume instead the static form of a single species.[8] In other words, they must split themselves and sacrifice an important part of their being, forfeiting their own complexity for a culture where it is read as an untenable duality.

Paradoxically, transformation, or the movement of life, is seen in Western culture as material and finite, while death, or the cessation of life, becomes the condition for an unlimited, albeit abstract and intangible, realm of being (redemption, the eternity of the soul), one happening at the expense of the other. It is precisely at this junction where Nemo and mermaids meet, linked by that unconscious, underwater world which he seeks to return to and they to escape from. Nemo's desire to lose the boundaries of his self and become one with the ocean, and the impossibility of his doing so, show him to be a member of a culture where such transformations are unthinkable.

It is not so much that Nemo wants to grow scales and a tail as that he longs to be actively integrated in a different way of looking at things, with his submarine exploration a metaphorical attempt at crossing over to what he describes as a world free of hierarchies and limitations. Nemo dismisses surface culture from the moment he goes under water—although he carries his many possessions and cultural treasures as personal memories, and even newspapers that date his last day in "civilization"—to the point that he and his crew use a completely new language in an extreme attempt to disregard all symbolic structures that bind them to society. However, despite his prolonged submarine stay, the prosthetic function of the *Nautilus* and his ingestion of sea products, Nemo continues to be a part of that culture he abhors, reproducing the cultural values and even the colonialist attitude he so adamantly criticizes.

While the reversal of the symbolic seems an impossible feat, the

8. For the symbolic and the imaginary, see footnote 7, pages 60–62.

THE MERMAID OF GOLLERUS. Pastel by Troy Howell, 1993. According to Irish legend, when a mermaid's cap is stolen, she cannot return to the sea. "The Mermaid of Gollerus" is one such story, in which the mermaid marries a man and bears him children, but later finds her cap and swims back to her underwater home.

same is not true for its opposite, characteristic of all socialization: the transition from the imaginary to the symbolic, represented by mermaids' ascension to land and their abilities to be (almost) fully integrated into the surface, albeit with disastrous consequences. Andersen's *The Little Mermaid* emerges, so to speak, during the mid-1800s as a popular emblem of this possibility in the only realm where it could be uncontestedly accepted: children's stories.[9] Unlike Nemo, mermaids have little trouble leaving behind their watery world and even their beloved families, entirely participating in human experience (to the point of marrying and having children, as Melusine does) except for one condition, which usually turns out to be the downfall of the entire project. It is this condition, the last connection to their original being, that ultimately renders mermaids a travesty in human eyes, as shown by their mates' revulsion, betrayal or abandonment. In *The Little Mermaid,* the mermaid princess pays for the parting of her tail into legs—which, more than walking or dancing, would allow her to have human intercourse and reproduce— with her voice. This unknowingly dooms her mission from the start, since her inability to breach the symbolic gap hinders her from fully performing as a human. Deprived of language, she cannot tell the prince that it was she who saved him from drowning, so he marries a human princess, believing her to be his real savior.

Disney's contemporary adaptation of Andersen's story preempts this unhappy ending by transforming the tale into one of raging hormones and filial disobedience (that is, sexuality and rebellion), dismissing the wise grandmother, bearer of mermaid tradition, in order to elevate the figure of "King Triton," the father of "Ariel," whose authority has been challenged by his daughter's desire to marry a human. Throwing the whole underwater kingdom into disarray, Ariel appeals for help to the "Sea Witch," a "bad mother" who knows how to manipulate everyone's

9. *The Little Mermaid* appeared in Danish in 1837 and was first translated into English in 1846.

desires and whose uncontrolled sexuality is represented in the figure of a sleazy, voracious, overweight octopus with iron-clutch tentacles and a bosom and mouth that at one point take up the whole screen. Eventually defeated by Ariel's young human prince, the Sea Witch fizzles out and all her magic spells are broken. Having recovered her voice (which was "contained," just like a special memory, in a magic bubble) and gained her father's approval, Ariel gets to keep her legs, marry the prince and stay on land.[10]

Besides privileging the story's patriarchal implications, Disney's Little Mermaid displays an element which is barely present in the original version, but which establishes an interesting connection between Captain Nemo and herself, as well as with the consumer society they both represent: the collection. Like Nemo, Ariel roams shipwrecks foraging for treasures, although hers have barely any material value, while his finance the whole *Nautilus* enterprise plus a few campaigns of political destabilization along the way. Yet both collections allow the characters to engage imaginarily in the worlds that so fascinate them: while Nemo fills the *Nautilus* with pearls, coral and hundreds of sea specimens in the name of research or finances, Ariel fills a huge underwater cave whose vertical formation reaches towards the surface, opening into a kind of submarine skylight, with the remains of human objects (glasses, vases, silverware, etc.) which she places in the interstices between the rocks, so that the cave-tower becomes a dizzying spiral of objects where the mermaid princess can get lost in her daydreams.

10. Perhaps one of the most interesting versions of *The Little Mermaid* is that created by the artist known as "Van Gool," whose illustrations are usually the alternative to Disney's and can be found in many toys and designs. Here, it is the prince who sacrifices his world, drinking a potion that enables him to live under the ocean, where he and the Little Mermaid marry and live happily ever after. See *"Van Gool's" The Little Mermaid, A Magna Fairy Tale Classic* (Leicester: Magna Books, 1993). In yet another version, they learn to live both on land and in the sea. See *My Very First Little Mermaid Storybook*, adapted by Rochelle Larkin (New York: Creative Child Press, 1993). The use of bubbles to represent memories is quite widespread in children's books and in comics.

This replacement of an experience by its material symbol (instead of the symbol being a medium, or way of achieving, the sought experience, as in religious and magic rituals) emphasizes the modern connection between objects and dreams which underlies all commodity fetishism, and which is at the heart of Disney's *Little Mermaid*. In this sense, the treasure cave episode is both a spin-off and a twist on the traditional mermaid stories, where rather than collecting objects to enhance their daydreams, mermaids offer them for the fulfillment of others' wishes, as in the legendary fair at the Cité de Limes, in Normandy, where merchant fairies

> attracted the fascination of spectators by proffering the marvelous merchandise of their magical treasure troves: supernatural plants that could heal the ailments of the soul as well as the wounds of the body; perfumes that rendered youth immortal; flowers that sang to charm the heart's troubles; precious stones, each graced with its own specific virtue: granite, to make one conquer all dangers and to protect one from adversity; sapphires, to make one chaste and pure; onyx, to give one health and beauty, and to allow one to see one's absent loved ones in one's dreams; ... invincible weapons, magical mirrors where the future can be foretold, where the secrets of the soul are unveiled; divining birds, like the caladrius, which can overcome illness with one look, but turns its gaze away from those it cannot heal and who are near death ... magnificent chests, where, instead of diamonds, and with glimmering lights a thousand times more sparkling and clear, dewdrops, crystallized by the art of fairies, lay shining; a collection of tiny fairies' wings, supple and soft, decking a mosaic of a thousand colors, for which the prettiest insects in all creation have been despoiled ... in one word, all of nature's alluring gifts, produced with the prodigious touches of art and labor ...

... and pushed over the edge of a precipice all those who were entranced by these enchantments.[11]

Mermaids' morphic change is intrinsically related to the fluidity of

11. From Le Roux de Lincy, *Livre des légendes* (1836), as quoted in Michel Bulteau, *Mythologie des filles des eaux* (Monaco: Éditions du Rocher, 1982), pp. 186–87.

water, an element that acts both as carrier—enabling the transmigration of souls, as in the underground river Lethe—and as reflector, offering a looking-glass-like surface for the projection of the self. In turn, water, and particularly ocean water, responds directly to the changes of the Moon, ruler of tides and menstrual cycles, psychic phenomena and the unconscious. This tight symbolic unity, where the ungraspable versatility of the unconscious is represented in the liquidity of water, is perhaps nowhere more apparent than in mermaids. Both water and the Moon are metaphorically condensed in the mirror that, along with a comb, usually accompanies mermaid depictions, and that, although loaded with symbolic meaning, is often reduced to signifying feminine vanity.

In this sense, one of the most interesting but rarely discussed metamorphoses undergone by mermaids (in their earlier form as Sirens) is their transformation into rocks as a result of their failure to charm sailors. Here again rocks constitute a multifarious discourse, adding to their already kaleidoscopic status: given that the Moon is nothing but a rock, and one that reflects light at that, mermaids' fossilization can be understood as their transformation into that lunar body which so determines them otherwise. At any rate, this is a paradoxical punishment since rocks, in the form of grottoes and caves, are not only mermaids' fabled abodes but their main connection to the surface world: mermaids usually appear sitting or lying on rocks, or represented by edifices like Melusine's castle.[12]

Petrification, then, would seem only to perpetuate the mermaids' nature under a different guise: more than inert matter, rocks could be seen as an extension or continuation of mermaids' bodies—half above, half under the sea, holding in their crevices those secrets that can destroy men if they get too close. Perhaps those mermaid apparitions that were seen as fatal signs in antiquity might be better interpreted as warnings of

12. According to Georges Kastner, in Nordic mythology everything related to druidic stones, rocky clefts, caves and grottoes retains traces of mermaids. See *Les Sirènes*, p. 166.

the imminence of shipwreck—by hitting a shallow reef, for example—than as malicious acts of destruction cast upon unwary sailors by evil temptresses. Mermaid bodies are said to be scattered between the southern tip of Italy and Sicily in the form of islands bearing their names, such as Leucosia and Ligeia. On this same coast, close to Mount Vesuvius and the ruins of Pompeii, the city of Parthenope, later known as Naples, venerated its namesake for a long time, celebrating with ritual games, coins and architecture the mermaid whose body was supposedly found in Campania.[13]

Petrification makes mermaids into metamorphic rocks—a transitional condition between states (i.e., molten and solid) that iterates the notion of the world as being in constant change instead of fixed polarities.

THE MERMAID PARTHENOPE. This seal by the eighteenth-century Neapolitan printer Bulifon depicts Parthenope with the inscription "Non sempre nuoce" (not always harmful). The city of Naples was first named after this mermaid. *Collection Carlo Bernardelli.*

Even though mermaids' return to animal form from rock is not part of their lore, in becoming rocks they are only entering a different manifestation of their being. As such, this is the last metamorphical twist in a long chain of transformations that led mermaids from their most ethereal and evanescent form—water nymphs—to the most concrete and permanent, passing through the in-between state of a mutant, sexual creature.

This turn of events is consistent with the fact that, as grantors of

13. Lao, *Las Sirenas*, p. 47; and Bulteau, *Mythologie des filles des eaux*, p. 39.

PHANTOM SHIP ON CRATER LAKE. This eroded lava formation was believed by Native Americans to be a phantom ship. According to legend, it would glide across the lake under the full moon, departed souls meeting with the gods of the deep water on its stone decks. *Oregon State Archives, Highway Division Records, photo #1555.*

wishes or rescuers of drowning men, mermaids lack any agency for themselves, acting always in function of a male other. Like rocks or mirrors, which transmit energy or give reflection but have no direct capacity for action, mermaids act as a vehicle for somebody else's desire. Their petrification further ratifies this passive identity by making them an indistinct part of the maritime panorama. Upon becoming rocks, mermaids give up their unique hybrid configuration for a primary organic state. In the end, it is their material aspect that carries the most weight. Perhaps this is why, of all their representations, mermaid images have been handed down through the ages in their most solidified form as statues and sculptures.

While as sea creatures mermaids symbolized the fantastic possibilities of the unconscious, as minerals they convey the ultimate fate of excessive metamorphosis: disapparition. It is as if so much going back and forth between species and elements, such an unbounded capacity for camouflage, finally rendered mermaids unable to form a stable identity of their own, remaining at the mercy of the very mutability that made them so special. This unstable reality is the key to why metamorphical creatures inspire such apprehension in the West: for a culture bent on fixed definitions and clearly delimitated categories, nothing is so threatening as a being that constantly transits between forms and states. It also explains why the unconscious is still regarded with such suspicion when not outright denial: the polymorphic language of the unconscious, which renders perception into associative images and symbolic narratives, is considered the dark side of a modern human experience that wants itself fully rational and comprehensible—that is, fully illuminated. Mermaids' grotesqueness as rocks or sculptures, however, is but an antecedent to that other transformation they underwent in the nineteenth century, the most bizarre of all their metamorphoses: fake mermaids.

Fake Mermaids

*The bones of sirens and of marine
monsters have the medicinal
virtue of arresting and pulling the
circulation of blood.*

ATHANASIUS KIRCHER,
Magnes, sive de arte magnetica, 1641

HE mermaid resurgence in the age of reason is befud-
dling: just when the allegories that represented the un-
conscious should have been exiting through the back
door, an unprecedented number of mermaid sightings
took place on the European coasts, witnessed and legally
certified by highly respected professionals and community
members. Since underwater exploration, as seen earlier, did
not seriously commence until the mid-1800s, when it began
bringing to the surface previously unsuspected forms of life and
providing a more complete picture of the unknown depths, the
range of submarine possibility was very wide and allowed for almost any-
thing. In an ocean populated with giant squids, multi-tentacled octopi
and voracious sharks, the presence of sea serpents and mermaids, two of
the most popular aquatic creatures of this time, was quite plausible, and

until the nineteenth century Spanish sailors had to swear to a magistrate they would not have sex with mermaids.[1]

Fake mermaids were a hit with Victorian society. Until then, mermaid relics had been few and far between: a mermaid hand described by the doctor Antonin Vallisner in the thirteenth century and another by the traveler Boullaye le Gouz in the seventeenth; a mermaid skin shown at the port of Thora in 1565; a malformed fetus (perhaps what is known as sirenoform) exhibited by Dr. James Parson in London's Charing Cross in the 1700s. But it was not until the eighteenth century that the "mermaid craze" really got under way. Like most freak exhibits of the time, the first recorded appearance of a fake mermaid took place in connection with a tavern, London's Crown Tavern, where a "Surprising Fish or Maremaid" with wings, fins, dolphin's tail and lion's head was shown in 1738 for one shilling per viewing.[2]

Shown again in London's Strand in 1775, where several scientists avowed it to be the real thing, this true "Curiosity among the Wonders of Creation" was not only the first but also the most radical of its genre, with most others contenting themselves with following the setup that P. T. Barnum would popularize about a hundred years later as the "Feejee Mermaid." This latter type was first shown in 1822 in London's Turf Coffee House in St. James, where it drew three to four hundred people daily, and was famously described by a Mr. J. Murray as "the upper

1. Lao, *Las Sirenas*, p. 167.
2. Gwen Benwell and Arthur Waugh, "In the Nineteenth Century," *Sea Enchantress: The Tale of the Mermaid and Her Kin* (London: Hutchinson, 1961), pp. 111–26. For the thirteenth-century hand, see Bulteau, *Mythologie des filles des eaux*, p. 55; Boullaye is mentioned in Benwell and Waugh, p. 122, and so is the mermaid skin, quoted from another traveler, Samuel Purchas, in *Purchas His Pilgrimage*; for the fetus, see Beatrice Philpotts, *Mermaids* (New York: Ballantine Books, 1980), p. 52; sirenomelia (fused limbs) is discussed in Lao, *Las Sirenas*, pp. 171–72; see also Fiedler, "From Theology to Teratology," *Freaks*, pp. 229–55. Although Peter the Great of Russia vainly attempted to get hold of the famous Amboina mermaid in the eighteenth century, mermaids do not appear in recorded collections until the 1800s.

part of the long-armed ape attached to the tail portion of the genus Salmo."[3] This "eighth wonder of the world" belonged to an American merchant, one Captain Eades, who had sold his trading vessel for five or six thousand dollars to pay for the mermaid, which he claimed to have bought from a Chinese fisherman, later exhibiting it "to the admiration of the ignorant, the perplexity of the learned, and the filling of his own purse." Maximizing its market potential, the fisherman claimed that before its death the mermaid had prophesied years of infertility and epidemics unless its likeness was distributed, starting a huge sale of pictured mermaids that more than made up for the mermaid's absence.[4]

Reputedly a Japanese export, these popular fake mermaids were made with the upper half of a monkey, the bottom half of a fish and an intricate web of wires, producing a truly hideous creature whose appeal resided far more in its mythical origins than in its concrete "revival." All the same, these fakes exercised the kind of fascination that their shrewd owners sought, reaping a substantial financial profit from what one of the most outstanding of these entrepreneurs, P. T. Barnum, called "Humbug, or the art of attracting attention."[5] In what would be one of his most famous hoaxes, garnering both himself and fake mermaids lasting fame, Barnum bought one of these stuffed creatures and showed it, amidst an unprecedented publicity scheme, at his American Museum on lower Broadway, in New York City.

A clever businessman with a knack for popular culture, Barnum caught on early to the curiosities rage, inaugurating his showman career

3. Philpotts, *Mermaids*, pp. 52–58, although Benwell and Waugh, in *Sea Enchantress* (p. 124), claim the St. James exhibit was a flop. Mermaid history is full of contradictions.
4. Andrew Steinmetz, *Japan and Her People* (London: Routledge, Warnes, and Routledge, 1859), pp. 193–94.
5. Barnum's lecture on humbug was personally attended by Francis T. Buckland, who quoted it in his *Curiosities of Natural History* (London: Richard Bentley and Son, 1893, second series, the Popular Edition), pp. 313–14. For an in-depth study of Barnum's career, see Bluford Adams, *E Pluribus Barnum: The Great Showman and the Making of U.S. Popular Culture* (Minneapolis: University of Minnesota Press, 1996).

SIRENOFORM INFANT. From M. Gould and Walter P. Lyle, *Anomalies and Curiosities of Medicine*, 1896. One of the most unusual fetal malformations known. Lacking exterior outlets for the digestive, urinary and genital systems, these fetuses, most of whom are female, are rarely born. The photograph is by Vera Hoar. *Parsons School of Design.*

MERMAID ADVERTISEMENT. One of Barnum's ads for the American Museum exhibition in 1842. *Museum of the City of New York.*

(his "true calling," after a series of short-lived business schemes) with a traveling circus called "Barnum's Grand Scientific and Musical Theatre" in 1836.[6] A few years later he contrived to purchase the American Museum collection, "the first Museum and most splendid collection in the United States," according to its founder and owner, Charles Willson Peale.[7] Begun as a gallery for Peale's own paintings in 1772, the American Museum eventually grew to house a substantial collection of naturalia, stuffed animals and artifacts, fully endorsing the kind of "natural and artificial curiosities" so typical of this time, a mix of disparate registers which, as in the wonder chambers of which these collections are but a residue, attempts to convey totality through the number and heterogeneity of its elements.

When Barnum purchased it in 1841, the American Museum included 234 animal cases containing bears, fish, reptiles and, most abundantly, birds; mineral and shell collections; Native American implements; assorted artificialia such as jugs from Pompeii and Herculaneum, model ships and historical paintings; and a fifty-foot glassed display of wildlife. Peale had pioneered this latter kind of exhibit, eventually known as a diorama, in the United States, as well as imitated London's "Eidophusikon" ("image of nature") with his "Moving Pictures with Changeable Effects," that included views of dawn, dusk and rainbows. Unwittingly following the tradition of Louis XIV, Peale also tried to obtain the embalmed body of a child.[8]

Not intimidated by abundance, Barnum immediately started to add to this collection, touring Europe for curiosities and attractions from 1844

6. Ann Tompert, *The Greatest Showman on Earth: A Biography of P. T. Barnum* (Minneapolis: Dillon Press, 1987), p. 29.
7. John Rickards Betts, "P. T. Barnum and the Popularization of Natural History," *Journal of the History of Ideas* 20 (1959): 353–68. See also Susan Stewart, "Death and Life, in That Order, in the Works of Charles Willson Peale," in Lynne Cooke and Peter Wollen, eds., *Visual Display: Culture Beyond Appearances* (Seattle: Bay Press, 1995), pp. 30–53.
8. For the embalmed child and the Eidophusikon, see Edward L. Schwarzchild, "Death-

to 1847 (from which he returned with the first living orangutan in the
United States) and leaving agents busily on the lookout for "novelties"
which helped transform the American Museum into a field trip for fami-
lies: elephants, a two-thousand-year-old mummy, automatons, cos-
morama rooms with over two hundred peep-show views of foreign cities
and landscapes, the first public aquarium in the country. Only the slip-
pery sea serpent, for which he had a standing offer, seems to have been
able to escape Barnum's grasp.[9]

Made prosperous by the Civil War's massive transit of soldiers eager
for distraction, and beset by calamities (his museums burnt down to the
ground three times), Barnum is better known nowadays for the circus he
cofounded in the 1870s; yet it was his work of the previous thirty years
that spanned the range of popular shows for decades to come, helping es-
tablish that unique and most far-reaching product of the United States,
mass popular culture. Baby contests, beauty pageants, human curiosities
(Tom Thumb, Chang and Eng, giants and dwarfs, femmes fatales[10])—
nothing escaped Barnum's "most morbid appetite for the marvellous"
and his ability to exploit physical and cultural difference by turning it

Defying/Defining Spectacles: Charles Willson Peale as Early American Freak Showman,"
in Garland Thomson, ed., *Freakery*, pp. 85–87; also Stewart, "Death and Life," in Cooke
and Wollen, eds., *Visual Display*, pp. 44–45. For a partial description of Barnum's mu-
seum, see Betts, "P. T. Barnum and the Popularization of Natural History," p. 354.

9. Adams, *E Pluribus Barnum*, p. 367; for a full tour of the American Museum, see the
museum's pamphlet: *Sights and Wonders in New York; including a Description of the
Mysteries, Miracles, Marvels, Phenomena, Curiosities, and Nondescripts, Contained in that
Great Congress of Wonders, Barnum's Museum; . . .* (New York: J. S. Redfield, 1849).

10. Although it is not certain that the famous "Spanish singer and adventuress" Lola
Montez (born Betty James in England in 1818) appeared in Barnum's shows, we do know
that by 1851 she was "holding receptions [in America] at which the privilege of shaking
the hand that had been held by so many royal princes was to be had for the fee of one
dollar," and that years later she was giving talks on "beauty," "gallantry" and "the comic
aspects of love" at St. James's Hall in London. Margaret Barton and Osbert Sitwell, *Sober
Truth: A Collection of Nineteenth-Century Episodes, Fantastic, Grotesque and Mysterious*
(London: Duckworth, 1930), pp. 134–42. Max Ophüls extrapolates upon the P. T. Bar-
num/Lola Montez collaboration in his extraordinary film *Lola Montés* (1955).

THE FEEJEE MERMAID. From *Struggles and Triumphs; or, The Life of P. T. Barnum Written by Himself*, 1927. "The upper part of the long-armed ape attached to the tail portion of the genus Salmo." *General Research Division, The New York Public Library, Astor, Lenox and Tilden Foundations.*

into something extraordinary. And, although he "crowded natural history into the spectacle of an evening," Barnum played a big role in the establishment of the natural history museums in the 1870s, particularly the American Museum of Natural History in New York and the Smithsonian Institution in Washington.[11]

The "Feejee Mermaid," which Barnum showed in the summer of 1842, was one of his earliest and most famous "humbugs," and a classic example of his modus operandi. Knowing that anticipation is the name of the game, Barnum bought the mermaid but, instead of immediately displaying it, he placed in the newspapers the story of a certain Dr. Griffin (in reality, one of Barnum's friends) who was on his way to London's Lyceum of Natural History with a genuine mermaid, found and preserved in the Fiji Islands. Barnum followed up this news story with pictures of mermaids (his manipulative use of printed media deserves a book of its own) and the distribution in public places of ten thousand pamphlets on mermaids. Finally, he secretly arranged a one-week show for Dr. Griffin and his mermaid at Concert Hall.

After the show was sold out and the public desperate for more, Barnum regally stepped in, announcing that Dr. Griffin would be showing the mermaid at the American Museum at no extra charge. Still, Barnum reserved his master stroke for the end. After thousands had paid admission to take a look at the fantastic mermaid only to find what in Barnum's own words was no more than a "hideous, shrivelled-up old mummy," the shrewd producer disingenuously claimed that if people were not satisfied with the mermaid, they still had their shilling's worth in looking at the rest of the museum. The exhibit not only tripled the museum's attendance in the first month but created a name both for Barnum (after this he became nationally known) and for fake mermaids, which gained a definite (if misspelled) identity.[12]

11. See Betts, "P. T. Barnum and the Popularization of Natural History," pp. 360–61.
12. See *Struggles and Triumphs: or, The Life of P. T. Barnum, Written by Himself*, edited,

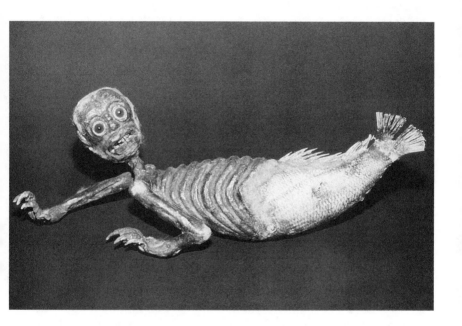

FAKE MERMAN. An even fishier type of mermaid. Originally sporting white hair, a beard and a mustache, this is one of a series of identical twelve-inch-long "marine monsters" made by the same artisan and then reproduced on postcards at the turn of the century. *Courtesy of Museo Civico di Storia Naturale, Venice.*

261

Mermaids' final transformation achieves something that even their legendary change into rocks could not accomplish, since as rocks or islands they lacked any particular shape and were therefore indistinguishable from other mineral formations. Fake mermaids produce the paradox of a petrified metamorphosis, that visual freezing of time proper to photographs, insects trapped in resin, and the inhabitants of Pompeii, forever cast in lava and ash. As such, mermaids are converted, mutatis mutandis, into mythical fossils—witnesses not so much to an elusive reality, but to the perennial desire to grasp it. Displayed in "dusty glass boxes," fake mermaids become the surrogate relics of ancient dreams. On this account, they are equivalent to the artificial ruins of Atlantis found in aquariums, or the scenes suspended in glass globes: visions for a culture fascinated by loss.

As rocks, mermaids embark on an allegorical process—transformed into the material remains of what they once were, they carry their myth inertly as a historical reference. As fakes, this process is completed: here, mermaids have turned into a veritable ruin—the decrepit version of their legendary selves—and, in so doing, they refuel their myth. Like those fake ruins which only after being covered by organic growth could lay some claim to their title, fake mermaids trace a highly idiosyncratic path that starts with their manufacture and ends with their cultural consumption as "natural fossils" (in the shape of supposedly embalmed corpses), garnering along the way the legitimizing marks of time.

The story of the fake merman whose hair had been randomly plucked out by souvenir seekers is a good case in point: jagged by such pillaging, the wear and tear which this particular fake underwent gave it an "aged" look, promoting its validity as a fossil.[13] Like the featherless Sirens before him, the bald merman unwittingly made a clean exchange, except

with an introduction, by George S. Bryan (New York: Alfred A. Knopf, 1927), vol 1, pp. 200-12.

13. See Buckland, *Curiosities of Natural History*, pp. 306–13.

that instead of swapping feathers for scales, he bartered the uncertain signs of merfolk realism for the irrefutable ones of historical decay, acquiring in this abject condition a degree of authenticity that even the most verisimilar rendition would have been unable to provide.

The paradoxical process of legitimation whereby mermaids acquire new life in death (both a figurative death as "found" sea creatures and a literal one as legendary figures) is the result of their tangible inscription in cultural experience—that is, mermaids' evolution from a merely symbolic to an allegorical register. By stepping out of the circumscribed, however mutable, boundaries of legend and literature, mermaids become for the first time susceptible to the ravages of time, even if only as ersatz mummies: away from the static mythical realm they always inhabited, mermaids enter the continuum of history. Further compounding this situation is their unprecedented exposure to public perusal: no longer ethereal creatures dancing in readers' imaginations, these half-human, half-fish beings can now be seen and touched, joining as collectible commodities the legions of underwater "curiosities" exhibited in museums and salons.

What takes place with fake mermaids is similar to the blurry effect produced by the reprinting of images from copies rather than originals: what is lost in precision is gained in illusion. This is because the myth's essential nature places it above all temporal contingency, allowing it to travel through time relatively intact and by definition setting it apart from lived experience. Inversely, the rugged, imperfect texture of the myth's material embodiment locates its object in that familiar space which encompasses both dreams and touch, senses and matter, night and day: the world of daydreams. Here, the remains of myths create an interregnum between reality and fantasy which distorts them without entirely erasing their particular configurations, and whose fugitive intensity is unparalleled by either.

The Copy

*A Stupendous Mirror of Departed
Empires.*

P. T. Barnum on his
1889 Barnum and Bailey Circus

Y the mid-1800s, then, mermaids have turned into the most confusing of beings, adding to their amphibious nature this triple crossover between fact and fiction, life and death, real and fake. All three account for fake mermaids' insertion into melancholic kitsch, that is, into modernity. For while mermaids acquire market value as spectacles, this very tangibility rips off the magical halo they held as mythical figures, only to return it in the form of a degraded version of sublime horror.

Mermaids' new status as "real" things elicits a mix of awe and disgust that, beyond all suspension of disbelief, is deeply intertwined with their increasing hybridity. As river nymphs or sea enchantresses, mermaids' polymorphic nature and their relation to water represented the fluidity and mutability of the unconscious. This connection withstands all the myth's cultural transits and manifestations, both positive and negative,

including its modern "drying up": even as shriveled prunes mermaids retain some of their symbolic characteristics. However, as is true with all allegorical processes, they have undergone a change, and instead of expressing the vitality of the unconscious, fake mermaids stand for that loss of life which is the stuff of nightmares.

This transformation takes place through a peculiar intertwining of mermaids' literal and metaphorical deaths, which unite to create a being that only through its condition as a replica attains a sense of reality. Mermaids' "death," instead of leading to disintegration through the natural processes of decay and corruption, introduces them to a process of artificial substitution where the absence of real corpses is compensated by the proliferation of fake ones. In other words, the demise of the mythical referent is represented not only literally as a ruin (the aging and decrepit merman) but also metaphorically as the modern emblem for symbolic loss: the copy, ruin of the original.

This counterfeit condition of fake mermaids is perfectly consistent with their modern status, since their lack of soul condemned them to being "a mere elemental mirror of the outward world," as illustrated in *Undine*, which predates Andersen's *The Little Mermaid* by a good twenty-five years and may be considered its direct antecedent.[1] A capricious and playful water nymph raised by an old fisherman and his wife, Undine obtains her soul upon wedding (or, more specifically, sexually consummating the union with) her beloved Huldebrand. She immediately becomes a "good woman": patient, devoted and subservient, tolerating her husband's waywardness and inconsideration in the name of an emotional depth she believes only creatures with souls can attain. The

1. Written and published in 1811 by Friedrich, Baron de La Motte-Fouqué, *Undine* was highly praised by Goethe and Heine, and was, according to Edmund Gosse, "the book Richard Wagner was reading on the last evening of his life." Gosse described Baron Friedrich as "the latest and the most uncompromising of the Romanticists" in his introduction to *Undine* (New York: Frederick A. Stokes Co., n.d.), pp. 3–17.

soul "reflects the world from within," she claims, something Undine's uncle, a powerful brook enraged by the ill treatment his niece is suffering, cannot understand. Therefore, mermaids are fated to know only the world of appearances: they lack the full range of experience that only a (human) soul can provide, an experience the story makes synonymous with the Christian ideology of suffering. Consistently, Undine declines her uncle's protection and warnings for the sake of her newfound human identity, in which pain and sadness make her a complete person, in contrast to the lighthearted gaiety—and shrewdness—that used to characterize her as a mermaid.

The story draws a correspondence between the soul's reflection of the inner world and the ocean's translucent rendition of the underwater one: covered by crystal domes, mermaids' residences give the impression of being inside Victorian glass globes, while the soul appears as a crystal ball filled with misty visions.[2] Furthermore, the depths of the submarine realm, much like those of the soul, can be observed from the human vantage point of "above," as when a dream takes Huldebrand over the Mediterranean and the sea becomes transparent, showing him the weeping Undine on its floor. The "inner recesses" of the soul and the bottom of the ocean are therefore simultaneously established as similar and distinct: similar because they both present a panorama of underlying, "hidden" motivations; distinct because these motivations constitute, respectively, the domains of culture and nature.

2. Perhaps the first mention of mermaids' underwater crystal palaces is the one in *Undine:* "In resounding domes of crystal, through which the sky looks in with its sun and stars, water spirits find their beautiful abode. Lofty trees of coral with blue and crimson fruits gleam in their gardens; they wander over the pure sand of the sea, and among lovely variegated shells, and amid all exquisite treasures of the old world, which the present is no longer worthy to enjoy. All these the floods have covered with their secret veils of silver, and the noble monuments sparkle below, stately and solemn, bedewed by the loving waters which allure from them many a beautiful moss-flower and entwining cluster of sea grass. . . ." From F. de la Motte-Fouqué, trans. Rev. Thomas Tracy, *Undine* (London: Macmillan and Co., 1897), p. 89.

THE GREAT WAVE. Photograph by Gustave Le Gray, c. 1856. Known in French simply as "Marine," this is an early photographic rendition of a subject whose ongoing movement cameras have tried for decades to grasp. *The Metropolitan Museum of Art, Gift of John Goldsmith Philips, 1976 (1976.646).*

SEAHORSES MATING. From T. F. H. Publications, *Seahorses*, 1956. Seahorses and their cousins the pipefish are the only known creatures where the males exclusively care for the eggs after fertilization and bear the young. Here two seahorses court and then mate, with the female's ovipositor penetrating the male; later, the male gives birth to a tiny seahorse from his brood pouch, which holds up to six hundred eggs.

In *Undine*'s Romantic perspective, the human psyche is symbolically represented in the soul, yet materially manifested in the forces of nature which, like those of the unconscious, are very powerful but, lacking self-knowledge, remain ultimately vacuous. In this way, *Undine* participates in the modern duality between rational and irrational, attributing to the former a moral superiority in the form of a "reality essence" (only by having a soul can life be experienced fully) whose absence dooms the rest of the natural kingdom—including spirits, although they have the power to materialize at will—to be nothing but empty appearance.

The impact of the soul is such that it transcends the interspecies boundary, something that not even love does successfully, since Huldebrand's betrayal is based on his ambivalence towards his wife's hybridity. Despite such an indication that having a soul is no guarantee of goodness, the message comes through loud and clear that souls redeem their possessors from any pre-soul shortcomings. *Undine* can be read as the battle between these two conditions, with final victory—despite all temptations—on the side of those who have been illuminated with a soul at the expense of their most cherished desires. This is reiterated in the fact that, regardless of her return to the underwater world, Undine gets to keep her much-earned soul and to lay claim over Huldebrand, whom she drowns in her tears the night of his second marriage. Her rival, Bertalda, on the other hand, is condemned for being vain and greedy—that is, for paying too much attention to appearances such as beauty and riches—and punished by promptly becoming a virgin widow.

This duality between appearance and essence follows the same theistic paradigms that subordinate allegory to symbol—the former considered empty and exterior, the latter full and interior. Their modern version, true to its industrial genesis, is the opposition between copy and original, which emphasizes seniority and exclusivity in a time when traditional precepts are receding and the boundaries between natural and artificial are being recast. Unlike their cultural successor, the postmod-

COLONY OF NESTING FLAMINGOS, BAHAMAS, WEST INDIES, 1905.
Featuring an array of daily activities, this is one of the few dioramas that represent crea-
tures in large numbers. The sheer volume of three-dimensional figures in the front

enhances the illusion of continuity with the painted backdrop. The most beautiful specimens of each kind of creature were often sacrificed for the sake of dioramic display. *Courtesy ot the American Museum of Natural History, neg. no. 3953. Photo by R.E. Dahlgren.*

271

ern simulacrum, which has no original (since mermaids do not exist, fake mermaids may be more properly considered simulacra), copies usually refer to an antecedent that they attempt to double. The loss or absence of this original is compensated, respectively, by both the copy and the simulacrum with sheer quantity.[3]

Copies engage two processes that, although connected, do not always go hand in hand: replication and seriality. It is the conversion of the first into the second that distinguishes the modern copy from all previous ones, since only with industrialization does serial reproduction become a major cultural force. The representation of a representation, a copy lacks all significatory entitlements. From a symbolic point of view, it does not stand for anything or, more precisely, it indicates referential emptiness. As such, copies are excluded from the hierarchical ladder of meaning, left to do what they do best: replicate themselves. Yet, in so doing, copies create an unprecedented accumulation that produces the contrary effect to emptiness: saturation. This representational overload is what eventually succeeds in turning the tables on the symbol, since it creates a new signifying landscape where symbolic meaning is rendered superfluous.

In this alternate vision, appearances (whether as allegories, artifices, copies or simulacra) are not divorced from but rather deeply constitutive of meaning, to which they add a material dimension that, instead of reducing, multiplies its potential in unpredictible ways. Fake mermaids, for example, are the manifestation of a modern longing for tangibility and organic connection that is quite absent from their mythological representation. Mermaids' shift from a symbolic, impalpable existence to an allegorical, materialized state attests the increasing importance of appearance in a century obsessed with empirical proof.

As symbols, mermaids' hybrid condition—their ability to transit be-

3. For the simulacrum, see Jean Baudrillard, *Simulations*, trans. Paul Foss et al. (New York: Semiotext[e], 1983).

THE DEVONIAN DIORAMA. This diorama from the now-defunct Earth History Hall shows the sea floor around Buffalo, New York, about 350 million years ago, during the Devonian period. A straight nautiloid cephalopod and a coiled nautiloid cephalopod are featured among trilobites, corals and crinoids. *Courtesy of the American Museum of Natural History, neg. no. 333960.*

273

tween human and spiritual spheres—is extremely relevant to a culture imbued with supernatural concerns and caught, half modern and half traditional, in a shift between two states. Once these concerns take a back seat to the more immediate displacement occasioned by industrialization—which replaces the organic with the mechanical and the spiritual with the material—the symbol loses its cultural function, and must be recycled into new meanings (that is, adapt to the changing times) in order to survive. In this context, the material world takes precedence over the metaphysical one, which until now it had merely represented, and the same traits that had been relegated to a secondary status—the corporeal, "surface" aspect of things—step into the foreground.

IN THE JAWS OF THE CARCHARODON MEGALODON, 1927. Nothing like the restoration of a fossil shark's jaws for a good photo-op. *Courtesy ot the American Museum of Natural History, neg. no. 12448. Photo by J. Beckett.*

Fake mermaids occupy a very particular place in the seriality scheme because their manufactured quality—the fact that they are handmade as opposed to mechanically produced—furthers the illusion that they are real creatures belonging to that organic, pre-industrial world which the nineteenth century was both annihilating and pining for. Furthermore, despite their popularity, fake mermaids are in short supply, a rarity which enhances their value as curiosities, and which, along with their

homeliness and the aging process they now undergo as objects, locates them indisputably in another, or rather in an in-between, era. In short, fake mermaids represent a kind of simulacrum whose manual production and scarce multiplication distinguish it from the seriality that characterizes most modern copies.

This unique positioning facilitates fake mermaids' imaginary shift from construct to fossil (that is, from artificialia to naturalia) as well as their insertion into the mode of accumulation and exhibition that supervened the collections of natural history: dioramas and Victorian interiors. Applying strategies of selection, decontextualization, and transformation, interiors and dioramas strove to scenify and promote their particular vision of culture. In a way, they can be considered as the private and public expressions of the same collective urge. For, while Victorian salons became the final—and intimate—resting place for the Wunderkammern's scattered remnants, dioramas still found a way to maintain the public-exhibition spirit of the old collections in those awesome still-life scenes that first surfaced in curiosity museums like the one which made Barnum's career.[4]

Enclosed spaces where moments have been captured—like the creatures inside them—for visual delight, dioramas' "educational" or utopian intent (to give us a slice of life) becomes completely secondary to their impact as voyeuristic spectacles—that uncanny feeling of secretly watching what is forbidden or impossible. Dioramas materialize the reconstructed memory of reminiscence, forgoing both the specimens' lived moment and their death. Built like their direct predecessors, curio cabinets, dioramas are three-walled rooms (later reduced to boxes)

4. While Wunderkammern scenified a magical vision of the universe, dioramas often re-create its nemesis: natural evolution, a historical notion of nature where creatures develop from the general to the specific. For dioramas, see Donna Haraway, "Teddy Bear Patriarchy: Taxidermy in the Garden of Eden, New York City, 1908–1936," *Primate Visions: Gender, Race, and Nature in the World of Modern Science* (New York: Routledge, 1989).

whose fourth wall is made of glass. Inside, every inch is filled with the kind of meaningful detail that eventually adds up to one big elaborate narrative: walls are used as fantastic backdrops, floors covered with the organic matter pertinent to the scenery, narrow spaces filled with dried or human-made trees and plants in order to create an exact replica of an imagined situation: animals at rest, animals feeding, animals staring blankly ahead.

As long as the artificial quality of this experience, no matter how partial or fantastic, remains in the forefront, it can be salvaged for the peculiar history of death and decay that constitutes melancholic kitsch. However, when their predominantly spatial narrative is superseded by a temporal sequence (as in the case of the ermines playing tea time in the Crystal Palace, which alludes to a human habit inscribed in time through repetition), natural history specimens immediately wax nostalgic and miss the opportunity to be rescued from their temporal paralysis. Not all is lost, however. Natural history specimens still can be redeemed as melancholic kitsch if rescued from the pretended continuity of reminiscence before turning into nostalgic kitsch.

While re-creating a utopian moment, naturalia are nostalgic; yet once they are acknowledged as nothing more than empty carcasses, organic fossils become susceptible to being allegorically refetishized, their temporal allusions transformed into a spatial landscape, a "petrified forest" where time itself has become a scenario. No longer the emblem of an intact memory, the organic fossil is now clearly a decayed fragment of the past, susceptible to the passing of time. Slowly, dioramas crumble and fade, becoming along with the musty smell of natural history museums and curiosity shops the relic of an imaginary moment.

This is why fake mermaids are both an extension of and a counterfigure to the ermines' tea party. While the latter displays a more blatant form of kitsch, "softening" (as classic arguments on kitsch would have it) the effect of death through the sentimentality of its anthropomorphic re-

creation,[5] fake mermaids are the dystopian side of that cuteness, bringing to the fore the deterioration and decay which were concealed, or rather preempted, in the ermine scene. In other words, the same mise-en-scène that "gives life" to the ermines' tea party and dioramic displays in their spatial narratives cannot but underscore mermaids' caducity, emphasizing their grotesqueness in an attempt to pass them off as real creatures. What must be concealed in the presentation of the ermines becomes the foundation for the presentation of the fake mermaids: the mortality that is a precondition for all organic beings. Fake mermaids' deadliness (as opposed to the ermines' or even dioramas' pretend liveliness) is subjected to such a high degree of spectacularity that it is commodified as a modern curiosity, death itself becoming kitsch—that is, melancholic kitsch.

5. On the softening effect of kitsch on death, see Friedlander, *Reflections on Nazism.*

The Dying Salon

*To live in a nineteenth-century interior meant
to remain intertwined and hermetically
wrapped in a spider's web, the events of the world
hanging in suspension like the bodies of
insects whose lymph has been sucked out. One
does not wish to tear away from this cave.*

WALTER BENJAMIN,
"The Interior, Traces," 1927–29

APPEARING in the mid-1800s, the fictional figures of Captain Nemo and the Little Mermaid represent the disparate relationship of men and women to modernization, as well as the different and uneven results of their efforts. Both attempt to break with their worlds and ultimately fail in doing so, but in the process achieve an intermediate step representative of that complex final phase of the shift from tradition to modernity which is the nineteenth century. How these figures are positioned regarding this moment is emblematic of gender distribution, which undergoes few changes—or rather, tolerates few of the changes that it goes through—and determines what aspects of this period's production will be considered valuable and which discarded as kitsch.

Despite all his crimes (murder, kidnapping, plundering) Captain Nemo goes down as a hero, the mastermind behind that vehicle of war cum traveling museum called *Nautilus*. His death is a reward, allowing him to finally merge with that underwater world he so skillfully and longingly occupied.[1] Nemo leaves behind inventions and discoveries that it will take at least another century to match, making of him a character well ahead of his time: the technical and scientific development to which he was dedicated became the predominant discourse of the twentieth century, with progress and efficiency attempting an absolute control over matter.

Mermaids' effort to subvert their destiny, transcending a world of leisure and pleasure to become whole social beings, succeeds only in shattering the strength of their hybridity, splitting it cleanly along two disparate poles. Mermaids either disappear in the extreme etherealness of a yet-to-be-gained spirituality as sea nymphs, remaining in this limbo for at least another three centuries, or they materialize in the rigidity of rock sculptures or the travesty of fake fossils, exhibited as grotesque curiosities in the early 1800s and then lapsing into the relative oblivion of fairy tales.

What is most striking about this modern mermaid duality is its excessiveness: for the fictional mermaids, there is no ground between foam and rock—they disappear as creatures, transformed into inert matter suspended in air or hanging from wires. In this extreme contrast, inhuman beauty or gruesome ugliness, there is a banishment of the ordinary that is not replaced with the admirable extraordinary (as in Nemo's case) but simply left bare, as if it didn't exist at all. In mermaid lore, women are only conceived of as fantastic or repulsive, with no mediating grada-

1. Nemo's death is left uncertain in Verne's text, but majestically rendered in Disney's film, where we see him raise a solitary arm in agony amid the red and blue velvet plushness of the *Nautilus* to open the golden folds of its gigantic eye and watch, for the last time, his beloved underwater realm as it is about to inundate the submarine.

UNDER THE FALLS, CATSKILL MOUNTAINS. Wood engraving in the style of Winslow Homer, from *Harper's Weekly*, 1872. Despite the constraints of a heavy and elaborate wardrobe, women managed to explore and enjoy nature throughout the nineteenth century. *Miriam and Ira D. Wallach Division of Art, Prints and Photographs, The New York Public Library, Astor, Lenox and Tilden Foundations.*

tions, including those that pertain to what is for many woman's uncontested territory, domesticity.

Starting with seventeenth-century grottoes and peaking with Victorian interiors, those Wunderkammern of the nineteenth, women produced a vast array of work related to natural history (everything from books to décor) that is now the stuff of an important part of twentieth-century collecting—a sort of posthumous artistic production. This is particularly relevant when we look at the different results that middle-class European women and men derived from their engagement with natural history: when exercised by men, it was worth scientific societies and museums; when practiced by women, it was downgraded to a superfluous triviality—"the naturalism of the boudoir." [2]

Yet women were an important force behind the nineteenth century's natural history boom, which not only expanded this field, but fully established as public domain what had until then been limited to aristocrats' curio cabinets or scientists' laboratories. Women worked the field in multiple capacities, and although several were among the best-known collectors of specimens (like Mary Anning, who collected fossils) and others (such as Susanna and Anna Lister) wrote or illustrated books about natural history for their spouses and male relatives, most often they excelled in the one area left to them, the home, transforming it into a veritable household museum.

Ironically, while natural history museums have become practically a thing of the past, worth visiting more for their dated displays which act like time capsules than for their constant efforts at remaining contemporary, the arts and crafts of Victorian ladies are actively sought in the

2. On women and natural history, see Barber, "The Naturalist of the Boudoir," *The Heyday of Natural History*, pp. 125–38. The title of this chapter was inspired by James Elaine's "Objects from the Dying Salon," shown at the Thread Waxing Space, New York, in the fall of 1995. This exhibition made death literal by splattering the corpses of birds and small animals on medieval, Renaissance, and Romantic lithographs and plates.

small collectors' circuit, increasingly so as this century comes to an end and those objects turn over a hundred years old, gaining a new legitimacy as relics. At the moment of its production and in the time since, however, this domestic art—and its corresponding museum, the home—was banished from the sphere of serious activity on the grounds of being superfluous, sentimental, pedagogical, and worst of all, imitative. Like mermaids, Victorian interiors seemed to lack the capacity for transcendence claimed as the hallmark of all veritable artistic activity.

Nineteenth-century interiors and the objects they contained are tributes to a preoccupation with death that manifests itself quite literally in the creation of closed atmospheres loaded with mortal reminiscences. In a way, this compulsive collection of aureatic debris recalls the pyramidal chambers of Egyptian pharaohs' tombs, replete with their most cherished objects. Queen Victoria certainly met this challenge: after her beloved Prince Albert died, his rooms were kept intact and every evening for all of forty years his clothes were laid out on the bed and the washbasin filled with fresh water, ready for his use.[3] In this Victoria was only a creature of her time: after the elaborate preparations for death and funerary rites of the previous centuries, the nineteenth turned to mourning as the center of death, focusing more on the living than on the deceased.[4]

The emphasis on what remained behind—the bereaved, but also the defunct's literal remains—was itself the consequence of yet another dramatic disjunction that took place during the 1800s. Until then, burial sites had lain within the cities, enabling the peaceful cohabitation of dead and living. Starting in the late eighteenth century, hygienic concerns and the secularization of burial rites transferred cemeteries to the

3. Strachey, *Queen Victoria*, pp. 402–3.
4. See Michel Vovelle, *L'Heure du grand passage: Chronique de la mort* (Paris: Gallimard, 1993); and Philippe Ariès, "The Reversal of Death: Changes in Attitudes Toward Death in Western Societies," in David E. Stannard, ed., *Death in America* (Philadelphia: University of Pennsylvania Press, 1975), pp. 134–58.

FADING AWAY. Photograph by Henry Peach Robinson, 1858. Enjoying "the mixture of the real and the artificial," Robinson composed this print from five different negatives, posing the models separately, including a healthy girl of about fourteen. Believing that because this was a photograph it was a truthful representation, the public was shocked by its subject. *Courtesy of the Royal Photographic Society Picture Library, Bath, England.*

outskirts, giving rise to the extraordinary necropolises of the nineteenth, whose neoclassic and neo-Gothic extravagances furthered that cult of death so dear to the Romantic spirit. One of the most striking of these relocations was that of the Parisian Cemetery of the Innocents, whose nocturnal dismantling helped create an atmosphere of mystery around death, marking the beginning of an era.

Considered the great age of mourning, the nineteenth century glorified memories, commodifying them as souvenirs and replacing the earlier rites with a culture of objects where this new sensibility was consistently expressed. Tears, for example, were represented by pearls, which along with agates became the fashionable mourning jewelry. The imbrication of the physical self in this death cult, whose enormous production is known as "Victorian funeralia," may be found in residual tokens such as the bizarre "hairwork" of the time, where funerary depictions of graveyards, urns and tombs of loved ones were fastidiously made from the hair of the deceased, with do-it-yourself hair kits available until the 1870s. Similarly, hair jewelry such as necklaces and earrings, and the better-known hair lockets (where hair would eventually be replaced by photographs), were an important part of the souvenir circuit.[5] The morbidity of retaining such inanimate, though precious, organic matter has an eerie paradox in that, for all its deadness, hair, along with nails, continues to grow from corpses for a time.

In this context, the ongoing preservation of natural specimens, either dead (butterflies), as fossils (shells), or in some kind of suspended animation (as in aquariums and their solid replicas, glass globes), reveals how the modern transformation of daily life was felt as deadly by the same culture that promoted it. The irony is that the attempts to retain this disappearing notion of life were exercised precisely through the science and technology that were displacing it. Just like the Wunderkam-

5. Some hair jewelry can be seen at the Victoria and Albert Museum in London.

mern before them, Victorian interiors were both a more personal expression of those rational discourses and simultaneously the repository of their quarries, with the predictable results of an object, or universe of objects, which were located in both the past and the present without fully belonging to either.

Extremely private spaces that acted as refuges from an increasingly pervasive public realm, nineteenth-century interiors sampled the outside world, bringing it back into the safety of an individual home where

THIRTEEN-YEAR-OLD N. W. THOMPSON IN A CASKET WITH FLOWER WREATHS. Fort Wayne, Indiana, 1889. This cabinet card indicates the growing use of flowers and wreaths (often with the name of the donor or a mourning inscription) in funerals. *Courtesy of Stanley B. Burns, M.D., and The Burns Archive.*

it was susceptible to domestic control. The Victorian interior is an isolated space where the most cherished furnishings are meticulously arranged, side by side and on top of one another, creating an intimate dialogue between things which only those versed in these secrets can de-

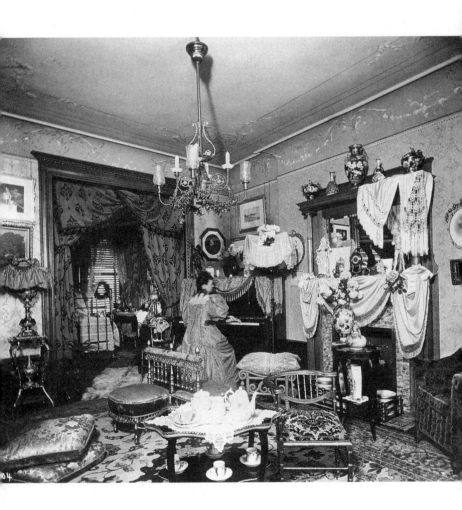

PARLOUR IN THE HOME OF MRS. LEONI, 1894. Photograph by Joseph Byron. Clutter was the Victorian answer to the existential emptiness brought about by rapid industrialization and the commodification of eras and places. *Museum of the City of New York.*

cipher. Although lacking the explicit religiousness of home altars, Victorian interiors render homage to the deities of the nineteenth century: things. It is for the admiration of the peculiar beauty of useless, decorative things that interiors gear their baroque arrangements, carefully construing infinite details into atmospheres conducive to leisurely daydreaming.

Miniatures, exotica, travel souvenirs, containers of all types (glasses, boxes, drawers), the world of things reproduces itself in the Victorian interior like in a hall of mirrors. Tea tables display complete—and unused—tea sets whose delicately painted flowers recreate bountiful bouquets and evoke paradisiacal gardens; glass armoires exhibit fanciful series of souvenir spoons or dishes; intricately ornamented albums bulge with images of family members themselves posing in fake scenarios; floors are covered by carpets in turn paved with Oriental rugs; walls flaunt elaborate wallpaper that double-frames the numerous pictures hanging from them like open windows to even more worlds; plush leather armchairs and velvet sofas lie around, seemingly inviting onlookers to relax and indulge in the pleasure of civilized conversation—that which occurs in hushed tones and abounds in foreign references.

Upon entering an interior, things acquire a family: immediately, their singularity finds a place in which to be exalted, their many stories— about their images, materials, manufacture, the place and occasion where they were found or received—create a whole microcosm that adds an extra layer to the already excessive one of the interior. Nevertheless, this saturated space is more than capable of opening a nook in its overcrowded habitat to the newcomers, gently moving over some of its gadgets to accommodate more treasures within its ever-expansive folds. Victorian salons are palaces of distracted contemplation, not places of action. Activity here is present only as an end product, an object and its story, dead before arrival, alive only in the moment eyes are set upon it

or lips softly recount its narrative. Once invested with such a degree of subjectivity, things gain a cultural life of their own—they can no longer be distinguished as separate entities, but rather constitute in themselves an extension of the human experience, becoming fully personalized. In this sense, the enclosedness of Victorian salons acts as a metaphor for a collective privacy—the act of remaining within oneself—in the face of massive reproduction.

In Victorian interiors, time is a sign, a marker of a certain taste or style, rid of allusions to movement, progress or development; it is rendered meaningless in an atmosphere whose very stifledness solicits that the world remain still for its abandoned contemplation. As in the souvenir, time is present here in the form of death: dried flowers, stuffed animals, the claustrophobic clutter of a place where there is no space for movement nor windows for air or light. The Victorian interior is like those attics or chests where people place objects that are never to leave them—a place that is not inhabited but occasionally visited, closed to the gaze of strangers, impermeable to unwelcome inquiries. Slowly, its many treasures begin gathering time in the form of a thin layer of dust that soon becomes as integral to them as low lighting and the musty smell of places where there is no ventilation. Things come to rest here in the certainty of a safe haven, a place where they will be handled adoringly, allocated to a shrine where they can themselves look back at the world.

In Victorian interiors things' whole mission becomes one of adornment and leisure: to witness an excess of time and a surplus of production, magnificently displaying the variegated intricacies of human fantasy in their endless artifice. It is this quality of uselessness, of simply giving free vent to the imagination, that makes them be felt as unnatural—a production that does not grow organically from an evolutionary process, but rather stems from the overripeness of a certain condition, as if time had gotten stuck but continued to generate its

substance, causing an unbounded accumulation, an excess that covers the horizon.

Rather than a natural cycle of life and death, nineteenth-century culture entered into a state of what can only be called extreme acculturation. This is the endless reproduction of cultural artifacts for culture's sake, justified with the one notion on which the entire apparatus of modernity was founded: novelty, the belief that only what was new—ideas, mechanisms, systems, objects—could guarantee progress and lead to that recently discovered utopia, the future. Paradoxically, when this idea of the future struck Western culture the new sense of time that arose brought an end to temporality. The cyclic movement of history was dissolved once the present was seen as discontinuous with the past because of

QUEEN VICTORIA WITH PRINCE EDWARD. Photograph by Hughes and Millens, 1896. An inconsolable widow, Queen Victoria wanted all the court and high society to be in mourning for her adored Prince Albert. *By courtesy of the National Portrait Gallery, London.*

the future: in order to progress, the past had to be left behind, rather than integrated meaningfully.

In other words, the movement of modernity, a distinctly forward motion as opposed to the cyclic movement of tradition, forced the past behind so that, for the first time, culture could look back at it as something completely different from the present. This self-consciousness, this ca-

pacity to gaze contemplatively at the self as something other, unrooted in chronology, engendered a desperate need to reclaim a temporal belonging. But given the sense that there is only progression and forward movement, all other times were seen as immobile, suspended in the vacuum of a now abstract and deracinated past. Void of temporal essence, the past could only manifest itself as extinct of all life, as a fossil. It was in the careful rearrangement of such fossils that time took shape for modernity—in the deadly stillness of a landscape made up of objects.

𝕸𝖞𝖙𝖍𝖎𝖈𝖆𝖑 𝕸𝖊𝖒𝖔𝖗𝖞

The best profit
of future is the past.

Chinese fortune cookie

ITSCH is the attempt to repossess the experience of inten-
sity and immediacy through an object. Since this recov-
ery can only be partial and transitory, as the fleetingness
of memories well testifies, kitsch objects may be consid-
ered failed commodities. However, in this constant movement between
partially retrieving a forfeited moment and immediately losing it again,
kitsch gains the potential of being a dialectical image: an object whose
decayed state exposes and deflects its utopian possibilities, a remnant
constantly reliving its own death, a ruin. This is why kitsch may be seen
as the debris of the aura: an irregular trail of glittery dust whose immi-
nent evanescence makes it extremely tantalizing.

Simultaneously imbued with both the aura's mysticism and the rea-
sons for its destruction, kitsch exudes the peculiar sadness of broken or
even half-forgotten dreams, which allow the oneiric realm to linger in our
consciousness, but also free us from their powerful seduction with their

eventual disappearance. Insofar as the intrinsic impossibility of kitsch leads it to be continually forgotten, making up a fundamental part of that familiar circuit of abandoned objects found in flea markets, thrift shops, antiquarian houses and discount stores, kitsch gains yet another layer of death: the dust of oblivion.

To fully comprehend this process we must return to the two types of memory discussed earlier. The emphasis then was placed on the memory of the unconscious, which, sacrificing the continuity of time for the intensity of experience, produced a fragmentary remembrance that, when commodified, became the souvenir. The souvenir suffers another death when, shattered and multiplied by massive reproduction, it is further distanced from the remembrance and subjected to consumer interpretations. This last death also heightens the object's melancholia, since it acquires a new degree of loss that triggers the unconscious desire to recover what is gone.

If the final product of the process of remembrance is this melancholic kitsch, then reminiscence, that other form of memory, which sacrifices the intensity of experience for a conscious or fabricated sense of continuity, generates a type of kitsch that is better known, but more limited in its cultural impact and scope: nostalgic kitsch. Incapable of tolerating the intensity of the moment, reminiscence selects and consolidates an event's acceptable parts into a memory perceived as complete, dispelling any recognition of the mythic load that gave the original experience part of its now forgotten intensity. This reconstructed experience is frozen as an emblem of itself, becoming a cultural fossil. As the intact shell of a supposedly founding experience, the cultural fossil is quickly fetishized: its mere presence serves to evoke and legitimize an origin whose imaginary autonomy acquires utopian overtones.

The disparity between the souvenir and the cultural fossil clearly exposes the latter's deceit. Intentionally fragmentary and involved in a process of commodification highly marked by death, the souvenir never places any claims on history—it is content with precariously reliving its

loss. The cultural fossil, on the other hand, places all its stakes on being a fundamental part of history, asserting a totality it never had, yet remaining moored in time. The cultural fossil lacks the movement which should characterize history and which is, in fact, more akin to the souvenir's deadly transformation into kitsch, as well as to kitsch's constant shifting as a cultural practice.

Once commodified, cultural fossils lead to a nostalgic kitsch that yearns after an experience whose lack is precisely glossed over by the desire for a utopian origin, producing a perfect memory of something that really never happened. The Crystal Palace ermine scene was mentioned earlier as a good example of such nostalgic kitsch, particularly because it traces the transformation of natural fossils into cultural ones. Instead of referring directly back to a lived moment and the full awareness of its death, like Rodney in his glass globe or even the fake mermaids do, the ermine scene erases this death and substitutes for it an impossible performance whose anthropomorphic qualities endear the ermines to us by alluding to a primal family scene. The utopian qualities of this scene account for both the nostalgia it inspires (nostalgia always longs for a lost golden moment, real or imaginary) and the specific kitsch it produces—one that is rigid and extremely circumscribed, since all its strength is spent on re-creating something that was never there in the first place or that has been extremely glorified.

In other words, nostalgia remits back to the conscious or reconstructed memory, rather than to the experience that generated it. Because of this, nostalgic kitsch lacks power of evocation, the intensity of the aura (both as mythic time and as experience) and the capacity to move in time as a cultural practice (unable to leave the past, it is trapped in a re-creation that fails to engage or transform the "original" experience). Consequently, it cannot be a dialectical image. Nostalgic kitsch is a dead-end street, as finite as its attempt to discard the complexity of the event that underlies its very existence.

What distinguishes nostalgic kitsch from melancholic kitsch is not whether they remit to a real or a mythical memory: as far as the unconscious is concerned, reality is mainly contingent on the vehemence with which events—imaginary or factual—are lived. The larger the impact, the more real the event is felt to be and the more potential it gains as a mythic memory whose very intensity uproots the experience from a signifying context, realigning it with similar experiences. In this sense, most memory is mythical, since rather than organizing itself exclusively around conventions of what is real (for example, temporal or spatial paradigms—chronology and location), memory also follows its own peculiar system, where cognitive and perceptual elements are tailored according to collective or individual universes of needs and desires. These customized universes are in constant flux and engage in endless power transactions, making their myths legitimate to some and not to others, viable one day and unthinkable the next, as the roller-coaster evolution of Atlantis clearly demonstrates.

Consequently, what matters most for the distinction between nostalgia and melancholia is not the validity of the memory referent, but the type of cognitive process (essential or experiential) through which an event is reconstituted as a memory. If the event, whether factual or fictional, is translated into the symbolic realm—that is, deprived of immediacy in favor of representational meaning—its mythical aspect is frozen into a cultural fossil. The event dies both as an experience and as a memory (insofar as memories are alive and capable of being involved in transformation), becoming fixated and unable to relate associatively with forthcoming events. Symbolic myth stands for an essential, ultimately intact and unreachable memory whose reminiscence must retain these same characteristics.

Nostalgia is about a past whose strength lies in its lack of immediate historical contingency, that is, in keeping the distance of abstraction. Golden ages are necessarily nostalgic, since inscribing their memory in

S<small>AINT</small>-C<small>LOUD</small>, J<small>UNE</small> 1926. Photograph by Eugène Atget. From 1901 until his death in 1927 Atget photographed the châteaux and parks of the French kings and the noble families of the Ancien Régime. The image here is the simplest of his long series of the reflecting pools at Saint-Cloud. *The Museum of Modern Art, New York. Abbott-Levy Collection. Partial gift of Shirley C. Burden. Copy Print © 1998 The Museum of Modern Art, New York.*

current time would undo that state of idealization from which they draw their sustenance. Ironically, while nostalgia sacrifices fundamental aspects of an event in order to inscribe it into a reconstructed historical continuum (cultural or individual), it simultaneously kills any possibility that the event, in its present state as a memory, may have of being engaged historically as an experience, producing further meaning or change. The symbol takes events away from their actual historical context in order to subordinate them to its own paradoxical temporal paradigms—a time out of time.

Symbolic memory and its ensuing nostalgic re-creation choose to eliminate the present in order to retain an untouchable past, trading the life of the memory for its cultural fossil. Symbolic myth is guaranteed a safe journey in time, protected from all historical contingency on the condition that it never veer away from this assigned role. Symbolic myth is dead and as such can be commodified in infinite replicas whose repetition will only serve to reiterate its unidimensional meaning, becoming a perfect vehicle for the traditional values it usually represents.

Alternatively, events can be reconstituted as memories through an allegorical process that favors the intensity of experience over its abstraction. Oblivious to the symbolic atemporality that permeates an event with divine transcendence, allegory seeks to maintain the event alive in time. The focus of allegorical memory is not on the originating event or its representation, but rather on that very intensity and immediacy that places the event squarely in the present. However, since the event is already gone and lived intensity is by definition fleeting and therefore ungraspable, allegory has no option but to attempt crystallizing transitoriness itself—that fugitive experience which it so desperately longs for.

The allegorical crystallization of events into memories is as distinct from that of the symbol as melancholy's and nostalgia's contrasting relationships to death. By being cognitively exposed to a chronological

movement where the intensity of all events necessarily fades, yet simultaneously retained in an objectified form in a state of hibernation, the allegorized event becomes doubly susceptible to the ravages of time. Susceptible first because being permanently available as a live experience, it is proportionally vulnerable to repeated forgetfulness, unlike in nostalgia, where, having been fossilized as a reconstructed piece of time, the event supposedly forgoes all temporal limitations, and is never forgotten. Susceptible in the second place because the object that the event is inscribed in is itself prone to physical decay, a form of aging that is irrelevant to nostalgia (which replaces it with another intact version) but that reinforces the sense of loss that melancholia strives to attain.

It is as if the very act of temporal suspension inspired its nemesis, decay, to attack with double force. Melancholic kitsch revels in memories because their feeling of loss nurtures its underlying rootlessness. Nostalgic kitsch evokes memories in order to dispel any such feelings, stubbornly hanging on to any inkling of the past that may provide it with a sense of continuity and belonging—that is, with a tradition. Nostalgic memories are intact, often referring back to a past whose mythical quality depends on its distance. Melancholic memories are shattered and dispersed, referring only to the process of loss that constitutes them, their mythical quality enhanced by this ungraspable condition.

A memory's insistence on belonging to a symbolic continuum ultimately excludes it from remaining alive in time, even if only to die the slow death of forgetfulness. Nostalgia's emphasis on intact experiences keeps them prisoners of only one reminiscence, while melancholia's abandon to the passing of time (in its fascination with death) grants remembrances many longing lives. Ruins and organic fossils meet therefore in melancholia, in the interiors and dioramas whose very enclosedness and obsession with trapping lived moments make them into veritable tombs of experience, tombs where corpses slowly accumulate the signs of both frozen and passing time.

Melancholy is much more illustrative of the modern condition than nostalgia, for in its continuous dismissal of perfection and totality, melancholy reenacts the constant transgression that modernity, in its desire to break from the past, must inflict on tradition. This broken-down condition implies that modernity's own production will never be safe from a state of permanent fluctuation: where the past is considered insufficient and the future is not yet within grasp, the movement that leaves one behind while reaching out for the other can only provide a slippery, unstable and angst-ridden certainty.

Nostalgia and melancholy represent two radically opposite perceptions of experiences and cultural sensibilities. One, traditional, symbolic and totalizing, uses memories to conceptually complete the partiality of events, protecting them with a frozen wreath from the decomposition of time; the other, modern, allegorical and fragmentary, glorifies the perishable aspect of events, seeking in their partial and decaying memory the confirmation of its own temporal dislocation. Melancholic kitsch is a unique experience contingent on its very absence, the ongoing flight of those moments that memories forever ardently recall.

RODNEY AND DEATH

———◆◆◆◆◆———

RODNEY'S aberrant decease places him in that peculiar limbo in which all creatures, animal and vegetable alike, find themselves when stuck between life and death—a precarious balancing act sustained on both the more tenuous and most resolute fibers of such antithetical states of being. In this indeterminate condition, life is but a glint in a misty glass eye, a protracted gesture about to be completed, a mute scream caught between throat and vocal cords without sufficient air to become audible.

Suspended death is an infinite nightmare that knows no end and remembers no beginning, only the interminable anguish of a recurrent scene. In this fluctuating boundary between paralysis and action, silence and eloquence, light and shade, reigns the impenetrable fate of half-finished lives. The partial cessation of animated sap transmutes into a thick resin similar to that which bleeds from the bark of trees, making pellucid jewels from insects carelessly drawn into these death traps by their sweet smell and honey-colored glow. Such is the fatal destiny of a sudden winter's unsuspecting victims, doomed to a hibernation where their velvet petals, translucent wings and furry skins crystallize into silver icicles.

Thanatopsis incarnate, Rodney's cataleptic stupor induces a trance similar to the gradual ebbing away of life: a moribund languor that no longer cares to struggle for its animating force. Yet a vital spark radiates from the fossilized hermit's eyes, an infinitesimal but distinct glimmer that speaks as loudly as words about the bottomless solitude of his panoptic jail. Incapacitated from retreating back into his shell, forever paralyzed in an exploratory position—legs walking on an inexistent ground, claws held out to grab the dense nothingness of his hardened prison—Rodney suffers from a unique asphyxia that suffocates those who can conceal themselves from the invasion of a staring, groping world only by blanking out under the enemy attack, as if this vanishing act could somehow protect them from such transgression.

Oh, how the closing windows of claustrophobia must rapidly open to another passage of air—the instinctive dissociation that constitutes a flight from some uncontrollable danger, leading us into the safety of a neighboring dimension. Here, we can stand alongside ourselves without fully giving in to the siege, gently attempting to break away from the malefic spell that numbs us until we succeed in mechanically leaving the cookie house of death. Outside, the regular pace of ordinary events—the inconspicuous appearance of electric light at dusk, the gravel-like sound of rubber tires against the pavement—returns us to our body with the quotidian solace of the familiar, that rhythmic repetition which grants us the paradoxical freedom of certainty.

Rodney exists in a deadlock between two states of being,

unable to fully launch into the lively fluctuations of the sea at night, or the solemn silence of a universe that has surrendered all claims to sensation. His split presence within the glass globe shows the unlikely encounter of life and death, a polar opposition come together for a perpetual instant in the fragile figure of a small hermit crab. Rodney's dual existence is a dead-still scene where movement seems to be lingering right around the corner, as if any moment now some cosmic signal would release player and stage from their transitory paralysis. Sadly, there is no escape from the watery grave in which Rodney is buried, a helpless buoy in the middle of a forgotten ocean. Caught in the eternal sleep of unfinished fairy stories, he can only go further inside his misery or out into the volatile atmosphere of human empathy—a precarious port to which he fastens himself, seeking in this temporary crossroads consolation for his bereavement.

Rodney's is the fate of time travelers who get lost, eventually succumbing to their disorientation as a predestined text from which there is no escape. That he was randomly estranged from his natural habitat does not change the fact that this small crustacean was naively meandering through the jungle of life with his antennae seeking only familiar dangers, disregarding those others—far worse and often more deadly—that tend to lurk behind. For being careless, for not knowing that there are no inviolable territories under the sun, he now pays with every moment of his truncated existence, a helpless arthropod stuck in the one exoskeleton which he will never outgrow.

Disjointed from the ordinary process of a crab's death—the brutal mutilation of limbs, the slow putrefaction of flesh—an inconspicuous ornament constantly changing hands and places, forced to passively observe the world around him bloom and decay season after season, Rodney cries silently, his tears freezing around him like a transparent igloo in an endless polar night. Loneliness is Rodney's staple, the unwonted curse that accompanied his fall from grace like our shadow that unyieldingly follows us, casting dark silhouettes.

Immobilized, hushed, solitary, Rodney can only rely on his minuscule eyes—forced to remain open day and night—to anchor himself on this gyrating planet. For Rodney life is a concave dimension, an interminable fish's-eye view where bodies are constantly changing shape and volume. Everything seeps his translucent bubble but none of it ever crosses the invisible wall that separates him from life: things glide around the glass globe's smooth surface as stolen glances to a secondhand mirror—fleeting images that occupy the reflective material without even minimally disturbing it, false promises of an affiliation whose disparate elements bounce off each other like the slippery fragments of a mercury droplet.

Eternally captive in a capsule whose entire universe is reduced to the domestic sphere, this mundane passenger is an involuntary witness to the unfolding of private stories which he watches with the same detachment that makes him an inconspicuous part of each home's décor. Like a mobile set, Rodney casts

his own minuscule tragedy onto whatever room he might land in, adapting to each particular syntax with the versatility of an experienced guest. His is the world of things: a silent, observing realm that sits in the midst of human activity, holding a lease contingent on the uncertain territories of joy and anger, indifference and care. From this peculiar vantage point, Rodney follows the rise and fall of feelings—those infinite nuances—as well as the comings and goings of other objects which must (but don't always) comply with the demands of human possession. It is perhaps in the active—or passive—role things play upon demand that their true nature surfaces, revealing a hidden knack for alliances, betrayals, dislikes and even outright rebellion.

Rodney is alive somewhere in the shallow depths of his incarceration. Ours is the quiet communion that occurs between beings whose bond is so strong it needs no outward manifestation, only the occasional glee at having found a kindred soul. It is not I who impose this bond on an inert being, but rather he who, reaching out from the bottom of his sadness, touched my heart that afternoon in the Château Tivoli, calling my then-distracted attention to the place where our existences converge, becoming in this mutual recognition such an intrinsic part of my life that it was inconceivable for me to leave without him. In Rodney's eyes I have been able to gaze into myself as never before, and in this awareness he has resuscitated to a new way of life, for since the moment we met, Rodney lives in me.

Index

Page numbers in *italics* refer to illustrations or their captions.

IN MEMORIAM
Ludwig
BELOVED KITTY
1990-1997

About the Author

Celeste Olalquiaga is the author of *Megalopolis: Contemporary Cultural Sensibilities,* also published by the University of Minnesota Press. She has received Rockefeller and Guggenheim awards, and lives in Paris.